Excellence II: The Continuing Quest in Art Education

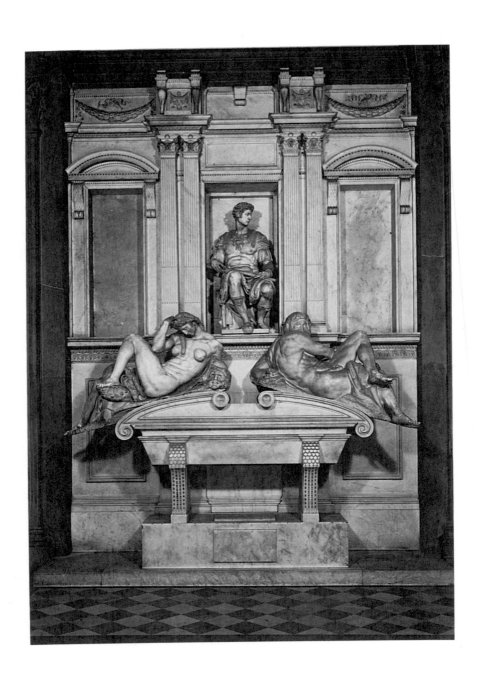

EXCELLENCE II:

THE CONTINUING QUEST IN ART EDUCATION

Ralph A. Smith

University of Illinois
at
Urbana-Champaign

National Art Education Association
Reston, Virginia

Cover: Michelangelo, *Guiliano de' Medici* and *Lorenzo de' Medici* (details) from the Tombs of the Medici, New Sacristy, S. Lorenzo, Florence, Italy 1524-34. Alinari/Art Resource, N.Y.

Frontispiece: Michelangelo, *Tomb of Guiliano de' Medici*, New Sacristy, S. Lorenzo, Florence, Italy 1524-34. Scala/Art Resource.

About NAEA . . .
Founded in 1947, the National Art Education Association is the largest professional art education association in the world. Membership includes elementary and secondary teachers, art administrators, museum educators, arts council staff, and university professors from throughout the United States and sixty-six foreign countries. NAEA's mission is to advance art education through professional development, service, advancement of knowledge, and leadership.

ISBN 0-937652-87-3

I dedicate *Excellence II* to classroom

teachers of art with whom responsibility

for cultivating a taste for excellence in

art ultimately rests.

Contents

Preface

The words were ominous: "The educational foundations of our society are presently being eroded by a rising tide of mediocrity that threatens our very future as a Nation and a people."

Thus, in 1983, did the National Commission on Excellence in Education declare our country to be a Nation at Risk unless serious reform with a renewed commitment to excellence headed the nation's educational agenda on all levels from teacher preparation to classroom curricula. While the theme of excellence in education was certainly not new, this report along with a cluster of other studies and reports aroused an unprecedented amount of attention and spurred a continuing debate about the meaning of educational excellence, the rightful place of the arts in basic education, and the challenges of achieving excellence in a democratic, pluralistic society.

In 1985, Nancy MacGregor, former president of the National Art Education Association, appointed Ralph A. Smith to chair an NAEA Committee on Excellence in Art Education and invited him, on behalf of the association, to write a response to the excellence-in-education movement. The result, *Excellence in Art Education: Ideas and Initiatives,* proved to be a valuable contribution to the ongoing discussion. Beginning with a thoughtful exploration of the meaning of excellence and excellence in art, *Excellence in Art Education* went further than most of the studies of the day by suggesting specific questions that should be asked of an excellent curriculum in art education and suggesting specific content for courses of study. This essay became a much sought after tool for curriculum design and teaching.

In the summer of 1993, the NAEA Board of Directors adopted a two-year agenda, "Recognizing Excellence," for achievement in art education. This agenda calls for a commitment to excellence in education, restoring confidence in the importance of what we do in the education of children, and reorienting the public's understanding of what art education means for every student. Now, mid-way through the agenda, we are pleased to present, *Excellence II: The Continuing Quest in Art Education.* This new, updated publication broadens the search for excellence, bringing into focus developments that have challenged art educators during the past eight years. Modernism and Postmodernism, Multiculturalism and Cultural Particularism are among the new chapters of the volume. Once again the study

addresses specific classroom needs and questions, this time with applications for the K-12 curriculum in contrast to the emphasis on secondary grades in the original version.

The search for excellence in education is a lifelong search and will doubtless take us in many directions in the decades to come. NAEA is pleased to present this new version of the 1986 publication, and we can only hope that its reflections and discoveries will resonate with educators, parents, and all who appreciate that art learning is often hard work requiring effort and commitment and persistence.

Mark R. Hansen, President
National Art Education Association

Introduction

The decision of Mark Hansen to select excellence and its recognition as the theme of his presidency of the National Art Education Association (1993-1995) is another reminder that dedication to quality and standards of achievement—in short, excellence—is a proper concern of any professional organization. As in the eighties, members of the association are being asked to consider the goal of cultivating an appreciation of excellence in art, to devise the means by which this may be accomplished, and to confer approbation on those who accept this challenge.

Since its publication in 1986 (slightly edited and updated version, 1987) *Excellence in Art Education* has become a standard reference in the literature of art education, and at the time of this writing it is enjoying a third printing. The first printing was quickly exhausted, and its sales helped to make a more extensive publication program economically feasible for the national organization. Many found the book's discussions of the ideal of excellence, excellence in art and art education, the question of elitism, and initiatives toward excellence informative and helpful, while others raised questions about its general point of view. Invited in 1984 by then NAEA president Nancy MacGregor, the original version was a response to the excellence-in-education movement stimulated by the publication of *A Nation at Risk* (1983), a movement on which we are now gaining some perspective.

Excellence in Art Education was written on behalf of the national association with the advice of a committee of its members. I was nonetheless ultimately responsible for its views. The present discussion is the result of my suggestion to president-elect Hansen that a new version of *Excellence in Art Education* would be congruent with his presidential theme. I proposed that it would recall the ideal of excellence, discuss new initiatives in the field, and address topics that either had not been dealt with or had been scanted in the original version. President Hansen responded favorably to this suggestion, as did the NAEA publications committee and the NAEA Board. It needs saying then that this version is a personal statement of ideas and reflects my own value system; it does not necessarily represent the views of the association's membership or leaders, although it seems reasonable to

suppose that President Hansen, the publications committee, and the board would not have approved the project unless they believed the pursuit of excellence to be in the best interests of the field.

The original version featured a response not only to the report *A Nation at Risk*—which in truth did not contain a significant discussion of the arts—but also to a number of more substantive publications, namely John Goodlad's *A Place Called School*, Ernest Boyer's *High School,* Theodore Sizer's *Horace's Compromise,* and Mortimer Adler's *The Paideia Proposal,* to mention only those that received extensive media coverage. These works were important for both their criticism of conditions detrimental to effective learning in the schools and for the remedy they proposed: a program of basic, general education composed of traditional subjects as well as literature and the arts. Because it had been largely neglected in discussions of educational reform, the secondary level of schooling tended to receive the major emphasis in these studies. Although the reports indicated the subject-matter areas that should constitute a program of general education, they offered little discussion of specific concepts, skills, and values. Interpretation for curriculum design and teaching was thus necessary. Accordingly, the original version of this book outlined a curriculum for the secondary grades that attempted to do justice not only to the seriousness and complexity of art but also to the demands of schooling and aesthetic learning.

Excellence II departs from the original and updated version by outlining a more comprehensive curriculum for art education, K-12. It further updates recent developments in the field and addresses the topics of multiculturalism and cultural particularism as well as modernism and postmodernism as they relate to art education. The discussions of aesthetic experience and the features of artistic excellence have been expanded into two chapters, and responses to questions raised about the original version are made in appropriate places. Although some of the language and argument of the original book have been retained, enough new material has been added and rewriting undertaken to warrant calling this volume a new version.

Finally, the preparation of this new version was prompted by the conviction that any democratic society that fails to encourage its young to appreciate and strive for excellence is destined to sink ever more deeply into the mire of mediocrity and thus to deny its members opportunities to actualize civilized values in their lives.

Acknowledgments

I am indebted to a number of people, namely Mark Hansen who responded positively to my suggestion to write a new version of *Excellence in Art Education,* Thomas A. Hatfield, executive director of the National Art Education Association, who provided encouragement and helped see the text through editing and printing, the NAEA publications committee, chaired by Anne El-Omami, and the NAEA Board for approving the proposal. Further thanks are due to Nancy MacGregor for her earlier and continuing encouragement. I especially thank all those who took the time to write and say how useful they found my discussionsin the first version. C. M. Smith is thanked for her efficient copyediting, and the members of the University of Illinois College of Education Word Processing Center— namely, June Chambliss, its director, and Selena Douglass, Lana Bates, Debra Gough, and Teri Frerichs—for the competent typing of the manuscript.

In addition to material contained in *Excellence in Art Education,* I have drawn on a number of my recent writings, which are used with the kind permission of their publishers: *The Sense of Art: A Study in Aesthetic Education* (New York: Routledge, 1989), especially its discussions of aesthetic experience, including the appendix; *Art Education: A Critical Necessity,* with Albert W. Levi (Urbana: University of Illinois Press, 1991), especially its interpretation of the humanities; "Toward Percipience: A Humanities Curriculum for Arts Education," in Bennett Reimer and Ralph A. Smith, eds., *The Arts, Education, and Aesthetic Knowing,* Ninety-first Yearbook of the National Society for the Study of Education, Part II (Chicago: University of Chicago Press, 1992): 51-69; "The Question of Multiculturalism," *Arts Education Policy Review* 94, no. 4 (March/April 1993): 2-18, with permission of the Helen Dwight Reid Educational Foundation, published by Heldref Publications, 1319 18th Street, N.W., Washington, D.C., copyright 1993; "Building a Sense of Art in Today's World," *Studies in Art Education* 33, no. 2 (Winter 1992): 71-85; and "Problems for a Philosophy of Art Education," *Studies in Art Education* 33, no. 4 (Summer 1992): 253-66.

Ralph A. Smith

1

Excellence, The Continuing Ideal

What the world has admired in the Greeks is the remarkably high level of their originality and achievements, and this high level premises a deeply held conviction of the importance of individual attainment. The goal of excellence, the means of achieving it, and (a very important matter) the approbation it is to receive are all determined by human judgment.

Moses Hadas

Excellence in Art Education centered attention on the discussion created by a number of reports and studies about education and the schools that received extended coverage by the media. In contrast to the decade of the sixties, especially the early 1960s when the concern for excellence arose from fear of the possible loss of American scientific and technological superiority, the anxiety of the 1980s stemmed largely from economic competition with other technologically advanced countries, especially Japan. Russian satellites circling the globe caused less consternation than did Hondas and Toyotas rolling off the ramps of ships in American seaports.

The response of numerous educators in the early 1960s, largely inspired by Jerome Bruner's *The Process of Education,* was to try to improve the teaching of scientific, mathematical, and technical subjects.[1] In the 1980s, interest in improving the teaching of these subjects continued, but the writing about curriculum by Goodlad, Boyer, Sizer, and Adler, among others, was more balanced. Boyer made a point of saying that the arts are

an essential part of a person's education, Goodlad stated that less time should be spent in the teaching of art on creative and performing activities and more on the study of works of art as cultural objects, Adler that classics and masterpieces are appropriate objects of study for adolescents, and Sizer that at least one major department of secondary schooling should be devoted to literature and the arts. Several other educational writers had been saying essentially the same thing for some time; they included Philip H. Phenix, Harry S. Broudy, and Maxine Greene among philosophers of art, and Edmund Feldman, Laura Chapman, and Elliot Eisner among art educators, the latter having written major textbooks on art education during the 1970s. Unfortunately, authors associated with the education profession tend to be ignored by those in positions to create an audience for educational ideas. Indeed, when the history of educational reform in the latter part of the twentieth century is written, it would be incomplete without an assessment of the role of the mass media in shaping public opinion about education. Whatever the media choose not to discuss (and thus not to publicize) might just as well never have been written.

I further remarked that the excellence-in-education movement of the 1980s was the expression of a more culturally and educationally conservative mood than that of the late 1960s and early 1970s, a period characterized by unrestrained criticism of established authority. We have yet to recover the cultural and educational ground that was lost during that countercultural period, a loss in large part due to the proliferation of school offerings and the behavior of many in higher education who renounced the prerogatives that experience and knowledge of their subjects had rightfully conferred on them. A misconceived egalitarianism led many critics to denounce legitimate authority and to characterize appeals to standards and excellence as "uptight" and "elitist." In brief, the 1960s and 1970s magnified a recurrent tendency in American education toward anti-intellectualism and loss of nerve. It is clear that the excesses of these two decades were responsible for the subsequent demand for a return to basic education and for a more coherent curriculum. Conservative writers were not alone in acknowledging this point; liberals also realized that matters had gotten out of hand.

What is the mood today? I think it is one of dismay and concern about the rapidly deteriorating conditions of school life and learning. Some of the signs are the fear of violence and disorder that afflicts teaching and affects school attendance, casual attitudes toward drug and alcohol use and

2

sexual behavior, the high degree of cultural illiteracy and embarrassing cross-cultural comparisons of scholastic achievement, the use of the schools to advance the agendas of special interest groups, and the infection of teaching and learning with the nihilism of fashionable intellectual currents. All these conditions have instigated a public discussion of school choice that has the fate of the public schools hanging in the balance. Most distressing from a formal pedagogical standpoint is the inability of the schools to develop substantive understanding in students, as is evident from studies and surveys showing that the young don't know the first things about either the history of their own country or democratic principles and values.[2] The mood of the nineties further differs from that of the immediately preceding decades in its change of attitude toward the idea of a richly diverse common culture, an idea that recognizes cultural pluralism without losing sight of those things that hold a society together. Today, by contrast, we see an increasing readiness to accommodate ethnocentrist and particularist thinking of the kind that rejects the very possibility of commonalities.

Important to consider for purposes of this essay is the intensification of the attack on excellence and standards in the name of cultural equity—the belief that inclusiveness and representativeness in matters of art and culture are more important than the quality of achievement or level of performance. This belief is central to the new egalitarianism and is part of the politicization of learning and schooling that has worrisome consequences. It is especially invidious when it fails to do justice to the special character of the human endeavor called art, for art is the last thing we should want to exempt from critical judgment. It is, in fact, rare for a society to attach no importance to the ranking of some things as better than others and to distinguishing some things as excellent. Surely, the ideal of excellence and its recognition is a structural feature of American life. It would require a volume of encyclopedia size with tiny print to list all the awards for achievement Americans yearly confer. Recognizing excellence of various kinds is certainly a major priority of the National Art Education Association whose list of annual awards and honors takes up a full page in the *NAEA News*. There is nothing surprising about such recognition; without standards of quality and accomplishment there is no way to motivate persons to realize their inherent capacities, no way to set significant goals and provide incentives to help them transcend the commonplace and the ordinary. No doubt many persons discover things they find worth doing for their own sakes and derive sufficient incentive from wanting to excel in them. Yet the capacity for self-

motivation is slowly acquired; most people require the nudge that the prospect of recognition and reward produces.

Those nineteenth-century cultural critics who anticipated the problems modern mass democracies would have in finding and maintaining high ideals realized that a preoccupation with quality would have to be a continual feature of society's agenda. America needs an enduring commitment to excellence to avoid sinking deeper into mediocrity. In the second edition of his *America as a Civilization* (1987), a monumental study of American life, manners, and morals, Max Lerner writes that Americans do not lack energy and vitality in facing many serious problems. But what they do lack are prudence and judgment, especially with regard to their high and popular culture.[3] One can only agree; it was precisely the failure of artists and members of the art world in the eighties to exercise prudence and judgment that gave critics opportunities to assail a range of questionable artistic happenings. Just as Lerner had in mind primarily the America located in the geographical area between Canada and Central America, I should also emphasize that it is not my purpose to recommend what other countries should do to develop aesthetic understanding in their young people. That would be presumptuous. But surely, the pursuit of excellence is relevant wherever societies place a high value on the fullest possible realization of significant human powers, important among which is the capacity to create and appreciate art. I will simply observe that it was a Canadian novelist, Morley Callaghan, who wrote that the real friends of Canada are those who not only believe in the idea of excellence but who try to realize its standards and defend the idea against its detractors.[4]

Artistic and aesthetic values are, of course, not ultimate values—intellectual and moral considerations must rank higher in any hierarchy of values—but no account of the good life is complete without a description of the role of art and aesthetic experience in the human career. In *Aesthetics and the Good Life*, Marcia M. Eaton, a philosopher of art who regularly addresses art educators, states her conviction that aesthetic activities and experiences are not only a very important aspect of living, they are part of what it means to lead a moral and rational life.[5]

The discussion of excellence in the 1960s and 1980s stressed the use of schooling for maintaining technological and economic superiority in the course of providing a broader, more comprehensive general education. In the 1990s these concerns are still evident but are now overshadowed by an interest in developing cultural literacy and in formulating educational

standards that will ensure to persons growing up in an increasingly complex and interconnected world the ability to participate effectively in public life and to benefit personally from involvement in cultural activities. At the time of this writing a grass-roots effort is under way to foster cultural literacy, and a number of professional groups and organizations have formulated national standards for the assessment of teaching and learning in art education. These efforts exhibit both the strengths and weaknesses of earlier attempts to spell out what the young should learn. On the positive side the standards are generally substantive; on the negative side they suffer from the constraints inherent in the political processes that shape them. Nonetheless, a renewal of interest in standards is consistent with the theme of this book.

Another impediment to devising an excellence curriculum are some attitudes endemic to American culture. Americans have never been entirely comfortable with the idea of pursuing and recognizing excellence. Champions of excellence have always had to contend with a pervasive anti-intellectualism that in matters of preference is satisfied with the ordinary over the exemplary and with attempts by commonplace minds to impose commonplaces whenever they can. Yet it is consistent with democratic principles to value excellence and to assert that all persons should have opportunities to transcend their common and ordinary selves in the quest for something superior. And it has long been a central tenet of liberal learning, of a liberal education, that personal fulfillment is best realized through disciplined encounters with serious ideas and works that challenge individuals to improve themselves.

One inference from the preceding discussion is that one does not seek to attain excellence in a vacuum; one pursues it within the framework of a society's ideals and with regard to kinds of excellence. The ancient Greeks began by prizing the excellence of the warrior and the athlete but, as their culture developed, they added aesthetic, intellectual, and moral values, including rhetoric, oratory, and the civic virtues required for urban living. The Greeks, moreover, bequeathed to later civilizations the idea of *paideia*, a term that refers essentially to the ways in which a society engenders in young people worthwhile qualities of mind, body, and character. It is testimony to the persuasiveness of the Greek meaning of paideia that our own paideia—that is, the way we cultivate general knowledge in the young—reveals similarities to the ancient ideal not only in valuing excellence and recognizing it (with whatever qualifications), but also in the belief that excellence may take various forms. In this respect we are all Greeks.[6]

5

Of course, the Greek conception of paideia was formulated essentially for an aristocracy. The basic task for a philosophy of art education in a democracy is to define what artistic excellence and aesthetic experience consist in and to suggest ways of developing the disposition to prize artistic excellence in all students, not just in a privileged class of society.

2

The 1980s' Call for Reform

[T]here was a noticeable absence of emphasis on the arts as cultural expression and artifact. The need for expression lies just back of the human need for food, water, and socialization. Yet the impression I get of the arts programs in the schools studied is that they go little beyond coloring, polishing, and playing—and much of this goes on in classes such as social studies as a kind of auxiliary activity rather than as art in its own right [Yet] to grow up without the opportunity to develop sophistication in arts appreciation is to grow up deprived.

<div align="right">John Goodlad</div>

In *Excellence in Art Education* I said that the studies and reports that instigated the excellence-in-education movement were a mixed bag: some were merely the products of relatively short and intensive periods of research, others little more than dramatic statements intended to ignite reaction, while still others were the result of multiyear investigations of greater substance. Since the tendency of the media to treat the various studies indiscriminately (as they were later to lump together the quite different books by E. D. Hirsch, Jr. and Alan Bloom) begged the question of their relative merits, it became necessary to make some distinctions. I also referred to a number of other studies by educational writers and organizations that, while receiving little or no media coverage, had greater relevance.

Many readers of the original version found the summary of these reports and statements helpful, and I recall them here in order to establish continuity of discussion.

The document that issued the call to reform, *A Nation at Risk,* though hardly the best statement on arts education among the reports, did mention it here and there.[1] It said that knowledge of English, mathematics, science, social studies, and computer science "together with work in the fine and performing arts and foreign languages constitutes the mind and spirit of our culture" (24-25). This casual mention of the arts was, however, sufficient to prompt most reviewers to omit any reference to the arts as a new basic subject; and, as I've implied, all that many know about such reports is gained from media statements or from summaries and abstracts prepared for those too busy to read entire documents. Yet along with its conventional rhetoric, *A Nation at Risk* also featured passages that contained the seeds for a justification of arts education as a basic subject. Thus, in referring to the quality of life, the book warned "that an overemphasis on technical and occupational skills will leave little time for studying the arts and humanities that so enrich daily life, help maintain civility, and develop a sense of community," whereas "knowledge of the humanities. . .must be harnessed to science and technology if the latter are to remain creative and humane, just as the humanities need to be informed by science and technology if they are to remain relevant to the human condition" (10-11). One objective of English study is to "know our literary heritage and how it enhances imagination and ethical understanding, and how it relates to the customs, ideas, and values of today's life and culture" (25). Unfortunately, the discussion of arts education, like that of other subjects, never rose above the level of general statement.

Five other reports—actually three are studies, one a manifesto, and the fifth a set of recommendations—did much better; for example, John Goodlad's *A Place Called School,* Ernest L. Boyer's *High School,* Theodore Sizer's *Horace's Compromise,* Mortimer Adler's *The Paideia Proposal,* and the College Board's *Academic Preparation in the Arts.*

In thinking about an excellence curriculum for arts education, it is prudent to consider the larger setting in which schooling is embedded. The era of ecological awareness we live in should have taught us to see things as interdependent components of systems that are trying to maintain equilibrium while undergoing uneven change. This awareness can lead us to a better understanding of the ways schools attempt to achieve their goals and

reform themselves. Perhaps no single work has contributed more to an ecological view of schooling than John Goodlad's *A Place Called School*, an ambitious and impressive multiyear study of schooling in America. Goodlad emphasized that since schooling is interdependent with other sectors of society and reflects and shares their problems, its shortcomings can be attributed to no single cause. He thus effectively laid to rest conspiracy explanations of the schools' ineffectiveness and further exposed misconceptions about schooling that derive from either misinformation or axe grinding.

The upshot of Goodlad's study was that the schools reflect the dominant values and attitudes of the larger society and attempt to change only when pressured to do so. These values and attitudes are not expressed in the statements of higher purpose subscribed to by practically all schools but in the operative values implicit in the circumstances of schooling—for example, in the contents of the curriculum and methods of teaching, in a school's attitude toward equality and access, and in its disposition toward change. The degree of seriousness and caring about teaching and learning is also important. Goodlad was conscious of the dramatic progress that has been made in providing access to schooling, and he remains generally optimistic (optimism, he says, goes with the educator's territory). However, extrapolating from research on a sample of schools, he presented a picture that might well prompt any prospective teacher to have second thoughts about choosing teaching as a career or any educational reformer about trying to improve schooling.

> Those women and men who do enter teaching today work in circumstances that include some gain in their autonomy in the community accompanied by some loss in prestige and status; an increase in the heterogeneity of students to be educated, especially at the secondary level; increased utilization of schools to solve critical social problems such as desegregation; a marked growth in governance of the schools through legislation and the courts; continuation of relatively low personal economic return; limited opportunities for career changes within the field of education; and continuation of school and classroom conditions that drain physical and emotional energy and tend to promote routine rather than sustained creative teaching (196).

That is not all. The concerns of teachers and students diverge in important ways. Teachers tend to place more emphasis on the academic function of

schools whereas students are more interested in vocational training and grades needed for graduation. Even more important to large numbers of students is the nonacademic side of school life that consists of social activities and sports. Although these characteristics of contemporary schooling have generated pessimism and despair in some observers, Goodlad wrote that "to think seriously about education conjures up intriguing possibilities both for schooling and a way of life as yet scarcely tried" (361).

Goodlad in effect concluded that the spirit and methods of progressive education, the curriculum reform movement of the late 1950s and 1960s, and the ideas about open education of the seventies have not had any appreciable effect on the quality of schooling. While efforts to promote significant learning are more discernible in the early grades, they are much less apparent at the secondary level. Many arts and vocational education courses offer variations from the dreary routines of teaching, but students think that these classes, though enjoyable, are easy and unimportant.

Regarding the teaching of the arts, Goodlad found a general condition of disarray and a lopsided emphasis on manual skills and performing activities—for example, on drawing, painting, ceramics, singing, dancing, pantomime, puppetry, acting in plays, filmmaking, embroidery, weaving, crafts, graphics, photography, and jazz. Too much popularity is enjoyed by merely seasonal projects, and too much time is spent on band practice and rehearsals for plays. As art instruction centers mainly on process, little attention is paid to appreciating works of art as artifacts and cultural expression, which is to say few opportunities are provided for students to develop a sophisticated understanding of the arts.

Goodlad's recommendations for improving secondary education recalled reports on general education from the 1940s and 1950s and emphasized a degree of choice in an otherwise common and balanced curriculum. His curriculum consists of seven domains (if one counts physical education) of instruction that are distributed over the secondary years approximately as follows: mathematics and science (18 percent); literature and language (18 percent); social studies (15 percent); the arts (15 percent); the vocations (15 percent), physical education (10 percent); and individually selected studies (10 percent). There could be some variation in these percentages and not everything would be prescribed. The seventh domain could consist of further concentration in one of the core areas, including the arts. Although Goodlad believes that students should not be permitted too much choice and that becoming interested on their own in

something they know little about is difficult, he admits that the seventh domain, the elective, could prove to have the most lasting value to students. As for the question of individual differences within a curriculum of common learnings, Goodlad thinks that the research on the topic suggests variability is more relevant to modes of teaching than to areas of study. Schools, moreover, should keep records on each student to determine the extent to which a student's program deviates from an ideal or prototype program. Goodlad's domains bear resemblance to the basic subjects and fundamental areas of knowledge and appreciation found in *A Nation at Risk,* Boyer's *High School,* and Adler's *The Paideia Proposal,* and his humanistic sentiments are similar to those expressed in Sizer's *Horace's Compromise.*

Unlike Adler, however, who emphasized that art making and performing activities are as important as talking and thinking about art, Goodlad realized that there is far too much making and performing in today's art education. He therefore stressed that such activities should be supplemented with the cultural study of the arts. But because he wanted his study to serve mostly as a goad to reflection about conditions of contemporary schooling and the need for substantive reform, Goodlad did not detail his recommendations for an arts curriculum. Instead, he acknowledged contemporary thinking about arts education in passing by referring to a volume commissioned by his study of schooling.[2] But everything considered, Goodlad's book boded well for art education and was an important initiative toward excellence in art education.

Mortimer Adler's manifesto, *The Paideia Proposal,* written on behalf of the members of the Paideia Group, is dedicated to Horace Mann, John Dewey, and Robert Hutchins, who form but one of several trinities we encounter throughout this brief tract. The report's Deweyan spirit is evident in the statement that the purpose of schooling is to prepare youth for further learning and more growth. The legacy of Horace Mann is discernible in the commitment to the public schools and to Mann's belief that public education is the gateway to universal equality. Adler acknowledges his debt to Robert Hutchins when he quotes Hutchins's conviction that "the best education for the best is the best education for all." Adler proceeds from the assumption that the basic similarities among individuals are more important than their differences, a position he thinks supports an argument for a common rather than a differentiated curriculum. He believes that whatever individual differences there are among students can be accommodated in a context of sameness. What is important to realize is that all children "have the same

inherent tendencies, the same inherent powers, the same inherent capacities" (43). And since social equality implies the same quality of life for all, there should be the same quality of schooling for all. Adler stressed that he was not recommending a monolithic educational system; on the contrary, he believes that reform must be achieved at the community level.

We encounter more trinities as Adler's scheme for education evolves. For the uses of schooling he proposes self-governing citizenship, earning a living, and the enjoyment of things of the mind and spirit. The mind may be improved in three ways: through the acquisition of organized knowledge in the most fundamental areas of human learning, for example, in language, literature, fine art, mathematics, natural science, history, geography, and social science; through the development of intellectual skills, for example, the skills of reading, writing, speaking, listening, observing, measuring, estimating, and calculating; and through the enlargement of understanding and aesthetic appreciation. The emphasis throughout such a curriculum should be on the study of the individual work, the development of a common vocabulary of ideas, and movement from easy to complex learning.

Adler continues with yet another triad in his discussion of modes of teaching: the didactic mode, which consists of the imparting of knowledge or teaching by telling; the mode of coaching, which involves teaching or showing how to acquire basic skills and requires drill and practice; and the Socratic mode, which is essentially dialogue that helps give birth to ideas. All three methods—didactic, coaching, and Socratic—should be used at all stages of intellectual, moral, and aesthetic development in trying to raise minds toward higher levels of understanding and appreciation.

What discussion there is of the arts can be found in connection with the goal of enlarging understanding and imagination. In the main, Adler thinks that emphasis should be placed on outstanding works of fine art, whether literary, musical, or visual, which are to be "appreciated aesthetically" or "enjoyed and admired for their excellence" (31). It is also important to discuss the arts critically in seminars where ideas and assumptions can be examined and clarified. In addition, Adler seems to have made a special appeal to art educators when he proposed that appreciation should be aided and enhanced directly through creative and performing activities: students should paint pictures, compose poetry, act in plays, and dance. Yet this recommendation should be placed beside Goodlad's criticism of the lopsided emphasis on making and playing in arts education.

Everything in Adler's manifesto, not surprisingly, comes together in three columns that feature three modes of learning (acquisition of organized knowledge, development of intellectual skills, and enlargement of understanding and appreciation) and three modes of teaching (didactic, coaching, and Socratic).

Adler further discussed auxiliary studies that consist of health and physical education, manual work, and career exploration, although he ruled out job training. He also acknowledged the importance of remedial instruction prior to school entrance and during the school years for those who need it. In connection with the preparation of teachers, Adler voiced the usual plea for fewer education courses and more work in the liberal arts and sciences. He made this recommendation, however, without acknowledging the serious problems that exist in undergraduate education.[3]

In *Excellence in Art Education* it was less important to discuss all of Adler's recommendations than to see his proposal as a significant commitment to excellence in art education. A renowned philosopher writing on behalf of a distinguished group of scholars and educators said that the arts have the capacity to expand human experience and contribute to the good life and therefore should be a basic subject in a core curriculum.

Subsequent publications of the Paideia Group addressed the problems and possibilities of establishing Paideia programs and contained discussions of three kinds of teaching and learning (seminars, coaching, and didactic instruction), descriptions of the subject matters the young should learn (English language and literature, mathematics, science, history, social studies, foreign languages, fine arts, manual arts, work, and physical education), reflections on the designing and recognizing of a Paideia program, and the grading of students. Of interest here is John Van Dorn's discussion of the subject matter of fine arts, which in the Paideia Program is separate from the subject matter of English language and literature.[4]

Inasmuch as the Paideia Program is grounded in a conception of general, nonspecialist education that stresses the teaching and learning of a range of liberal arts, the fine and useful arts among them, Van Dorn's notion of the learner is that of an artist or doer. This is not meant in the sense that the aim of fine arts education is the training of artists, but rather in the sense that students learn a spectrum of appropriate skills, for example those encompassed by the subject matter of a Paideia curriculum. In contrast to Goodlad's finding that far too much emphasis is being placed on creative and performing activities in arts education, Van Dorn tips the scales toward

performance, with less time devoted to the study of masterworks, although they too are an important part of a Paideia fine arts component.

What a study of the fine arts in both their creative and contemplative aspects contributes is an appreciation of things that are valuable for their own sakes. This is not to say that exposure to the fine arts has no consequences. Creative and performing activities and the study of outstanding works can lead to discoveries about the world both without and within individuals. The difference is that although the fine arts contribute to human understanding, they do so in detail and accents different from knowledge gained in other subjects in the Paideia curriculum. The goal of fine arts education in a Paideia program, then, is learning to know and to do in music, dance, drama, drawing, painting, sculpture, and crafts, with music, drama, and dance leaning more toward the symbolic arts (which are related to traditional fine arts) and the rest leaning more toward the material arts (which are associated with the useful arts)—a distinction I don't think holds up too well to scrutiny because it tends to perpetuate the mind-body dualism rejected by several contemporary writers.[5]

Otherwise Van Dorn provides conventional practical advice for teaching and learning. Start slowly and informally and only gradually increase the level of difficulty, but be sure to progress in a clear direction so that earlier feeds into later learning. Appreciate the important role that coaching has to play in apprenticeship situations and use seminars for discussion of selected masterworks, especially in the later years. The aim of the masterwork seminars is "to see that insights into works of art are really possible, can be arrived at, articulated, and improved by being made explicit. What is sought is full awareness and an intelligent response; the ability to see and hear with discrimination, lest we be blind and deaf to what goes on in the arts and artifacts, good or bad, that are everywhere around us" (149).

Van Dorn further advises what should be obvious. Integrate the fine arts into other subjects where appropriate, but not as a substitute for the study of the fine arts for their distinctive values; take account of the character of a given student population and teach accordingly (which is to say, incorporate the study of works by different ethnic groups and cultures without forgetting that the cultural heritage of the United States is largely Western and European); involve community groups and artists, and so forth. And when teachers and administrators are challenged to articulate the value of fine arts education, recall the benefits of a liberal arts education to a democratic society. Such an education

will prepare the individual for whatever challenge society confronts him or her with. In addition to which, the trained mind is better able to keep its balance in a bewildering world and enjoy what good it has to offer. Both are among the conditions of human freedom. Human beings are not free without some real sense of their environment and some power to design their lives; they are prisoners of fear, incompetence, and ignorance—easy prey for the bigot, the exploiter, and the tyrant who may at any time appear. A well-schooled population, aware of its human capacities and proud of its human distinction, is the best defense against such evils, indeed the only defense that in the long run has any chance of success (152-53).

Another study, Ernest L. Boyer's *High School,* sponsored by the Carnegie Foundation for the Advancement of Teaching, has been mentioned as a work that not only stressed the study of the arts as a basic subject of a core or common curriculum but also contained recommendations for major changes in the way we currently train teachers of art for the schools. Speaking in accents different from those of *A Nation at Risk* and taking a skeptical view of other studies that stressed improvements only in mathematical, scientific, and technological areas, Boyer asked that more attention be paid to the love of learning for its own sake, to the use of learning to improve the quality of life, and to the pursuit of excellence as well as equity. Sensitive to the circumstances that inhibit genuine teaching and learning and to the limitations of standard achievement tests for measuring the quality of schooling, Boyer, after ritualistic acknowledgment of the progress schools have made, went on to say that schools today really have no coherent goals and are in effect adrift. To set things on a steady course, objectives must be clarified, curriculum offerings considerably pared down, and the conditions of teaching improved. Most of all, a core of basic subjects should be created. What constitutes the content of such a core?

Broadly defined, it is a study of those consequential ideas, experiences, and traditions common to all of us by virtue of our membership in the human family at a particular moment in history. These shared experiences include our use of symbols, our sense of history, our membership in groups and institutions, our relationship to nature, our need for well-being, and our growing dependence on technology (95).

The particular components of the core are English, literature, the arts, foreign languages, civics, science, mathematics, technology, and health

education. As if to insure that they would be included in summaries of the core, Boyer's discussion of literature and the arts preceded that of the sciences, mathematics, and technology. (Recall that references to the arts tended to be left out of summaries of *A Nation at Risk.*)

Although it may be questioned why literature should be separated from the arts—literature after all is a cluster of art forms that includes poetry, novels, and plays—Boyer and the writers of most of the other reports do so. He writes that in addition to being carriers of the cultural heritage and the measure of a civilization, the arts are especially suited to express the gamut of human emotions. If Boyer's brief remarks contain anything approaching a definition of art or a notion about its basic function, it is the view that art is a nonverbal form of communication that educates the emotions and validates feeling in an increasingly insensitive world. Such a conception of art's role is common enough, although it does raise a number of questions. What do works of art communicate that verbal discourse does not? What does it mean to validate feeling or to educate the emotions? The ability to educate the emotions would seem to be a more characteristic function of literature than of the visual arts. Admittedly, we do not expect to find a well-conceived aesthetic theory in the kind of book Boyer wrote, and the purpose of asking these questions is only to underline once more the fact that the reports and studies under consideration were of little help in conceptualizing art education for purposes of teaching and learning. The importance of Boyer's study lies in the prominence it gave to the study of the arts.

In substance, scope, consideration, and flexibility, Boyer's curriculum for the high school stood out among the reports in question and in the respects mentioned resembles Goodlad's recommendations more than it does those of either *A Nation at Risk* or *The Paideia Proposal.* Especially during the last two years of high school, Boyer would depart from strict requirements and permit a pattern of requirements and electives. A unit of service is also recommended in order to give students a sense of institutional realities and some involvement in community life.

Theodore Sizer's *Horace's Compromise: The Dilemma of the American High School* was the first in a series of reports sponsored by the National Association of Secondary School Principals and the Commission on Educational Issues of the National Association of Independent Schools. The volume presented observations Sizer made of a number of American high schools over a two-year period during which he visited mainly social studies and biology classes. He also attempted to detect the ambience of the

16

schools he observed and how it either furthered or impeded the schools' principal obligation to promote substantive learning. The volume is yet another global study of secondary education, although Sizer was especially concerned to assess the schools' effects on the fundamental activity of teaching.

Horace is Horace Smith, a fictitious composite of the knowledgeable, decent, and dedicated teacher who is forced by the circumstances of teaching in today's high schools to make a number of compromises that redound to the benefit of neither his students, himself, nor the society these students will enter. Yet the hope for improving schooling and teaching lies mainly with the Horace Smiths and the adolescents they teach, adolescents who, Sizer thinks, deserve better than what they are getting and who are capable of doing more than they are asked.

Of all the reports and studies under discussion here, Sizer's was the most personal and humanistic in its concern for the quality of schooling and the lives of adolescents. He viewed the schools as human institutions in which students receive learners' permits to learn how to learn and to become decent human beings. Sizer's bugbear were models of school management derived from the social sciences. In his opening chapter he writes that his

> point of view throughout has been primarily that of schoolteacher and principal, roles that force on one an intense awareness of the frailties and strengths of individual human beings. There is a bias here that I recognize—that the craft of teaching is both art and science, and that the poetry in learning and teaching is as important to promote as the purposeful. Social and behavioral science, usually driven by purposeful ends, has dominated the way contemporary Americans view and administer their schools. Such science undoubtedly has its contributions, but the humanities' place deserves fresh emphasis. We deal with adolescents' hearts as well as brains, with human idiosyncrasies as well as their calculable commonalities (8).

In his last chapter Sizer wrote that although it is important to have Horace Smith and others like him if the schools are to be improved, the climate of these schools will be determined by the respect we accord to adolescents. We must take them more seriously "not out of some resurgence of 1960s' chic," but "out of simple human courtesy and recognition that adolescents do have power, power that can be influenced to serve decent and constructive ends" (220).

Sizer's was perhaps the best critical response to the kind of industrial model of schooling that made educational headlines in the 1970s. If Sizer is to be believed, the model is sufficiently institutionalized to constitute a serious obstacle to reform and humanistic education.[6] Above all, Sizer was concerned about a pyramidal system of governance from the top down that tends toward greater standardization and emphasizes those aspects of schooling that lend themselves to efficient control and measurement. Among the consequences of such a structure are a large scale of operations, orderly predictability, high degrees of specificity, quantitative reporting and evaluation, resistance to significant change, and the suppression of local initiatives. The system, moreover, generally rewards those in the top positions of an interlocking complex of school administrators and the institutions that prepare and certify them. The fact of the matter is, says Sizer, that the system is getting in the way of genuine teaching and learning, the schools' fundamental enterprise. There is no question that career incentives are greater at the upper administration levels of the educational system than they are in teaching and that administrators prefer to keep matters that way. This is why teachers often have to leave the classroom to improve their economic condition. Surely something is seriously defective in an educational organization that undervalues what is most central to it, teaching.

Sizer's findings about the structure, substance, and ambience of high schools were similar to Goodlad's and Boyer's, but his remedy had a different emphasis. Influenced by his own background and interests—which include history, the deanship of the Harvard graduate college of education, and the principalship of Phillips Academy, a prestigious private school—Sizer was reluctant to limit the freedom of parents and students to choose the kind of school and educational program they prefer. Society, he thinks, can justifiably demand the mastery of only a minimum number of basic skills in the three R's and civics. He even went so far as to say that if mastery of such basic skills and ideas can be demonstrated before high school, students need not attend it; but he didn't follow up that recommendation.

Assuming that basic skills and ideas have been mastered and that students have exercised their option to continue attending high school, what should they study? First of all, schools are to be given greater latitude in determining and designing their programs than would be permitted by the recommendations of the other studies under discussion. But the guiding

motto should be "less is more." In order to stop the proliferation of subjects and reduce the frenetic quality of the school day, Sizer would limit the curriculum to four basic areas of study, each of which would be assigned a significant block of time and would allow some choice in the methods for moving students through it. In many instances, this would mean abandoning the conventional fifty-minute period in favor of longer periods of instruction and learning. The four basic areas of study, which could be located in large departments, are inquiry and expression, mathematics and science, literature and the arts, and philosophy and history.

Sizer expands "expression" beyond written communication, which is basic, to include visual communication through gesture, physical nuance, and tone. Expression also encompasses literature and the arts, which are sufficiently different to form a discrete area of study. Unlike other writers, Sizer thinks it is wasteful to teach literature and the other arts separately inasmuch as "aesthetic expression and learning from others' attempts to find meaning are of a piece" (133). Except, however, for brief references to classes in Shakespeare's *Romeo and Juliet* and Graham Green's short story "The Destructors," Sizer does not offer descriptions of arts teaching in the schools he observed.

Sizer anticipated questions by saying that tracking will not be a problem because individual interests and differential rates of learning can be accommodated in the areas and blocks of time allotted. Significant physical and career education, though not of the conventional sort, could also be provided in such blocks. And, in contrast to the Paideia Program, Sizer thinks it is more important to overcome ethnocentrism than to learn a foreign language for which one has no use. Standards would be maintained through a combination of demonstrated performance in each of the four basic areas of study and through external testing.

One final observation. Sizer's volume belongs to a small genre of educational writing devoted to what is sometimes called humanistic or qualitative evaluation as distinct from quantitative assessment. The genre is rapidly becoming professionalized and thus is in danger of overextending itself. Ideally, humanistic evaluation requires considerable finesse and consists of an artful blending of first-hand observation, empirical data, and mature judgment. Sizer's book shows that humanistic evaluation is not for novices. Referring to his effort as a word portrait somewhere between journalism and nonfiction that attempts to convey to readers the "feel" of a school, he acknowledges that writing of this type does reveal a point of view

and cannot avoid some distortion. He is correct, of course; but as a sample of the genre in question Sizer's work seems to have struck a good balance between description, interpretation, and evaluation.

The character and components of an excellence curriculum for arts education should not, of course, be tailored solely to the needs of college-bound youth. Only if recommendations for college preparation are consistent with an excellence curriculum for all students do they warrant attention. In this connection, the College Board's publication *Academic Preparation in the Arts* was relevant to thinking about an excellence curriculum in art education, at least at the secondary level.

Academic Preparation in the Arts went farther than its predecessor *Academic Preparation for College* in describing the goals, scope, and sequence of secondary arts education. Its central assumption is that art is a basic subject that has distinct goals and outcomes the attainment of which concomitantly contributes to the development of general academic competencies (such as speaking and listening, reading, studying, reasoning, and observing). While I think the report is unnecessarily hesitant in stating its case—characteristic deference is made to alternative ways of achieving objectives—the principal writers, Dennis Wolf and Thomas Wolf, were persuaded that the teaching of art as a distinct subject should impart three kinds of knowledge (understood as abilities)—knowledge not only of how to produce or perform works of art but also of how to analyze, interpret, evaluate, and understand them culturally and historically.

Although lacking a discussion of a comprehensive plan for a curriculum, *Academic Preparation in the Arts* is a pamphlet filled with common sense and comments on a number of issues that have exercised critics of art education policy over the past two decades. The authors understand the value of intensive, carefully designed instruction in the arts, realizing that much more than mere exposure is needed to secure lasting understanding and enjoyment of the arts. They further acknowledge that the study of the arts helps people to transcend their immediate culture and overcome the blindness inherent in ethnocentrism. Common sense is also evident in the realization that the use of the arts to promote the objectives of history or social studies is no substitute for the deliberate cultivation of aesthetic skills. Moreover, the authors are aware of the insignificance of the contribution that artist residencies are able to make to the long-range objectives of aesthetic learning. The model excellence curriculum I discuss in chapter 9 assumes the importance of the abilities described by the College

Board report but advances beyond that document in detailing the scope and sequence of a curriculum designed to attain them.

One cavils only at the report's lack of critical decisiveness, by which I mean its reluctance to state that doing things in a certain way is more likely to prove more effective than another way. The excellence curriculum argued for in chapter 9 is not presented as merely one possibility among many; it is meant to be a model. Moreover, debate and dicussion about arts education cannot rely solely on statements of general aims and skills. E. D. Hirsch Jr., has pointed out the limitations of this kind of educational thinking. One has to get specific. *Academic Preparation in the Arts* nonetheless deserved mention for its potential usefulness in designing an excellence curriculum. Before continuing, it is perhaps worth noting that educators of a predominantly Left political persuasion tend to see the excellence reports of the 1980s simply as an effort on the part of educational reformers to reproduce through the schools the values of the dominant groups in society. This interpretation may be true of some of the more technical reports I didn't discuss, but it is difficult to square the charge with the writings of Adler, Boyer, Goodlad, and Sizer, as well with the work of the following writers who, because they were not sponsored by prestigious organizations, received less publicity than they deserved.[7]

Certainly the charge of cultural reproduction cannot be leveled at Harry S. Broudy's *Truth and Credibility: The Citizen's Dilemma,* a volume that contains a persuasive argument for the arts and humanities as part of a program of general education. Broudy's case for a liberal, general education is grounded in a cogent social analysis, a knowledge of classical and modern philosophy, and a good understanding of the real world of the public schools. Important for my purposes was his reliance on the arts and humanities to help remoralize a society that has been induced by technological and information overload, specialism, and the pitfalls of planning to abandon moral and aesthetic attitudes in favor of economic and technical solutions to problems.

Broudy, one of this country's distinguished philosophers of education, emphasizes the arts and humanities because they are important resources for building in individuals what he calls a sense of warranted commitment. By presenting dramatic value images of life's accomplishments and predicaments, the products of the arts and humanities function as models of human excellence whose persuasiveness is enhanced by their aesthetic appeal.

When he emphasized the educative value of classics and exemplars Broudy assumed the continuing relevance of classical humanism. Yet in making the arts and humanities the central loci of personal and existential truth, he also revealed his long-standing interest in the modern philosophy of existentialism. Nor was he indifferent to practical realities. Indeed, one of the several merits of his work was the attempt to synthesize tenets of classical humanism, existentialism, and pragmatism. Broudy's debts were not just to Aristotle but also to Kierkegaard and Dewey.

Broudy answered affirmatively the question asked by Robert Penn Warren, this country's first Poet Laureate, whether making our world more humanely habitable involves acceptance not only of the knowledge that comes from the sciences but also of the kind that comes from the feelingful acts of the imagination characteristically embedded in the arts and literature. One of the problems with modern society, asserted Broudy, is that the humanists, journalists, and other professionals who have the power significantly to influence thought and action have themselves become part of the problem. It is as if Broudy borrowed his words directly from Saul Bellow's principal character in *The Dean's December* who bitterly complained that journalists in particular "fail to deal with the moral, emotional, imaginative life, in short, the *true* life of human beings, and that their great power prevents people from having access to this true life." Not content to condemn journalists, Bellow's character went on to indict academics, corporate functionaries, lawyers, and many others "incapable of clarifying our principal problems and of depicting democracy to itself in this time of agonized struggle."[8]

Broudy recognized the dilemma of the citizen who has the double burden of trying to decide not only what but also whom to believe. His proposed remedy was the reaffirmation of traditional democratic ideals embodied in the American Creed, the acceptance of the methods of science for producing warranted assertions about matters of fact, and a common, general education that judiciously balances the various realms of intellectual, moral, and aesthetic value. A reintegration of values can avoid the harmful reductionism that occurs when one value realm becomes dominant in a society—for example, when works of art are no longer admired for the meanings and aesthetic pleasure they can afford but are prized only for their economic value. When reductionism makes it impossible for persons to maximize the diverse values of human existence, the good life suffers as a consequence—a central insight also of the Paideia Program.

The path to the remoralization of society is opened not by the rejection of science but by the recognition of what the sciences cannot do and what the arts and humanities can. The task for designers of what may be called a credibility curriculum is to effect an equilibrium among the different realms of value, a task that today implies reinvigorating the arts and humanities to offset the emphasis on scientific and technological subjects. Such a curriculum would consist of genuinely liberal studies that would serve the end of self-cultivation rather than the amelioration of social problems and the objectives of special-interest groups. Intellectually, a credibility curriculum is charged with building the interpretive frameworks for understanding what citizens will need to know in order to live well and to act rationally in behalf of the common good. Morally, it is justified by its commitment to democratic values and the criteria of a just society. Aesthetically, such a curriculum avails itself of the products of the arts and humanities for the satisfaction they provide and their existential truths.

More specifically, Broudy's curriculum of general studies is grounded in a conception of four uses of knowledge: replicative, associative, interpretive, and applicative. The interpretive and associative uses are especially pertinent to building a sense of warranted commitment. Extrapolating from the work of Michael Polanyi, Broudy hypothesized that materials learned explicitly during the school years function tacitly later in life when individuals encounter a broad range of situations, including those that involve the understanding and appreciation of works of art.

> The disciplines studied explicitly in school become resources used tacitly in life; their details are forgotten, leaving frames or lenses or stencils of interpretation, both of fact and value. Perspective and context are the functional residues of general education. We understand with them, even though we are not attending to them. I believe that a convincing case can be made for the functionality of formal course work in the associative and interpretive uses of knowledge, even though the content of the formal courses cannot be recalled on cue (137).

Although all experience contributes to building up an individual's store of images and concepts through which experience is felt, understood, and evaluated, for Broudy the arts are preeminently suited to develop the associative and interpretive uses of learning.

Broudy assigned aesthetic education the task of teaching students how to use the resources of the arts. Such education has a twofold function:

it teaches students how to experience the arts aesthetically for their inherent values and delight, and it contributes to their general imagic-conceptual store, or apperceptive mass, that functions tacitly in interpreting a broad spectrum of situations. For all the reasons just given, Broudy's credibility curriculum is a far more cogent and substantive analysis of excellence and equity than anything found in the excellence-in-education literature. His writing also reflects optimism about individuals' ability to remoralize themselves and society. Given sufficient investments of energy and a wholehearted commitment, he believes that a credibility curriculum can go a long way toward creating a society that provides maximum opportunities for the realization of value in all the important domains of human life, greater social justice, and more compassion—his three criteria for the good society.

Another indication that the climate of opinion in the 1980s was favorable to the development of an excellence curriculum for art education was Maxine Greene's chapter "Aesthetic Literacy in General Education" in a 1981 National Society for the Study of Education yearbook titled *Philosophy and Education*. Greene, a distinguished philosopher of art with special interests in literature and the arts, cited a number of paradoxes and anomalies in the relations of art, society, and schooling today. Among them are the contrast between the virtual explosion of interest in the arts, including high art, in the culture and their relative neglect in the schools, and the disparity between the intensity of people's expressed interest in art and the unenlightened character of their response to it. The countermeasure Greene suggests is a logical one; it is to help persons to become aesthetically literate.

Greene understands "aesthetic literacy" as the possession of interpretive skills that enable persons to engage works of art in their full complexity. Central to the development of such literacy is training each person's capacity to have aesthetic experiences of practically anything, but mainly of outstanding works of art. Her recommendations are hence compatible with the theme of *Excellence II*. Greene writes that whether we understand works of art as symbol systems, provinces of meaning, or privileged objects capable of inducing a certain kind of response, we do well to appreciate the fact that it takes interpretive skills to render works of art intelligible. She laments that far too little is done "to empower students to perceive aesthetically, to become discriminating in their encounters with the arts, to develop vocabularies for articulating what such encounters permit them to see or to hear or to feel" (118). These remarks can perhaps be interpreted as aimed at correcting the lopsided emphasis on playing and performing observed by Goodlad in his study of schooling.

24

To overcome aesthetic illiteracy, Greene recommended a substantial grounding in aesthetics (the philosophy of art) as part of an art teacher's training. This would enable teachers to handle questions that emerge in attempts to engage and understand works of art, questions concerning the definition of art, the nature of aesthetic concepts, troublesome and misleading dichotomies, and so forth. Seldom has the case for the relevance of aesthetics, aesthetic terminology, and aesthetic education been made so emphatically. Indeed, Greene's argument lays to rest any lingering doubts about the importance of aesthetic theory for art education. The idea of aesthetic education in Greene's sense has proven its value not only in her work at the Lincoln Center for the Performing Arts in New York City but also in Broudy's comparable involvement with the Los Angeles Music Center as well as in the use of the Southwestern Regional Laboratory's (SWRL) aesthetic education materials in the efforts of the Getty Center for Education in the Arts.

Despite improving recognition in the literature of art education of the usefulness of aesthetics, aesthetic considerations, and aesthetic terminology, it is likely that that their full relevance will take still more time to be widely appreciated. Aesthetics has become institutionalized in departments of philosophy only during the past forty years or so, while recommendations to employ aesthetics in art-educational thinking date mainly from the last two decades. The point here, however, is Greene's readiness to entertain the importance of the philosophy of art as part of the art teacher's preparation. Such readiness accords well with an excellence curriculum, for aesthetics, as I will show in a later discussion, helps students to understand a number of issues about the status, meaning, and value of art.

I have indicated that we are going through a period when greater attention is being centered on the more global aspects of schools, on what is increasingly called "schooling." The concentration on schooling instead of discrete characteristics of schools emerged mainly in response to impatience with varieties of reductionism in studies of education. Impatience has been expressed not only with the mechanistic views of learning manifested in behavioral theory but also with assessments of schooling's effectiveness along only one rather than several of its dimensions. Dissatisfaction with the shortcomings of behaviorism has generated a strong interest in cognitive learning theory, which emphasizes developing mental skills and promoting substantive learning.

A publication of the American Educational Studies Association from the 1980s titled *Pride and Promise: Schools of Excellence for All*

People is noteworthy for its greater emphasis on substance. It not only pointed out the multiple functions of schools and the limitations of reductionist thinking, but also stressed the development of intellectual power as the primary purpose of schooling. We read:

> Both individual interests and the nation's most fundamental commitments recommend that the school's primary purpose be the development of intellectual power. This transcending goal must infuse the culture of the school. It must be translated into curricula which acknowledge that student performance below certain levels of literacy means lifelong disadvantage, that skill acquisition below certain levels means limited opportunities and mortgaged futures. It must be reflected in the way schools are organized and the way in which all people therein are treated. It must also suffuse the content and the activities through which schools seek to carry out several quite different functions parents want them to fulfill: [e.g., academic, social/civic, personal, and vocational] (13).

If some find the idea that art education too should stress intellectual power incongruous, it is because the field has harbored serious misconceptions about the essence of art and learning. A proper view of the nature of human understanding, however, dispels fears that intellectual rigor and aesthetic considerations are incompatible. Once again, the authors of *Pride and Promise:* "There are different kinds of knowledge and there are different objects of knowledge. We want youngsters to become acquainted with the array. Thus it makes sense to require that each become familiar with particular forms of literature; the sciences; mathematics; the social sciences or social studies; the fine and performing arts. It seems reasonable to ask that each youngster's high school career include extensive attention to these five areas. Such a requirement, however, need not specify either an organization for the content or a particular method of instruction" (22-23). By this last caveat the authors mean that curriculum designers should state requirements only in terms of basic concepts and skills. Depending on the character of a particular school—its teaching staff, resources, and student population—it should be possible, without sacrifice of intellectual rigor, to organize content in different ways and to have the curriculum take account of student needs, interests, and maturity.

However, as I've already mentioned, in the case of an excellence curriculum for art education it will not always be feasible to separate the teaching of basic concepts and skills from well-defined content or to be

indifferent to the method of teaching, for to a large extent an excellence curriculum implies a specific organization of knowledge and particular teaching methods. Certainly it is not enough to say students should become acquainted with forms of literature and the fine and performing arts, for that only begs the questions of what "acquaintance" and "forms" mean and what kinds of literature and fine art should be studied. In the context of an excellence curriculum these matters cannot be left to arbitrary decisions.

Another development suggesting that art education in the 1980s was poised to embark on a quest for excellence was the reconceptualization of the field that had occurred over the previous two decades. Although practitioners of art education espouse every imaginable viewpoint on their area (each wave of reform seems to leave some residue) and although earlier views still carry influence, the theoretical literature has been moving away from a conception of art education as a general developmental activity. The emphasis on psychological and social growth is losing ground to one on the mastery of the basic concepts and skills of art.

The late 1950s and early 1960s marked a time when art education began to think of itself as an organized field of knowledge and when its image began to change. Whereas previously the emphasis had been almost exclusively on the child as artist, a more balanced view emerged in which, though creative activities were not necessarily ruled out, they were supplemented in important ways with the development of perceptual skills, historical understanding, and aesthetic judgment. The new conception of art education conveyed the message that significant educational value can be realized in perceiving as well as in creating art; or, according to one prominent strand of thought during the period, in aesthetically experiencing works of art as well as in making them.

In the course of reconceptualizing the field, some art educators found occasion to level criticism at certain groups and organizations—mainly governmental and philanthropic—that were attempting to champion the arts as catalysts for general educational reform. While representatives of these groups believed the arts could perform their catalytic function best by becoming incorporated into all school subjects, critics among art educators insisted that such an educational use of the arts should be no substitute for formal art instruction as part of a common, general education. These critics took their stand on a view of art education as a discrete instructional area in which subject-matter specialists teach an understanding and appre-

ciation of art in ways that will enable students upon leaving school to engage works of art intelligently. What emerged, then, was the image of the student as enlightened percipient, where "enlightened" suggests a rigorous notion of appreciation.

I found it convenient to discuss the new theoretical developments in the literature of art education under the rubrics knowledge and value.[9] The first rubric, knowledge, reflects the importance theorists now attach to content or subject matter in the teaching of art. This emphasis, deriving from the conviction that characteristic ideas, concepts, and principles are involved in developing an educated understanding and appreciation of art, argues for a separate area of instruction in the curriculum. Knowledge and subject matter, moreover, serve to secure end states variously called qualitative intelligence, enlightened cherishing, aesthetic literacy, and reflective percipience—the latter term being one I favor. All refer to a set of special competencies, skills, or dispositions involved in educated commerce with art.

That leaves the rubric of value. For it is one thing to say that art education serves the purpose of developing qualities of mind designated as enlightened cherishing, qualitative thinking, aesthetic literacy, or reflective percipience but quite another to describe the benefits to the individual and society conferred by percipience in matters of art In the estimation of numerous writers, the value of art resides in its capacity to energize perception and expand the scope of awareness. The term "aesthetic experience" is often used to refer to the sort of experience typically afforded by art. But terminology is less important than the recognition of a difference between having knowledge *about* art and personally *experiencing* its presence and power. No one has marked this distinction better than Frank Sibley. It does no good, he said, simply to be told that a work of art has a certain character or meaning; one has to see and feel its qualities and import for oneself. Appreciation is possible in no other way.[10]

A number of writers contributed to the reconceptualization of the field of art education. In *Excellence in Art Education* I assumed that they did not necessarily endorse that book's premises, general themes, or terminology but that, collectively, they helped to establish a theoretical position for pursuing excellence in art education. Philosophers of art such as Thomas Munro, L. A. Reid, Iredell Jenkins, D. W. Gotshalk, Virgil C. Aldrich, Donald Crawford, Monroe C. Beardsley, Morris Weitz, Eugene F. Kaelin, Francis Sparshott, Harold Osborne, and Nelson Goodman had written on the relevance of philosophy of art to the problem areas of art education, often

in cooperation with or at the invitation of those in the field of art education.[11] Philosophers of education such as Nathaniel Champlin, Francis Villemain, Harry S. Broudy, Philip H. Phenix, and Maxine Greene had emphasized the importance of qualitative thinking, enlightened cherishing, aesthetic meaning, or aesthetic literacy, respectively. Theorists of art education such as Manuel Barkan, Vincent Lanier, Elliot W. Eisner, David W. Ecker, Edmund B. Feldman, Laura Chapman, Stanley S. Madeja, Gilbert Clark, Michael Day, and W. Dwaine Greer had articulated one or more of the following themes: the teaching of art as a subject important in its own right; the structure of knowledge in art education; art education as a discipline; the cognitive character of artistic creation and appreciation; and the value to art education of the disciplines of artistic creation, aesthetics, art history, and art criticism.

A number of other art educators—for example, Edmund B. Feldman, Gene A. Mittler, Nancy MacGregor, Robert Clements, and George Geahigan—had contributed to an understanding of the nature of art criticism and the teaching of critical skills. Curriculum specialists such as Eisner, Chapman, Ronald Silverman, and Arthur Efland had written systematically about curriculum design and implementation and showed how curriculum design in art education could proceed. Research scholars such as Howard Gardner and David Perkins, along with Michael J. Parsons, had provided insights into the nature of aesthetic development and a number of other skills involved in our experience of art. Although less had been done to indicate the relevance of art history to art education, the writings of Mary Erickson, Michael McCarthy, Marcia Pointon, and Paul Brazier were mentioned. Some writers' interests were catholic and overlapped several domains of art education. Finally, the major textbooks that appeared during the period in question—for example, those by Feldman, Eisner, and Chapman—all acknowledged the importance not only of the creative aspect of art education but also its philosophical, historical, and critical dimensions.[12]

A significant amount of theorizing in the field of art education was thus moving away from a conception of art education that was not insistent on the study of art as a subject and toward one that, for the most part, was. This trend was discernible not only in the standard textbook and journal literature but, perhaps even more significantly, in the commission reports, publications, and policy statements of the National Art Education Association, for example, *Quality Art Education: An Interpretation* (1986).

The literature just mentioned is impressive for its intellectual content, commitment to the value of art, and recognition of art's role in human existence. Those who think educators are incapable of addressing

the problems of art education seriously would be well-advised to sample what the field's leading theorists have had to say on the topic. These writers view art not as a form of vapid self-expression and mindless play, nor do they see art education classes as places from which thinking absents itself. Rather, they construe art as a demanding subject in which understanding and enjoyment derive from the disciplined mastery of the ideas and skills involved in making and appreciating works of art. This literature also contains a wealth of suggestion for designing, implementing, and evaluating curricula. When the call for excellence came in the 1980s, the field of art education was prepared to respond; or, better, the field had for some time been asserting leadership in trying to achieve greater substance and higher quality in the teaching of art in the schools. But since few outside the area of art education read its literature, stereotypes about educators continue to abound.

What emerges from the literature in question is the acceptance of aesthetic knowing, or some comparable notion, as the goal of art education, where such knowing refers to percipience in matters of art and culture. But before aesthetic knowing could become a goal of art education—before, that is, art education could take seriously not only the creation of artworks but also the perception, interpretation, and judgment of them—art itself had to be appreciated for its own values; it had to be valued for those aspects that are most characteristically admired in works of art.

Initiatives to improve the quality of art education during the period under discussion came not only from the profession of art education but also from the public and private sectors. I said in the original version that some caution was in order in taking leads from these sectors. The cultural and educational officials of public and private organizations, not to say the organizations themselves, often turn out to be here today and gone tomorrow. And program officials have their own career goals to worry about. We have seen the emergence and demise of the JDR 3rd Fund and its educational activities in the arts, the arts and humanities branch of the (now) Department of Education, the CEMREL and SWRL aesthetic education programs, the position of arts and humanities adviser in the National Institute of Education, and many of the ventures associated with these programs and officials. Only the profession of art education itself has a persistent, long-term commitment to maintaining and improving the quality of art instruction in the schools. And it is a good question whether external agencies sometimes do more

harm than good in the field of art education, not only because of the nature of some of the ideas they have promoted (several of which have definitely been inimical to the best interests of art and art education), but also because dissension results in the field when individuals and departments vie for approving nods from funding agencies. With such reservations duly noted, I said in *Excellence in Art Education* that a number of the initiatives made by public and private agencies were consistent with the spirit and theme of excellence.

One external agency that deserved prominent mention in 1986 was the program of the Getty Center for Education in the Arts, an operating entity of the J. Paul Getty Trust. Although the Center's major concern at the time was the improvement of elementary art education, the Center's outlook seemed quite consistent with ideas that could also be implemented in a K-12 curriculum. Given the Trust's significant investment in humanistic and art-historical studies, it seemed reasonable to assume that the Center would eventually address the problems of secondary art education. I bypassed the Center's interests in case studies of schools and museum education and concentrated on its general approach and ideas about implementation.

I believed the Getty Center's programs held promise for improving the substance of art education because it treated the study of the visual art as "discipline-based," that is, as being grounded in several disciplines—for example, art history, aesthetics, art criticism, and artistic creation—that are relevant to understanding and appreciating art. In contrast to some previous ventures on the part of private or external organizations, the Center wisely abstained from the evangelical rhetoric of innovation. And instead of ignoring the educational profession, it prudently took its cues from the field and involved a significant number of its members as consultants and participants in its various activities. Most importantly, it was serious about art and art education. A sense of the Center's general attitude and of its link to the excellence-in-education movement can be gained from Leilani Lattin Duke's remarks in "Striving for Excellence in Art Education." Duke, the director of the Center since its inception, wrote that "the goal of education in the arts should be to foster the learning of the higher order intellectual skills through presenting arts instruction as a compound discipline. Such an integrated approach includes (a) aesthetic perception, (b) productive or performing skills, (c) art criticism, and (d) art history."[13] To be sure, it was not clear at the time how curriculum designers should integrate the various components of the compound discipline or decide their relative proportions.

What was important was that the Center was encouraging discussions of these questions.

The educational policy of the National Endowment for the Arts also warranted attention for its increased emphasis on the historical, philosophical, and critical studies of the arts that quite clearly reflected some of the ideas contained in the literature I have just mentioned. When it supplemented its artists-in-residency programs with provisions for conventional curriculum planning and assessment, the Endowment in effect admitted that pedagogical value resides not only in creative and performing activities but also in the critical understanding and appreciation of works of art.[14] The new policy thus had potential for contributing to an excellence curriculum. I said that the test of the policy would be the extent to which the agency's budget reflected a serious commitment to curriculum planning and evaluation. I further speculated that in supporting historical and critical studies, the Endowment might create an identity problem for itself; for the more it talked about aesthetics, art history, and art criticism in addition to artistic creation, the more it would sound like the Humanities Endowment.

Yet another educational venture that deserved a mention was the five-year program of the Rockefeller Brothers Fund that awarded gifts of $10,000 to ten outstanding school art programs during each year of the program.[15] The Fund acted on the belief that excellence should be identified and rewarded. But an examination of the criteria schools were instructed to use in applying for the awards revealed that the Fund's program reinforced the emphasis on productive and performing activities in art instruction and was apparently not concerned to rectify the deplorable condition of arts instruction to which Goodlad had drawn attention. I did not want to be unduly skeptical about an undertaking whose stated aim was to reward excellence, and so I said that until an objective evaluation of award recipients proves otherwise, one could assume that what quality there is in arts education in the schools had been identified. I went on to remark, however, that this was not the way the Getty Center operated. The Center started with a definite conception of an exemplary art education program and, with the assistance of the Rand Corporation and a team of observers, searched for instances of it—but was hard put to locate a baker's dozen.[16]

Doubtless there were other public and private agencies whose efforts were compatible with the goals of an excellence curriculum, but the Getty Center and the National Endowment for the Arts seemed to constitute

the major initiatives at the time. The lobbying efforts of the Alliance for Arts in Education, for example, were performing an important function, but advocacy campaigns fell outside the major concerns of my discussion.

In a section devoted to future needs and developments, I said in *Excellence in Art Education* that it was crucial that the arts education organizations participate in the national debate on education. This would mean addressing difficult questions and facing up to certain realities, a prospect that many of those comfortably placed in the arts education establishment might not relish. I particularly emphasized that if the field of arts education did not reform itself, the teaching of the arts in the schools would face an uncertain future and fail to become a basic subject of general education. The vigorous efforts expended by various groups and the professional art education associations, including the leadership of the NAEA, in pressuring the government to include the arts in their "Education 2000" program, and the subsequent formulation of national standards for teaching and learning, indicate that not only is talk of reform in the air but tangible progress is being made.[17] I also pointed out that one of the problems of art education is the low esteem suffered by colleges of education and departments of art education and those who staff them, a situation that seemed to be worsening. One result was that students who might have chosen art teaching as a career were beginning to seek careers in other fields, and another was that the budgets and services of art education departments were being severely reduced or eliminated. To compensate, and to respond to social pressures, many departments of art education began mounting ambitious recruiting programs to attract minority and foreign students. Another response was the tendency of members of art education faculties to seek security in administrative positions, to take a second job, or to cultivate their private gardens as best they could. Some were simply awaiting retirement or taking early retirement.

The problems of arts education were exacerbated by the proclivity of educational associations in art, music, literature, theater, dance, and film to go their separate ways. Just at the time when studies of schooling had concluded that the very structure of the educational system had become an impediment to learning, it also became evident that the splintering of arts education into separate specialties inhibited the development of a significant arts requirement for the schools. I said that arts education had to undergo

change if visual art was to have any chance of becoming a new basic subject. Perhaps the current "standards" phase of the reform movement will have some effect.

One of my suggestions was that the field of arts education first of all define its mission from the perspective of a general, humanistic education that emphasizes the theme of excellence and access to excellence for all, in short, excellence and equity. The basic right of all students is a right to the best, nothing less. Rather than following the fashions of the day, the field of arts education should take its cues from the demands of its subject and the nature of aesthetic learning. A corollary was that teacher preparation programs should stress significant work in the history and theory of the arts, or the humanities generally, as well as in educational theory. What future teachers would need is a combination of subject-matter mastery and pedagogical competence. Such was my view of matters in the mid 1980s.

3

Recent Developments: 1986-1994

A major shift in the perceived goals for teaching the visual arts in school has occurred since the 1950s and 1960s when it was thought that visual arts teaching should aim primarily at stimulating personal expression and creativity. The 1980s perception is that visual arts teaching should not only instruct students in studio methods but also provide a sense of civilization through the study of art history, criticism, and aesthetics.

> *Toward Civilization: A Report on Arts Education*
> National Endowment for the Arts

Since the publication of *Excellence in Art Education* a number of major publications have appeared that exemplify the continuing growth of scholarship in the field of art education. Noteworthy historical studies are Arthur Efland's *History of Art Education* (1990) and Foster Wygant's *School Art in American Culture: 1820-1970* (1993).[1] For the first time Efland's book provides the field with a sense of its history from antiquity to the present, while Wygant's volume presents a finely textured study of its modern period. These works and others are forging a historical memory that is vital to the maturing of any field.

The area of cognitive studies is reflected in the field of art education through the influence of new works investigating the mind and its powers. A landmark volume is Michael J. Parsons' *How We Understand Art: A*

Cognitive Developmental Account of Aesthetic Experience (1987).[2] Based
on ten years of research of responses made to works of art, Parsons describes
five stages of aesthetic growth from the early years through adulthood,
thereby contributing to the growing literature that takes an interest in art
from the beholder's point of view. Two aspects of the significance of
cognitive studies for arts education are instructively canvassed in a National
Society for the Study of Education Yearbook *The Arts, Education, and
Aesthetic Knowing* (1992). One aspect is psychological and consists of
inquiry into the nature of cognitive powers (memory, perception, imagina-
tion, etc.); the other is an emphasis on substantive content and subject
matter.[3] *Art, Mind, and Education* (1989), edited by Howard Gardner and
D. N. Perkins, conveys a good sense of the former, as does Gardner's
monograph *Art Education and Human Development* (1990),[4] while the
volumes in the series "Disciplines in Art Education: Contexts of Under-
standing (1991- 95)," a cooperative venture of the Getty Center for Educa-
tion in the Arts and the University of Illinois Press, convey a sense of the
latter.[5]

By far the greatest investment in the reform of art education in
recent years has been made by the Getty Center for Education in the Arts
whose activities were just getting under way when *Excellence in Art
Education* was being written. In both its publication program and curricu-
lum implementation centers the Center has continued to advance its ap-
proach to the teaching of art known as discipline-based art education. The
basic assumption of this approach continues to be that art education should
consist not only of creative activities but also of historical and critical
studies, which is to say that the teaching of art should draw on the ideas and
methods of the disciplines of artistic creation, the history of art, art criticism,
and aesthetics. A basic document of the Getty's approach is *Discipline-
Based Art Education: Origins, Meaning, and Development* (1989), cur-
rently in its second printing. In addition to essays on the antecedents of
DBAE, it contains a major statement on the nature of DBAE and brief essays
on the disciplines of artistic creation, art history, art criticism, and aesthetics,
plus one on cognitive development.[6] A handbook on DBAE by Stephen M.
Dobbs (1992) and a curriculum sampler edited by Kay Alexander and
Michael Day (1991) offer further perspective on the meaning of DBAE and
practical applications of it.[7]

Before discussing in greater detail developments that have a bearing on the
theme of *Excellence II,* it will be helpful to provide a broad picture of the

excellence-in-education reform movement since its inception in the early 1980s. For this purpose I turn to two studies, one that concisely summarizes a number of other studies and documents what it takes to be the successes of the movement, and another that, while acknowledging some impressive gains, concludes that the reform movement of the 1980s is failing.

In *Network News and Views,* a publication of the Educational Excellence Network, Michael Kirst and Carolyn Kelley report what they regard as the positive results of the reform efforts of the 1980s and early 1990s.[8] The authors disclaim interest in tracing the history of the movement, although they think that some of the reforms enacted were part of a larger reform initiative that had been underway since the 1970s. Nor were they interested in providing an overall assessment of the movement.

What the authors looked for was evidence that *A Nation at Risk* (NAR) recommendations were taken seriously—recommendations that young people not only spend more time in school but also devote more time to new demanding courses. Accordingly, in summarizing a number of studies the authors report changes in course-taking patterns, classroom instruction, dropout rates, test scores, eligibility for admission to higher education, supply and quality of teachers, and equity among the races. These changes, they say, have resulted in the strengthening of the teaching profession, higher teacher salaries, new career and professional development patterns, more accountability in terms of mandatory testing of teachers and students and school comparisons, modification of teacher preparation, increased course-taking requirements (especially in academic subjects such as science, mathematics, and biology), greater appreciation of higher-order thinking skills, declining dropout rates, more homework, increased recruitment of teachers, and overall improvement in the quality and content of instruction.

Regarding course-taking patterns, the trend has been toward an increase in academic courses for all students, with college-bound students taking more rigorous advance placement courses. The average number of credits per student has also increased, as has the level of the difficulty of courses. By academic courses Kirst and Kelley mean mainly science, in which the largest gains were made, and math and English. There was a notable increase in gateway courses that are prerequisites for enrolling in more advanced courses. The courses mentioned most often are algebra, biology, chemistry, physics, and, less often, calculus. The authors state that newly required courses were not merely watered-down versions of courses

traditionally required, but were truly rigorous. As for NAR-recommended courses, there was an increase of 27 percent from 13 percent in 1983 to 40 percent in 1993. And from 1981 to 1991 there was an increase of 235,000 students taking advance placement courses, for which some college credit was often given. What is more, and significant in view of NAR recommendations and goals, the number of minority students taking such courses doubled from 1981 to 1991.

The decline in dropout rates is another sign of the movement's success, a full 2 percent from 1973 to 1990. Noteworthy is that in 1990, 78 percent of black 19- and 20-year-olds had completed high school, or earned a GED equivalent, compared to 83 percent of whites, which means that greater equity among the races was being achieved. The rate for Hispanics was 60 percent. In 1990, the dropout rate declined from 6.2 percent to 4.1 percent. The authors conclude that an increase in academic course requirements, as was anticipated, has not lead to increased dropout rates.

Test scores were another concern of the reformers. After a long period of steady decline they began to rise during the late 1970s and 1980s. Such gains are shown by national data, independent studies of selected states, National Assessment of Educational Progress data, Standard Assessment Tests, and the California Assessment Test. Improvement in test scores, especially in reading and writing, is once again being reported, with the gains made by some groups, particularly blacks, outpacing those made by whites. In short, the authors question the precipitous decline in test scores often reported in the media; they assert that it is simply not occurring.

Other signs of the success of the reform movement are better career opportunities and higher salary schedules for teachers, which suggests a public willing to take education more seriously, and a decline of 8 percent over a six-year period (from 1983-84 to 1989-90) in remedial reading courses offered by colleges for entering freshmen. Further evidence for the already mentioned attainment of equity has been a greater decline in dropout rates for minorities than for other students, which suggests improvement in the acquisition of basic skills and achievement on Standard Achievement Tests. Enrollment by minority students in academic courses, including advance placement courses, has also been notable. Females were outpacing males in enrollment in math and science.

Information about changes in classroom instruction was not reported as fully as other goals due in part to difficulty in obtaining it, but on the basis of what the authors found they infer that more homework was being

assigned and pedagogy was undergoing change. They cite as examples the assignment of more manipulative activities and less reliance on lectures.

Kirst and Kelley conclude that federal, state, and local policies have probably played a causative role in bringing about changes, but they acknowledge that additional research is required for a more balanced picture of the 1980s reform movement. And they ask a central question: Has the 30 percent increase in spending (after inflation) on public education in 1990 over spending in 1980 yielded proportionate dividends?

In contrast to Kirst and Kelley's summary of the successes of the reform movement, Thomas Toch's *In the Name of Excellence* attempts to provide a broad perspective and overall assessment of reform efforts, from 1983 to the early 1990s.[9] Toch began to follow the excellence-in-education movement while a staff writer for *Education Week,* and at the time of the publication of his study he was the education correspondent for *U.S. News and World Report.* His account of the reform movement is highly detailed and well documented, and his observations and judgments have received endorsements from many of the 1980s' reformers. Anyone wanting to know what has occurred in the reform movement of the last decade can learn much from his account. Toch's discussion divides into three parts: the evolution of the reform movement; the reasons that the movement, despite some gains, was relatively ineffective; and the consequences of that ineffectiveness for an educational system more and more characterized by apathy and alienation, especially in its secondary schools. His conclusions are drawn from observations made over a two-year period in sixty schools in various parts of the country, the reading of major reports and studies, and the actions of teachers unions and state legislatures. His chronicle is a perceptive account of how educational ideas are conceived, circulated, and received in a democratic society in which public schools are controlled by state and local authorities and are subject to external pressures from the federal government and other agencies.

In Toch's understanding, the central aims of the excellence movement were quite simple: in order to come to grips with a post-industrial information age and meet the challenges it poses to economic and social well-being, standards of learning must be raised, and access to substantive academic subjects and the higher-level mental skills they engender should be broadened to include all students, not just the academically gifted. To respond to these challenges it will not be enough to reform teacher education; schools must be reorganized, and the assessment of learning must take

diverse forms. As initially conceived, says Toch, the excellence movement intended "to redefine the priorities of the nation's high schools" and "replace a largely utilitarian vision of public education with an academic vision" (4).

Why had such changes become necessary? Toch points to the cultural, political, and economic events of the 1960s and 1970s that literally paralyzed whatever power the schools had to achieve their main mission— the achievement of significant learning. Culturally, the schools suffered the excesses of the neo-progressives of the 1960s who criticized them for being undemocratic, elitist, and unresponsive to student interests. However justified this criticism might have been, it weakened the authority of teachers, de-emphasized the value of academic subjects, and eliminated numerous graduation requirements, all of which helped to create a shopping mall version of the curriculum. (Anyone who was teaching in higher education during the same period will recall similar developments there.) Economically, the recession of the early 1980s prompted property tax revolts that forced the schools to retrench, limit salaries, and discourage better-qualified graduates from entering the teaching profession. Politically, the schools were made into a leading institution for addressing major social problems. Principals increasingly became preoccupied with managing conflict among contending interest groups, each of them exerting pressure on schools to stress its particular set of values, while teachers, in order to avoid lawsuits, became more and more cautious lest they be found in violation of children's rights or accused of racism and sexism. Busing to achieve integration complicated matters, as did the policy of teachers' unions to disregard recommendations for merit pay and career ladders for teachers, or anything that threatened to weaken the principles of collective bargaining and seniority rights. If one adds the shift of policy-making from the local to the state and federal level, which thickened the bureaucratic operation of schools to often absurd degrees, and the steady decline of test scores, not to mention embarrassing comparisons with student achievement in other advanced technological countries, one can form a good sense of why the time seemed right for reform. The cultural, political, and economic mess the schools had skidded into had to be sorted out. Failure to act would condemn the United States to serious competitive disadvantage in a global market and, more importantly, would deprive future generations of young people of opportunities to develop the ideas and skills that are part of a rewarding and meaningful life—what used to be called a good life.

One direct consequence of the legacies of the 1960s and 1970s was the public's loss of confidence in the public schools. Given the failure of the schools to develop even minimal competencies, employers were forced to provide remedial courses for many of the graduates entering the work force; and many parents who could afford to do so sought out private rather than public schools for their children. Even public school teachers were beginning to send their own children to private schools, for both better instruction and greater protection.

Toch contends that the events of the decades immediately preceding the appearance of *A Nation at Risk* (1983) largely explain the extraordinary public response to the reform movement. However, what was accomplished, what failed, and what should be the agenda for continuing change?

First of all, persons who think that national reports and highly publicized studies have little or no impact will be forced to change their minds by Toch's chronicle. Critical descriptions of the conditions of the nation's schools obviously touched a nerve. Politicians, legislators, numerous commissions, funds, testing services, and professional educational organizations were quick to voice responses to problems that Goodlad said had reached "crippling proportions." Several of the more widely discussed among the ensuing reports stressed the need to provide students with more marketable skills, and various corporations began assisting schools in developing capabilities they were looking for in future employees. Sensing that education had become a viable political issue, governors of states soon joined in "the great debate" about education. One sign of the public's interest in the status of learning in the schools was a poll taken in 1983 which reported that in people's estimation the quality of education was second in importance only to the economy. Also surprising was the reaction to two books published almost simultaneously in 1987, Alan Bloom's *The Closing of the American Mind* and E. D. Hirsch, Jr.'s *Cultural Literacy.* The media, realizing that education was a timely topic, gave them far more coverage than it had to the reform efforts of the late 1950s and early 1960s (which, it is recalled, swirled around the propositions in Jerome Bruner's *The Process of Education*). *Education Week,* a newspaper founded in 1981, helped to propel the movement, as did *Network News and Views,* founded in the same year. It was clear, in other words, that the reform movement of the 1980s had become a public and not just a professional concern. Suddenly, the names of Goodlad, Boyer, Adler, Sizer, among others, were heard every-

where, as were these authors themselves who were busy speaking, consulting, giving testimony, and appearing on television.

The reaction of educators and the educational establishment, however, was more mixed and often antithetical. Educators who responded positively to the need for reform were the exception rather than the rule. Indeed, the NAEA's sponsoring of *Excellence in Art Education* was one such exception. The tendency of school administrators, school board members, teachers' unions, and vocational educators was to say that things weren't as bad as the reports claimed and that the schools were in fact making steady progress in improving learning. It was therefore asserted that the reformers' recommendations were ill-conceived and overstated; that many of the schools' problems could be solved simply by spending more money; and that major academic reform and the restructuring of schools were not necessary.

Toch acknowledges that, resistance and indifference notwithstanding, an impressive number of reforms were nonetheless enacted in the 1980s, primarily at the state level—3,000 in all by his count. Most of the reforms were of the sort that could be easily implemented and quantified. They conveyed the message to the public that something was being done, which in turn facilitated the passage of bills that increased the money spent for schools and teachers' salaries. These actions meant that the reform movement was essentially a state-regulated movement. Yet more funding and higher salaries were not the only things that changed; the addition of more academic, graduation, and certification requirements, honors diplomas, loan programs, homework, and tests could also be observed. Career ladders for teachers as well as financial incentive programs were established, class size was reduced, extra-curricular activities were curtailed, and there was more curriculum standardization. Preschool and kindergarten programs also expanded—all, as Toch puts it, "to broaden the academic mission of the public schools, to promote excellence in education" (38).

One notable feature of the excellence movement was that business leaders, in calling on schools to ensure America's economic competitiveness, didn't ask that specific vocational skills be taught; rather, they wanted competence in basic academic skills, critical thinking abilities, and mature judgment. Toch approvingly quoted Theodore Sizer who had written that "the best vocational education is general education that cultivates the use of one's mind." What is more, demographic projections clearly implied that special attention had to be paid to the teaching of disadvantaged minority

students whose environments either inhibited or discouraged the development of academic skills. It was essential that they too try to "make the grade," to trade on the title of one of the excellence reports. For this reason Toch found especially reprehensible those who continued to believe that minority children were either incapable of mastering higher-level skills or uninterested in trying to do so and should therefore be allowed to be visual, physical, and active. Toch underlines the radical nature of the idea that all students, not just the college bound, should have the opportunity to develop academic skills. The vision of academic preparation for all ran counter to the traditions of public schooling and met stiff resistance, especially from vocational educators. Spokespeople for the National Vocational Education Association reacted by denouncing the notion of an aristocracy of subjects and denying that any relationship existed between academic knowledge and effective schooling. Furthermore, by claiming that the socialization of the child and the acquisition of practical skills are more important than the development of mind, they voiced the utilitarian conception of schooling opposed by the excellence movement. Another line of attack on the excellence movement was the contention that an academic vision of learning implied the hegemony of knowledge and reliance on the disciplines when the important thing about schooling should be free and informal education—which had been the message of the neo-progressive critics of the 1960s and 1970s.

It should be remembered that the clarion call of the reformers was excellence *and* equity. Countless talks, conferences, and commissions echoed this dual challenge. The phrase was reiterated time after time not only in this country but also in others that espoused democratic values. Over and over the reformers pressed the point that all students should attain a high level of intellectual accomplishment. Yet in the schools the reformers frequently encountered not the striving for equality and excellence but the rhetoric of equality of results—a stance diametrically opposed to the ideal of excellence and its recognition. In response, reformers and their sympathizers argued that an ill-conceived egalitarianism ultimately fosters mediocrity, and they recalled an older egalitarianism that was consistent with excellence and its recognition. In this context, Toch quotes Christopher Lasch who in 1978 wrote that exempting disadvantaged students from exacting standards was to "condemn the lower class to a second-rate education and thus help to perpetuate the inequalities [social reformers] seek to abolish. In the name of egalitarianism [those who advocate lower

standards for lower-class students] preserve the most insidious form of elitism, which in one guise or another holds the masses incapable of intellectual exertion." Such an attitude, however, "not only guarantees the monopolization of educational advantages by the few; it lowers the quality of elite education itself and threatens to bring about a reign of universal ignorance" (59-60). The nearness of this reign, I might add, is being documented by concerned critics of American education approximately a decade later.

If states took the lead in initiating actual reforms it was not without intense political opposition. Toch's chapter on educational reform in Texas is a tutorial in ways to enlist support for reform. Among other things, Toch discusses the reasons for the failure or short-circuiting of reforms and the effect of uncontrollable events—for example, the collapse of oil prices in 1986—on good intentions.

How, overall, did the reform movement fare? Toch thinks that given a reform agenda emphasizing academic study for the development of mind, a common cultural language, and a core curriculum, the story, despite partial successes, is one of failure. The successes I've mentioned. The failures are legion, and they testify to the resistance of schools to influences from without. Despite the increases in graduation requirements, the formulation of statewide standards, new curriculum and pedagogical ventures, and constraints placed on extracurricular activities, and despite improved class attendance, longer school days, and a surge of enrollment in academic courses, Toch concludes that precious little educational excellence can be found in American public schools.

Why? Toch thinks that the reformers' goal of teaching a rigorous academic curriculum to a wider range of students is being undermined in three ways: by a proliferation of courses that treat academic subject matter with extreme superficiality, by the assignment of large numbers of teachers to academic subjects they are unprepared to teach, and by the failure of educators to explore ways of teaching academic subjects to students who traditionally have not received a serious academic education—students for whom academic subjects frequently do not come easily and for whom traditional teaching methods are often inadequate. In brief, in implementing the curriculum reforms of the 1980s the nation's educators failed to take the steps in the classroom necessary to achieve more than a token compliance with the reforms. They have largely sidestepped the difficult but essential task of supplying qualified teachers and the fresh instructional strategies

needed to reach an expanded range of students with the type of challenging academic course work traditionally reserved for academic and social elites.

Despite the reformers' successful push for new graduation requirements, says Toch, students are receiving an education that is academic in name only. He cites instance after instance of how the reform agenda was compromised. To mention but a few: new required academic courses were quickly watered down and taught by unqualified teachers; not only less able but even capable students have migrated toward elementary versions of academic subjects; numerous honors courses are less than rigorous and can often be taken by practically anyone; legislative mandates that had been politically endorsed by professional groups were later sabotaged, in some cases going to the length of rescinding the mandate itself; unions opposed merit pay and career ladders for teachers; vocational educators and sentimentalists remained mired in anti-intellectualism; disadvantaged minority children were patronized rather than exhorted to make the effort to develop ideas and skills requisite for effective participation in society; special education was stigmatized as a place not just for handicapped students but also for those with so-called learning disabilities—often a pseudonym for disruptive behavior or lack of motivation; grade inflation increased as a result not only of a misconceived egalitarianism but also of a tacit understanding between teachers and students that classroom order and good conduct are enough to earn passing grades; and students continued to be sorted into different educational tracks, the bottom ones of which offer only pathetically attenuated learning. In brief, increased graduation requirements have resulted neither in higher academic standards nor in disciplined learning. Schooling in large continues to be dominated by a utilitarian ethos that stresses practical rather than intellectual skills. Toch writes:

> Unless many more public educators can be persuaded to embrace the spirit as well as the letter of reform, unless they can be convinced that the majority of the nation's students, the work-bound as well as the college-bound, are best served by a rigorous academic education, many students will continue to be treated as second-class citizens in the nation's secondary schools. They will continue to be victimized by superficial courses, unqualified teachers, and failed instructional strategies (133).

Anyone wanting to make excellence and its recognition an important goal and feature of learning in American schools will profit from

reading Toch's chapter on the attitudes of the American Federation of Teachers (AFT) and the National Education Association (NEA) toward the issue of professionalizing teacher education, another goal of the reform movement. Albert Shanker, the head of the AFT, came to realize that the the public's lack of confidence in the nation's schools, which became evident in its response to *A Nation at Risk* and other reports, meant that the AFT could not continue to stand mainly on collective bargaining and seniority if it wanted to survive. Shanker thus threw his support to the reformers who were recommending such things as competency tests and career ladders for teachers, merit pay based on performance, and greater authority for teachers in deciding the criteria for promotion and the process of curriculum development. Yet Toch says that the NEA often went to extraordinary lengths to oppose all of this. He quoted the Executive Director of the NEA, who at a 1988 convention said that the NEA "must never sacrifice unionism at the altar of professionalism," while the NEA president declared that new collective bargaining laws for teachers would be his highest priority.

Nonetheless, some progress was made toward breaking the hold of union solidarity. Some school districts instituted reward systems that recognized teacher excellence. In others, career ladders were established and staff development improved; numerous new ventures in curriculum design were launched. Induction into the teaching profession and supervision and monitoring of practice teaching also improved, magnet schools proliferated, peer review of teaching was more widely accepted, alternative certification was offered to liberal arts graduates, and interest was generated in national standards and certification of teachers, and, increasingly, in a national curriculum. Whenever a new undertaking proved promising it was, of course, touted by the reformers. But such efforts—often impressive, said Toch, in their imagination and sensibleness—were mere dents in the structure of American public school education. Trade unionism offered the greatest resistance. He writes that

> despite the avalanche of new initiatives in teaching, many of them reforms rarely discussed in public education even a decade ago, the union-backed impediments to teaching reform—seniority, the single salary schedule, traditional state licensing laws, rigid distinctions between "labor" and "management" in schools—remain in place in the vast majority of the nation's school systems. In much of public school teaching, it's business as usual [Yet] there is an inherent conflict between traditional industrial-style teacher union-

ism—with its predisposition to confrontation, its commitment to limiting the responsibilities of teachers in schools, and its opposition to meaningful standards—and the high standards and accountability inherent in the professionalism that the reformers seek for teaching. Shanker and the AFT have acknowledged this reality and have sought to redefine teacher unionism and the role of teacher unions to accommodate it. The NEA has not, and it is the NEA, with its vast membership and resources, that has the greatest ability to shape the future of public school teaching (204).

Toch considers a call to meaningful standards a reflection of disenchantment with the standardized testing that had become a key instrument in the politics of educational reform. Standardized testing originated in response to a demand for greater accountability. Paradoxically, however, instead of assessing significant learning, these tests measure something much less. Easy to design, easy to take, easy to evaluate, and easy to use in comparing results in one school or district with others, standardized tests assessed not knowledge of significant content or critical thinking but rather, for the most part, minimal reading skills. Nor did multiple-choice questions, the coins of the realm, offer opportunities to evaluate writing ability. Yet reliance on standardized tests makes sense once it is realized that they served the reform movement very well. School principals, superintendents, and governors, indeed anyone with political ambition, could use low test results to argue for more funds to spend on education or raised scores to show that a school, district, or state was achieving excellence and hence deserved higher funding. In short, test scores built political capital. Inevitably, teachers began teaching for the tests irrespective of whether they thought passing the tests indicated any significant mastery. In fact, few teachers understand the technical aspects of test validity, and what Toch says about standardized testing is enough to make anyone skeptical about claims made for higher scores. He quotes one testing official as saying, "A [standardized] test score is a sloppy thing." Moreover, the decision to adopt standardized testing initiated a cumulative process. One thing led to another; for example, the tests led to the redesigning of textbooks that contained the information to be included in the tests. As in the past, efforts were being made to teacher-proof curriculum materials. The limitations of poorly conceived methods of performance-based learning and accountability have often been pointed out, but unfortunately such cautionary words haven't inhibited the institutionalization of technocratic modes of assessment. The question is not whether to

assess performance or to insist on accountability but rather to examine the limitations of quantitative assessment and seek additional means of evaluation. Once more, Toch:

> Greater accountability is a necessity in public education, and good tests can help spur improvements in schools and classrooms. But standardized multiple-choice achievement tests are preeminent in the nation's schools today, and they are doing little to promote educational excellence. On the contrary, they are contributing significantly to the ill-conceived teaching and learning that they were designed to counter. And because multiple-choice tests afford a means of measuring school performance that is administratively manageable, relatively inexpensive, and seemingly easy to interpret, it will take a tremendous commitment to diminish their presence in the nation's classrooms (232).

Finally, if it seems that Toch criticizes unfairly the job teachers are doing in the nation's schools, it should be pointed out that their job has actually been made more difficult by some of the reforms that were enacted—as if the 1960s and 1970s hadn't laid a heavy enough burden on them. And when teachers become distraught the effect is not lost on students. Consider for a moment what teachers have been asked to do (apart from displaying the loyalty exacted by their unions) since the 1960s: teach the structure of subjects (i.e., their basic concepts and skills); support open classrooms and informal learning; attend to the needs of the poor and disadvantaged; mainstream the handicapped; teach drug and sex education; return to the traditional basics; teach the new basics; cultivate excellence and equity; incorporate multicultural, feminist, and gay values into the curriculum; and be alert to cognitive, affective, and motor skills, values clarification, career education, mastery learning, collaborative learning, seven types of intelligence, portfolio assessment, outcome-based education, and on and on and on. (Small wonder that some writers recommend that instead of maximizing learning opportunities the schools should optimize what they can do best.) Not surprisingly, teachers develop a defensive posture and cry "Enough!" As state mandate after mandate deprives teachers of precious time to teach what they think is important, they understandably become increasingly alienated from teaching. In some cases, teachers develop more loyalty to the external agency that funds their particular specialty than to their profession or school. Others wear unionism on their sleeves, while still others quietly sabotage new initiatives. To no one's amazement, absentee

rates are high for teachers as well as students, and many teachers are switching to different jobs. Equally understandable is the tacit collusion between teachers and students, mentioned earlier, that allows mere attendance and orderly behavior to be rewarded. Yet grade inflation and the use of meaningless grades as a measure of significant achievement are not a particularly good way to enhance students' self-esteem. For all of these reasons, and many others, liberal as well as conservative educational critics are taking a highly pessimistic view of the schools' ability to educate in any meaningful sense, which further erodes confidence in the schools and hastens the flight to private schools.[10]

Adding to the crippling of American public education is the sheer size of modern schools, which, as a result of consolidation, now attempt to educate excessive numbers of students. In this regard, the Conant model for school improvement has come under some criticism. Consolidation, it seems, isn't necessarily the answer, for it depersonalizes school management and learning and encourages an expanding bureaucracy. Most of all, the human side of schooling suffers. The remedy? Break up schools, create schools within schools, and develop more magnet schools. Such actions can engender a sense of community and make it easier for teachers and students to identify with a school and its distinctive educational function. One is reminded of one of the demands of civic humanism: honor the human scale. Deconsolidation may be too tall an order for some school districts, but it is at least plausible to suggest that some of the schools in urban centers could be reduced to a more human scale and become viable places for learning.

In concluding his observations, Toch asks for a synthesis of the best sentiments of the reformers of the 1960s and 1970s and the 1980s' reformers recommendations for excellence and equity.

> What is needed, it seems, is a synthesis on a broad scale within public education of the 1960s reformers' desire to humanize schools and the 1980s reformers' commitment to rigorous academic standards. Though the excellence movement was in part spawned by the excesses of the 1960s educational philosophy, the observations of the public schools that led the reformers of two decades ago to their radical prescriptions are still valid and remain largely unaddressed. If the reforms they engendered led eventually (through an overemphasis on child-centeredness and a diminution of traditional academic disciplines) to a decline in academic standards, their criticisms that the public schools were repressive, impersonal places that promoted conformity at the expense of personal expression and

rendered learning boring and lifeless were and remain essentially accurate. And their attempts to reshape the curriculum and class-room teaching to tap students' natural curiosity, to make them active participants in the educational process rather than passive receptacles of facts and figures, to make school more personal and more fun, were important and necessary steps, even if their particu-lar methods of achieving those goals were flawed (272-73).

I think this is a too accommodating gesture toward the 1960s and 1970s. Certainly it doesn't accord with what I perceived was going on in certain attempts to change art education, but a conciliatory note is at least an expression of good will.

Returning more specifically to art education, how has the reform movement of the 1980s affected the status of art education in the schools? Has there been an increase in the number of new art courses? Are they more rigorous? And how can we know for certain? I ask this latter question because surveys and case studies are only partly successful in capturing the status of art education in the schools. The sometimes questionable motives of poll takers (who often have political axes to grind), faulty survey designs (owing to the nature of the questions asked and the credibility of responses elicited), and the inevitable limitations of case studies (for instance, the biases and weak qualifications of many observers and the small number of programs they are able to study) all constrain the effectiveness of such efforts. Despite these drawbacks, a rough picture—albeit a constantly changing one—has emerged from recent studies and reports.

In a discussion of a report on the status of arts education in the United States that was completed in 1989-90, Charles Leonhard summa-rizes its findings and adds new information about the impact of the economic recession of recent years on arts education. Leonhard reports data on four arts: the visual arts, music, drama/theater, and dance.[11]

We find that almost every elementary school offers instruction in art and music, although it may not always be required. Local and district decision making largely determine the content and sequence of instruction, and state departments of education provide curriculum guides and support for the purchase of materials. More than half of middle schools require one or more courses in the four arts, with a preponderance of courses in the visual arts, followed closely by music. Instruction in dance and drama/theater is virtually absent in middle schools, although special magnet schools offer opportunities to study a spectrum of the arts.

For high schools the data on compulsory instruction vary widely. At the time of the study (1989) twenty states had an arts requirement for high school graduation, either for all students or for a select group (the college bound); six states included the arts in a set of courses from which students must select to fulfill a requirement (the majority of students do not choose art courses); twenty-two states had no requirement; and one state offered financial incentives to school districts that require work in the arts. The lack of an arts requirement in many states is due to well-established traditions of local control. Related or integrated arts courses that combine several arts are available in about half of middle and high schools, and, in general, schools enrich their art programs by sponsoring field trips and artist residencies. Overall, the percentages of schools having a fine-arts requirement beyond the elementary years are: small middle, 46.7; large middle, 56.7; small high, 44.0; large high, 52.7.

Leonhard reports that since the completion of the study, economic hard times have taken a severe toll on art instruction in the schools. Widespread resistance to tax referenda is largely responsible for cutbacks. As a result, numerous programs as well as teaching and supervisory positions have been eliminated. Although the condition of the arts in the schools has improved since 1962, the last time systematic data were collected, a general conclusion would echo that of the government report *Toward Civilization*, which states that "basic arts education does not exist in the United States today."[12]

There is one significant finding of the status of arts education study that bears directly on the theme of *Excellence II* and the likelihood of the acceptance of a K-12 excellence curriculum in art education it recommends. This is the influence the idea of discipline-based art education has had since the establishment of the Getty Center for Education in the Arts in the early 1980s. "It appears," writes Leonhard, "that the concept of Discipline-Based Art Education is being widely applied in art education programs. More than 95 percent of the respondents to the art survey indicated that they incorporate DBAE 'to a great extent' or 'to some extent' " (40). The impact of the Getty Center's efforts is also apparent in the fact that over half of the states have incorporated the premises of disciplined-based art education in their guidelines.[13] While it would be helpful to know what the reporting agents understand by discipline-based art education, it is reasonable to interpret the data to mean that, in addition to creative activities, greater attention is being paid to historical, critical, and philosophical considerations. If this is so, then one can also suppose that art education is moving in a direction that

accords with the recommendations for an excellence curriculum described in chapter 9.

The Leonhard status of the arts education report is silent on the influence of Harvard Project Zero. This omission is noteworthy because Project Zero is often referred to in the literature of art education and has received some attention in the national media. Accordingly, I will devote some space to its approach to art education.[14]

Since the beginnings of Project Zero in the late 1960s—the term "zero" expressing the Project members' belief that little had been accomplished in the line of research they favored—its participants have undertaken considerable research in the study of cognition as it is manifested in a number of areas, ranging from creative and perceptual activities, including mass media activities, to museum education and critical thinking, to mention but a few. The Project received national attention, however, for its more practical work in curriculum design and implementation in the Pittsburgh school district, namely, a project called ARTS PROPEL. "Propel" is meant to imply a concern with production, perception, and reflection, but primarily, it is important to note, as these relate to productive activities. In contrast to the Getty Center's notion of discipline-based art education, Howard Gardner, in describing ARTS PROPEL, writes that "production must remain central in arts education and particularly so among pre-collegiate students. The heart of any arts-educational process must be the capacity to handle, to use, to transform different artistic symbol systems—to think with and in the materials of an artistic medium. Such processes can occur only if artistic creation remains the cornerstone of all pedagogical efforts" (281).

Clearly, the model for the student learner is the serious artist whose cognitive acts differ only in degree of maturity from those of young children. Young children, and older ones as well, are encouraged to think and act like artists whose understandings take a distinctive shape and form, or in more technical terms, who exhibit fluency in a range of artistic symbol systems. The underlying concern is the development of the higher mental powers. The theoretical underpinning for such work is found in Nelson Goodman's theory of symbolic systems, presented in his *Languages of Art,* and Gardner's theory of multiple intelligence, set out in his *Frames of Mind.*[15] Other interests, such as appropriate modes of assessing artistic development, are also addressed by the ARTS PROPEL project.

Although there is much in "the Harvard way" that can be accommodated in the excellence curriculum I describe in chapter 9, the differences

between the premises of each are fundamental. The understanding and appreciation of the completed work of mature artists do not figure as prominently in projects such as ARTS PROPEL as they do in an excellence curriculum, which endorses the taste for excellence as a major objective. In addition, the image informing the teaching and learning of art in an excellence curriculum is not that of the creative artist but rather that of the reflective percipient, a conception that assigns prominent roles to a sense of art history, critical principles of judgment, and aesthetic theory. While an excellence curriculum assumes that creative and performing activities will contribute to the strengthening of cognitive powers, it doesn't place these activities at the heart of art education or at the center of all pedagogical efforts. As important, and perhaps more so, is the development of art-historical awareness and a critical stance toward art. The reason is that it will be as respondents to works of art, ideally reflective ones, that most adolescents will experience the arts once they have left school.

What I call a humanities interpretation of art education in chapter 9 has the additional advantage of responding to other cultural needs; for example, it helps to restore a sense of civilization and raise the level of cultural literacy. In short, I think it is fair to say that, consistent with the psychological perspective Gardner brings to thinking about arts education, Project Zero efforts are more concerned with discovering the roots and character of cognitive functioning in young minds than in cultivating a taste for excellence in art. Indeed, Gardner acknowledges that an approach to arts education that stresses imparting literacy skills in forms of artistic symbolization is able to avoid many of the prickly problems arising in considerations of artistic merit (276). This admission is made against the background of Nelson Goodman's discussion of aesthetic merit in *Languages of Art* in which he says that "works of art are not race horses, and picking a winner is not the goal" (262). Understanding is. For Goodman, then, as well as for Gardner, aesthetic merit is not a major concern. Yet quite obviously some artworks are "winners"; we know them by the name masterworks, and their privileged status derives from their proven and enduring significance. Certainly, this is a central assumption of an excellence curriculum.

Furthermore, the writings of some of those who have been associated with Project Zero show signs that the justification for studying the arts, though initially emphasizing the cultivation of important cognitive powers (higher-level mental skills) and the assessment of learning, should ultimately embrace social goals. For example, in a discussion of policy

considerations, Dennie Palmer Wolf and Mary Burger point out some of the similarities between what they call artistry-based art education (the model of ARTS PROPEL) and discipline-based art education (the Getty model)—although I think it is clear that their sympathies lie with the former.[16] True, Wolf and Burger are not writers who endorse sentimental child-centered conceptions of aesthetic learning. They do not interpret creative activities as the free, spontaneous expression of feeling; rather they see them as strategic in developing a fundamental way of knowing—aesthetic knowing—which compares favorably with the mental processes of mature, serious artists. This attitude is consistent with the basic outlook of Project Zero.[17] "The arts," say Wolf and Burger, "have been re-envisioned, not as crafts or as occasions for self-expression, but as occasions for meaning-making that depend utterly on fluency in symbol systems" (131).

Once more, the attitudes, skills, knowledge, and experience of the mature artist serve as a model for the child, and Wolf and Burger convey what they think these are in their description of the work of a contemporary Hispanic artist. Drawing on religious, political, and cultural legacies in order to gain a better understanding of her own relations to self and culture, this artist provides the writers with an illustration of what they call the nature of complex meaning-making in the arts. By analyzing and integrating various vantage points, the artist created an artistic statement that was simultaneously sensual, symbolic, and cultural and recalled in its expressiveness the works of such nineteenth- and twentieth-century artists as Goya, Picasso, and Orozco. To achieve her ends, the artist—to stay with Wolf and Burger's terminology—exercised such significant mental (i.e., cognitive) powers as reflection and revision, self-regulation, and assessment of nuances. The child in arts education is likewise envisioned as a serious thinker, constructive problem solver, and creator of visions. Thus art education is seen as contributing to the building of higher-order thinking skills, in part through encouraging the young to think and to solve problems as artists do. Conversations with artists are also recommended, as is creation of a studiolike atmosphere in the classroom.

The circle, in other words, is complete. We are back to where art education reformers found matters at midcentury when they called into question the model of the creative artist as a model for aesthetic learning. But Wolf and Burger have more in mind than fluency with artistic symbols. There is also a political agenda. "Questions will erupt," they predict, "about the hegemony of Western art and its canons; gender, body image, and

exploitation; race, marginality, and identity. Moreover, if arts education were to become serious, it would be disruptive" (120-21).

Wolf and Burger's ideas seem to be a fusion of what Efland calls the rationalist, expressionist, and social reconstructionist streams of art education.[18] Theoretical underpinning derives from cognitive studies, method from artistic activities, and social concern from political commitments. The authors do not seem to question the advisability of basing a justification on an attempt to move a marginal subject like art education into the mainstream on the strength of that subject's potential for disruption. Neither do they, committed as they are to multiculturalism, remark on the consequences of cultural diversity for the ideal of a *common* culture or on the present-day need to restore historical memory and upgrade cultural literacy in the society. I have more to say about this in chapter 9.

An excellence curriculum likewise values the arts as sources of distinctive ways of knowing, meaning-making, and all that these imply for the development of mental powers. But in contrast to artistry-based conceptions, it takes learning rooted in art history, criticism, and aesthetics to be just as important as creative activities in building a sense of art and cultivating a taste for excellence. Therein lies the basic difference between an essentially psychological stance toward art education and the humanities approach described in chapter 9. One might ask, as Efland does, whether a harmonious confluence of different streams of art education might not be possible. But not all streams can flow together smoothly, which is why I will make few further references to ARTS PROPEL or Project Zero in this book. Its approach to arts education has not turned out to be what I, along with many reformers in art education, had hoped it would be. I thought that it would pay much more attention to ways of developing an understanding and appreciation of mature works of art and help lay to rest the child-as-artist image that has misled art education in so many ways.[19]

In conclusion, the gains of the excellence reform movement and its failures must be kept in mind when we think about excellence and its recognition in art education, for the larger context in which art education is imbedded is not necessarily receptive to the goal of excellence, and in some instances is resisting it vigorously. There are also those in the field of art education who consider the pursuit of excellence elitist in the condemnatory sense of the word. It is therefore necessary to recall the criteria of excellence in art and address the question of elitism. This is the task of the next three chapters.

4

Aesthetic Experience

Part of what it means to lead a moral and rational life is to respond aesthetically to objects, events, and other people. Having aesthetic experiences is thus one of life's central goals. Aesthetic activities and responses enrich life and provide us with . . . "delight" not only by providing pleasure but by sensitizing, vitalizing, and inspiring human beings.

Marcia M. Eaton

In his comprehensive and systematic *The Theory of the Arts,* Francis Sparshott writes that in one sense art is a simple thing. Leonardo's *Mona Lisa,* Shakespeare's *Hamlet,* Beethoven's *Eroica,* Dante's *Divine Comedy,* and Michelangelo's *David* "are expected to provide worthwhile experiences merely in being listened to, looked at, or read. The less doubt we have that this is what a thing is for, the more confidently we take it to be a work of art."[1] No doubt; but it took Sparshott 684 pages of text and notes to explain the different conceptions of the worthwhile in our experiences of art that have been propounded by thinkers from antiquity to the present. What is ostensibly simple turns out to be complicated and problematic. Since there is nonetheless truth in what Sparshott says, I take the principal objective of art education to be the development of a disposition to appreciate excellence in art for the sake of the worthwhile experience such appreciation is capable of bringing about.[2] Following a number of notable theorists, the name I give

to such experience is aesthetic experience. Accordingly, this chapter presents five theories of aesthetic experience. The discussion is continued in the appendix where the history of the idea of aesthetic experience is sketched and examples are given of what may be taken as aesthetic responses to a range of phenomena.

Before proceeding, it will be helpful to remark briefly on the kind of topic under discussion. The description of human experience from any point of view is extremely difficult, and the characterization of what Abraham Maslow once called the farther reaches of human nature—its creative, imaginative, and spiritual peaks, for example—is perhaps the most difficult of all. Because these realms of human experience are more intractable to inquiry than others, we must be prepared for a certain imprecision in attempts to capture their nature. Now this may be just one more of those things that should go without saying were it not for the fact that it is occasionally forgotten even by students of the arts and humanities.

There is a further consideration. Discussions of human behavior and art take place at different levels. At one level, fartherest removed from the classroom, we find the discourse of frontier inquiry in which scholars examine ideas and hypotheses in technical or quasi-technical language, and at another level there is the less technical language of teaching and learning. Confusion results when no effort is made to translate technical language into more readily understandable terms, and the problem is compounded when the same terms function in both technical and nontechnical contexts. "Aesthetic experience" is one such term. It is found in both technical analyses of the concept and increasingly in ordinary parlance.[3]

In discussing aesthetic experience I do not assume that works of art are the only things capable of providing it. Practically anything can be experienced from an aesthetic point of view and have more or less aesthetic value. Yet, with notable exceptions, works of art are objects preeminently capable of inducing aesthetic experience, which the following discussions of aesthetic experience should make clear. I stress that aesthetic experience, as I understand it now and as I understood it in *Excellence in Art Education*, has both cognitive and affective strands and is valuable for both its constitutive and revelatory values: it shapes the self in positive ways while providing humanistic insight into natural phenomena and human life. In other words, aesthetic perception encompasses more than surface phenomena, more than sensory, technical, and formal qualities; it also encompasses expressive and symbolic meanings. It is misleading then to characterize the

theory of art I hold as formalist. Or, put differently, I am not saying that an excellence curriculum should be committed to a view of "art for art's sake" where this implies that attention should be paid only to a work's formal aesthetic qualities. Nor, strictly speaking, is value conceived as being intrinsic. Works of art are valuable because they are instrumental to occasioning worthwhile aesthetic experiences, experiences that are energized and charged with feelings and meanings.

Monroe C. Beardsley: *Aesthetic Experience as Essentially Gratifying.*
Beardsley's *Aesthetics: Problems in the Philosophy of Criticism,* first published in 1958 and updated in 1981, has been one of the most widely read works in American philosophical aesthetics since John Dewey's *Art as Experience.*[4] A systematic examination of a wide range of aesthetic topics, *Aesthetics* is particularly concerned with the analysis of the presuppositions Beardsley detected in a large number of critical statements made by art, music, and literary critics. Since, however, one cannot determine the cogency of reasons and judgments without a theory of relevance, Beardsley also provides an instrumental theory of aesthetic value that influences both his analysis of concepts and his ideas about the role of art in human life. This latter concern makes Beardsley's writings one of the rare instances in modern aesthetics in which an author keeps the human significance and relevance of art constantly in mind. This is also what gives his writings inherent educational significance.

The conceptual problem Beardsley wrestled with more than any other is whether there is a kind of human experience we may appropriately call aesthetic that is not only sufficiently distinct from other kinds of experience but also important enough to warrant society's efforts to cultivate it. He was particularly interested in the possibility that works of art may be ideally suited to occasion such experience even though other things might also possess aesthetic potential in varying degrees. Beardsley never took his success in answering these questions for granted, and he usually expressed some dissatisfaction with the results of his analytical efforts. Although he modified details of his theory over the years, he held to the belief that the *artistic* goodness of works of art consists in their capacity to induce in a well-qualified observer a high degree of aesthetic experience. Such experience is valuable for a number of its features but mainly for the special feelings of pleasure, enjoyment, satisfaction, or gratification it evokes—the variety of terms suggesting the difficulty of defining the hedonic effect that character-

izes our commerce with art, although Beardsley came to prefer "gratification."[5]

Beardsley's theory then is a hedonistic one, but not in any simple sense. Aesthetic gratification is neither a general state of feeling well nor the kind of enjoyment that attends the informal congeniality of friendly conversation, partisan cheering at sports events, or participation in political activities. It is a gratification uniquely derived from the sensitive and knowledgeable experiencing of outstanding works of art—a painting by Raphael, a piano sonata by Beethoven, a sonnet by Shakespeare, a novel by Jane Austen.

In Beardsley's last essay on aesthetic experience, in *The Aesthetic Point of View,* he asks us to consider a characterization that assigns to it as many (or as few) as five features, although not all five must be present for aesthetic experience to happen. This is to say he did not reduce aesthetic experience to a single pervasive emotion but rather conceived it as eliciting a cluster of feelings. This clustering of feelings is what makes aesthetic experience both compound and disjunctive, that is, while consisting of a number of features it also separates itself fairly well, though not wholly, from other types of experience.[6]

A compressed paraphrase of Beardsley's characterization of aesthetic experience could run as follows. In our aesthetic experience of an outstanding work of art, we fix our attention on an object of notable presence whose elements, formal relations, aesthetic qualities, and semantic aspects are freely entertained. One indication of the presence of aesthetic character is our feeling that things are working themselves out in appropriate and fitting ways. Another indication is a lessening of our concern about the past and future and its replacement by an intense engagement with what is immediately presented or invoked by the object, with *its* world—which may, of course, reflect back on the world external to it. During aesthetic involvement we further achieve an emotional distancing from a work, a certain detached affect that we need in order to maintain control over the experience. This detachment enables us to enjoy (in a special sense) an artwork's tragic import rather than be overwhelmed by it. Most importantly, during experiences with an aesthetic character exhilarating moments of discovery can occur, moments that exercise the powers of mind. What we discover is the existence not only of coherence among a work's ostensibly conflicting formal aspects but also of connections between percepts and meanings; and this realization comes to us as a kind of sense-making, of

gaining intelligibility. Because aesthetic experience requires object-directed attention and detached affect, and rewards these with a felt freedom from ordinary concerns and an active sense of discovery, it may also result in feelings of wholeness, of personal integration, and a greater acceptance as well as expansion of the self.

Once more, Beardsley acknowledges that aesthetic experience might well contain more or fewer features than his account of it indicates; his intention was always to open up rather than to close off a line of thought. But for all that may be felt during or learned by means of aesthetic experience, Beardsley believed that its unique value consists in the quality of gratification it provides. Rare, he said, are those stretches of time during which the elements of human experience combine in just these ways; when they do they afford a state of gratified well-being. And we can only agree. When in the course of a typical day do we experience the stimulation, the lack of coercion, the controlled emotional involvement, the feeling of genuine discovery, and the sense of gratification and self-fulfillment that we tend to feel during the experience of a great or even just a good work of art? Such a state of mind is a distinctive form of human satisfaction, a significant realization of human value, and therefore a part of a good or worthwhile life. It is by virtue of affording aesthetic experiences, then, that Beardsley believed works of art serve us well and realize their potentialities.

Harold Osborne: Aesthetic Experience as Percipience. Beardsley's belief is echoed by Osborne, who in *The Art of Appreciation* argues that works of art serve us well by stimulating and expanding the powers of percipience.[7]

What is percipience? Osborne equates percipience with aesthetic appreciation and experience. He understands the aesthetic experience of a work of art to involve the directing of attention over a limited sensory field so that the field's qualities are brought into focus according to their own inherent intensity, their similarities and contrast, and their peculiar groupings. Such perception is full and complete and proceeds without the sort of editing that characterizes our practical concerns and activities. The mental attitude assumed during aesthetic experience is further unlike the kind required for conceptual analysis or for the historian's rooting out of causes and effects; instead, aesthetic experience involves the exercise of integrative vision. Identifying the representational contents of Picasso's *Guernica,* for example, is not the same thing as perceiving the work's fusion of subject, form, and expression in an act of synoptic perception.

61

The kind of rapt attention that marks aesthetic interest also lends aesthetic experience a characteristic emotional color; its mood, Osborne thinks, approximates serenity (perhaps a questionable term) even when the object being perceived has a dynamic character. Also important to realize is that perceptual absorption in the object of aesthetic experience means that we are less conscious of our own feelings and more aware of the object's qualities and properties; it is as if we were dwelling in the object itself. The demands of perceptual awareness and the obligation to see the object in its full complexity also tend to discourage mere idle musings and associations. Aesthetic experience thus has a characteristic rigor; imagination is required to comprehend a work's qualities, but imagination is also held in check. Another feature of aesthetic experience is that appearance takes precedence over material existence. The fact that an object is a material thing existing in the world is of less interest than the imagery the material thing presents. Such imagery is suited to sustaining awareness in the aesthetic mode in part because it takes us out of ourselves into new worlds. Ego consciousness, however, never disappears completely; if it did we would risk losing contact with the work's qualities and meanings.

Osborne reminds us that aesthetic percipience is exercised in many areas of human life, but he thinks that works of fine art and their counterparts in nature are capable of expanding it to its fullest. This is to say that works of art can extend the perceptive faculties and that to be properly apprehended they demand of percipients an ever-increasing mental finesse. Central then to Osborne's theory is the heightened awareness of things persons feel during aesthetic experience. This awareness not only makes them feel more vital, awake, and alert than usual, it also allows their minds to work with greater freedom and effectiveness. And new discoveries and insights are the constant reward.

Osborne argues that percipience, like reason, should be cultivated for its own sake. But while reason characteristically finds its fullest outlet and expansion in philosophy, logic, mathematics, and the theoretical sciences, the cultivation of percipience has always been the motive for the expression of spiritual needs and aspirations. Whatever ideology one embraces, liberation from life's material constraints for the purpose of realizing more fully and more freely one's humanity is a near-universal yearning and guiding ideal. This is what the British art historian Lord Kenneth Clark seemed to have had in mind when he said that even in a predominantly secular society the majority of people still long to experience

moments of pure, nonmaterial satisfaction and that such satisfaction can be obtained more reliably through works of art than through any other means.[8] This suggests that when we talk about the uses of art we must do so in a very special sense.

Nelson Goodman: Aesthetic Experience as Understanding. In addressing Goodman's work we confront ideas that originated in modern developments in the theory of understanding and the logic of symbolic systems. Goodman's major thesis—that art is essentially cognitive—has encouraged some educational theorists to use his ideas to ground more firmly a justification of arts education.

The central proposition of Goodman's theory is that art is a symbolic system of human understanding that shares with other forms of inquiry, including the sciences, the human quest for enlightenment. Condensed accounts of Beardsley's and Osborne's ideas of aesthetic experience having been provided, here is how Goodman in *Languages of Art* describes engagements with art. "Aesthetic experience is dynamic rather than static. It involves making delicate discriminations and discerning subtle relationships, identifying symbol systems and characters within these systems and what these characters denote and exemplify, interpreting works and reorganizing the world in terms of works and works in terms of the world. Much of our experience and many of our skills are brought to bear and may be transformed by the encounter. The aesthetic 'attitude' is restless, searching, testing—is less attitude than action: creation and re-creation."[9]

In these words we detect what is shared with and what is different from the accounts of aesthetic experience given by Beardsley and Osborne. All three—Beardsley, Osborne, and Goodman—acknowledge that perception is dynamic, discriminating, and interpretive and that a person's view of the world may be transformed by aesthetic encounters. Goodman's account is distinguished by what he does and does not emphasize. Identifying symbol systems and characters within these systems has a technical meaning in Goodman's theory; it involves understanding the ways in which the properties of works of art denote and exemplify. Goodman's account of aesthetic experience does not feature a peculiar sort of gratification, for he does not think that the criterion of the aesthetic is to be found in a superior quality or greater magnitude of satisfaction. And though he emphasizes that the primary purpose of art is cognition itself, his accent is different from Osborne's. For Osborne, it is sufficient that the cognition of art serves to animate and strengthen the powers of percipience. Goodman goes beyond

63

this to stress the role that cognition plays in the shaping and reshaping of worlds, in short, in providing understanding.

In saying that works of art provide understanding, Goodman has in mind their capacity to make us see, hear, and read differently and to make new connections among things. And when this is understood some of the differences between Beardsley, Osborne, and Goodman begin to fade, although others still remain. We should also realize that although Goodman uses the term "aesthetic experience," his theory of art is less an account of how we perceive and appreciate works of art than an explanation of art's cognitive status. What Goodman calls the symptoms of the aesthetic— syntactical and semantic density, relative repleteness, exemplification, and multiple and complex reference—are not aesthetic qualities but technical terms that refer to the functions of characters in a work of art construed as a symbol system. They explain how works of art, even nonrepresentational or strictly formal ones, denote and refer.

Eugene F. Kaelin: Aesthetic Experience and Institutional Efficacy. Kaelin's aesthetic ideas constitute yet another philosophical perspective on the arts and aesthetic experience. Although Kaelin is influenced by Continental points of view that are less evident in the theories of Beardsley, Osborne, and Goodman, the benefits he ascribes to aesthetic experience are similar to those described by these writers. In *An Aesthetics for Educators* Kaelin says that works of art are good for the aesthetic experiences they provide, which in turn are good for the aesthetic communication that occurs and the intensification and clarification of human experience that result.[10] The satisfaction felt when an artwork's system of counters (that is, a work's surface and depth features) are fused successfully constitutes the hedonic aspect of aesthetic experience, and in this respect Kaelin's theory resembles Beardsley's. Kaelin's belief that art has the capacity to intensify and clarify human experience also accommodates Osborne's thoughts regarding the artwork's capacity to stimulate the powers of percipience. Although Kaelin's philosophical orientation is antithetical to Goodman's, one aspect of it stresses precisely what Goodman's does: the ability of works of art to present fresh perceptions of things. Indeed, an interesting result of the comparison of aesthetic theories is the discovery that theoretical differences about the nature and meaning of art do not necessarily entail divergent views on the benefits realizable through aesthertic experience.

Noteworthy in Kaelin's aesthetics are the value he places on human freedom and his belief that the cultivation of the capacity for aesthetic experience through schooling is relevant to the free functioning of the institution of art. In other words, aesthetic experience has both personal and social value. A theory of aesthetic education thus helps to define the kind of individual any free society would wish to produce—an individual who embodies the human values of tolerance, communication, judgment, and freedom in contrast to the disvalues of intolerance, dogmatism, conformity, and suppression. How, according to Kaelin, does aesthetic experience exemplify such values? His answer lies in understanding the ways in which aesthetic experience originates, unfolds, and achieves closure.

Kaelin describes how percipients, when confronting works of art, bracket out irrelevant considerations and create contexts of significance whose intrinsic properties provide the material for immediate aesthetic experience. Attention to the presentational qualities of works of art involves perception of what is variously termed matter and form, subject and treatment, and local and regional qualities, all of which are aspects of a work's surface and depth relations. Successful perceptual fusion of a work's system of counters results in acts of expressive response that constitute the consummatory value of aesthetic experience. In Kaelin's terminology "felt expressiveness" implies a sense of fittingness or appropriateness between surface and depth counters. A case in point is his description of the counters of Picasso's *Guernica*. After indicating and interpreting the work's various features, Kaelin writes that "so interpreted, our experience of *Guernica* deepens, and it comes to closure in a single act of expressive response in which we perceive the fittingness of this surface—all broken planes and jagged edges in the stark contrast of black and white—to represent this depth, the equally stark contrast of the living and the dead" (76). What Kaelin calls a single act of expressive response is what Osborne calls an instance of synoptic or integrative vision, Goodman the discerning and interpreting of characters within a symbol system, and Beardsley the characterizing of object directedness.

Once more, the point of looking at notable works of art is found to lie in the worthwhile aesthetic experiences they afford, where worthwhileness consists of the value of aesthetic communication and the exercise of perceptual skills and aesthetic judgment. All of this occurs in a context of significance governed by the intrinsic values of an artwork's system of counters. Kaelin in effect offers his own version of Erwin Panofsky's belief

that a work of art is essentially a humanly made object that demands to be experienced aesthetically. Works of art "come to exist," writes Kaelin, "only in the experience of persons who have opened themselves to the expressiveness of a sensuous surface and allowed their understandings and imagination to be guided by controlled responses set up thereon" (77-78). Everything then that we prize in the traditional ideal of liberal education is present in Kaelin's account of aesthetic experience, especially the notion that disciplined encounters with excellence test, strengthen, and expand basic human powers.

One further aspect of Kaelin's idea of aesthetic experience deserves mentioning. The willingness of percipients to be guided by a work's context of significance means that a work's value cannot be predetermined or assessed on the basis of conformance to rule or ideology. Kaelin's method of analysis takes its cues from the immediate givens of a work of art and assumes that value depends on a work's unique context of significance and not on the superimposition of interpretive frameworks. One cannot know in advance what a work of art will feature or what it might have to say about reality and human concerns. Aesthetic communication is thus essentially free communication. Through acts of artistic creation and appreciation, persons choose their futures—in the first instance by creating new worlds of aesthetic value, and in the second by opening themselves to new possibilities of experience. In other words, art serves Being by helping to realize human powers and potentialities that benefit both the individual and society.

Marcia M. Eaton: Aesthetic Experience and Contextualism. Of the four theorists discussed so far, Kaelin is distinctive for his interest in the relations of art and cultural institutions. A differently accented institutional theory of art and aesthetic experience is that of Marcia M. Eaton, also a philosopher of art. Her theory is a response to a central problem of contemporary philosophical thinking about art: how to provide a coherent and judicious account of the relations of art and society while preserving what is special about art and the important role it plays in the human career. Eaton's theory of art within a tradition further addresses the slippery questions of what is demanded by the objective status of artworks and what individuals bring to an aesthetic situation. Because Eaton holds that art and aesthetic experience are integral parts of a good life and that developing the capacity for aesthetic response is one of life's central goals, her thinking is consistent with Osborne's belief that aesthetic questions should be addressed with the

advancement and progress of humanity in mind and Kaelin's that arts education is a relevant concern of aesthetics proper. In setting out Eaton's theory of art within traditions, I will draw on her arguments in *Basic Issues in Aesthetics* and *Aesthetics and the Good Life* and indicate how her ideas compare with those of Beardsley, Osborne, Goodman, and Kaelin.

In *Basic Issues in Aesthetics,* Eaton organizes her chapters around artist-centered and viewer-centered issues, art and language, aesthetic and artistic objects and their contexts, interpretation and criticism, and aesthetic value.[11] Her disposition is to examine objectively the standard literature bearing on the issues she discusses while at the same time criticizing it constructively. In the chapter that most concerns the topic at hand, Eaton remarks that what was once a "form versus content" debate in aesthetic theory has become, in effect, a "form versus context" debate. She finds this debate fruitful insofar as it points out an important fact—that content and context play important roles in our experience of art. In the course of her discussion Eaton deals with the problem of the status of the work of art (or the nature of its particular reality or being, which is known as the ontological problem of art), the role of history and artistic categories (e.g., symphonic form, Baroque style, sonnet, etc.), institutional theories of art, and movements that go by the names of structuralism and deconstruction. The problem of an artwork's reality or the nature of its being is important because it bears on the distinction between art and nonart and between the aesthetic and nonaesthetic. For example, if, as some theorists claim, the history of a work of art is part of its essence or reality then definitions of art and aesthetic experience must take this fact into account and show how historical elements manifest themselves. For the view that a work of art contains its history as part of its nature conflicts with another influential position holding that the artwork is an autonomous object that should be experienced solely for its intrinsic features (its sensory, formal, and expressive aspects). This is the central assumption of formalist theories of art that, while they performed the important service of drawing percipients' attention to qualities in artworks they might otherwise have missed, have now been found too limiting. Opposing viewpoints that have gained prominence say that if an artwork is to be properly apprehended, perception must go beyond its internal features to external considerations. Most importantly, in Eaton's view, traditions must be taken into account.

To understand Eaton's meaning of traditions and the role they play in our aesthetic experience of works of art, it is necessary to realize that she

associates traditions with what members of a culture or community value or take an interest in. And we can detect what these values and interests are by examining the languages that develop within such communities. Following Wittgenstein, Eaton calls such traditions "forms of life." In *Aesthetics and the Good Life,* she writes that "what we value is intimately enmenshed in the language that we speak. We learn *what* words point to, but at the same time we learn *what is worth* pointing to. What we point to is thus tied to our interests and values."[12] The cultural terms used by critics and others to describe the qualities of artworks—for example, unified, harmonious, expressive, or vivid—do not merely point to objective features of the things described. They also point to qualities valued by members of a certain language community, namely the language community of Western culture. These qualities, moreover, are not just worth *perceiving* but also *reflecting* upon; perception alone does not constitute aesthetic experience. Other communities with their different forms of life might find other things more valuable and worth paying attention to. Traditions are thus both existing and preexisting values and preferences.

The import of Eaton's definition of art within traditions is that it provides a clue to the nature of our aesthetic experiences of art and other things. Aesthetic experience "is identified through historic and cultural traditions as worth attention and contemplation" (106). Eaton's project, then, is to synthesize formalist and contextualist theories of art. Much of the attractiveness of her theory derives from its bringing together things formerly kept separate. At the same time she is concerned to find a way to distinguish, at least in certain respects, art from nonart and aesthetic from nonaesthetic experience. Part of her reason for doing so is to address the difficulties created by movements in contemporary art and critical theory that question the retention of such distinctions.

If external considerations enter into perceiving and reflecting upon works of art, then the obvious question is, How do they do it? Eaton's summary in *Basic Issues* of the ways in which this happens is quite informative. Artworks can be experienced in terms of their ideological and social conditions, in terms of the categories or genre into which they are placed, and in terms of historical, art, and cultural criticism. Again, contextualist theories typically assume that external information constitutes part of the reality of a work, even though such information may not be directly perceptible. But Eaton does not consider all forms of contextualism equally fruitful. Marxist theories suffer from the weaknesses of reductive

explanations and fail to indicate what makes artworks special or what peculiar role they play in the human career. If "formalism calls for a narrow isolation of artworks from their contexts and hence distorts them and our experience of them," then "Marxism identifies artworks with their contexts and hence does not allow us to see what is special about them" (88). On the other hand, placing artworks in certain categories in order to gain a better understanding of them seems uncontroversial, as does the belief that the experience of many artworks would be severely impeded if relevant art-historical knowledge and theories of art and criticism were not made part of the atmosphere in which we identify and discuss them.

The point of all contextualist theories is that our understanding of what art is and how we should experience it must take into account more than its directly perceptible features; it is not enough just to look and see. Other things—social conditions, categories of classification, institutional products, history and criticism of art, and theories of art—come into play more or less explicitly.

Eaton's characterization of art within traditions thus places strategic value on the role of historical knowledge and critical talk about art. This is apparent in her definitions of art, aesthetic experience, and aesthetic value in *Aesthetics and the Good Life.* For example, she holds that "*x* is a work of art if and only if (1) *x* is an artifact, and (2) *x* is discussed in such a way that information about *x* directs the viewer's attention to features that are considered worthy of attending to in aesthetic traditions (history, criticism, theory)." Such a definition, she emphasizes, relies on a conception of aesthetic experience and aesthetic value. For example, "An experience is aesthetic if there is delight taken in an intrinsic feature of an object or event, and that feature is traditionally considered worth attending to, that is, worth perceiving or reflecting upon" (147). As for "aesthetic value," as Eaton puts it in *Basic Issues,* it "is the value a thing or event has due to its capacity to evoke pleasure that is recognized as arising from features in the object traditionally considered worthy of attention and reflection" (143). This means that intrinsic features are those properties—the qualities of medium, form, and content—that historical, critical, and theoretical writings on art have traditionally recommended as worthy of attention. Whatever external information is relevant to understanding, the experience of a work must arise from these features. Eaton's theory then is not simply classificatory, formulated to identify something as art apart from any value it might have as an artwork. Her definition of art and the aesthetic is what is variously called an honorific, value-laden, or persuasive definition.

In Eaton's theory, works that have a greater number of intrinsic features worth attending to also have a greater capacity to induce aesthetic experience; consequently, assuming aesthetic experiences are worth having, some aesthetic experiences will have more value than others. They may be more intense, unified, complex, profound, and so forth. Yet we cannot tell whether a person has had an aesthetic experience or responded aesthetically to something until we discover how that person *treats* a given object. And a characteristic, but not the only, way of treating works of art is to *talk* about them.[13] If a person talks about intrinsic features traditionally considered worthwhile, which is to say if the talk for the most part uses the vocabularies of historical analysis, art criticism, and art theory, then the person's response is aesthetic; if the person talks about something other than traditionally valued intrinsic features, we may infer the person's response was nonaesthetic. It is this kind of attention to and talk about an object that induct a thing that otherwise would not be regarded as art into the world of art where it then achieves art status. Boulders, pieces of driftwood, or ditches may have little or minimal aesthetic value; but if they get treated as art, get talked about in relevant terms, they in effect become works of art.

To collapse, as some would, the distinction between art and nonart and aesthetic and nonaesthetic would of course permit practically anything at all to have art status conferred on it. But Eaton wants to set some limits to the granting of such status. She realized the need for a definition of art that would exclude some things when she saw a jar containing parts of a slaughtered horse exhibited in a museum. But no matter how it is done, calling something art has consequences: it will be recognized as art, revered, discussed, displayed, purchased—in short, treated in special ways. This prompts the sobering thought that if we want to live in a certain kind of society we had better be concerned about the sort of art it encourages its artists to produce. Public support for art and policy decisions are among the topics that can be more fruitfully debated with the help of Eaton's theory.

Is it possible to respond negatively to the intrinsic features of artworks, to experience, as it were, aesthetic pain without nullifying aesthetic experience itself? Eaton thinks so—her example is listening to choirs singing off-key[14]—but in such cases a work will afford less delight. And in instances of excessive pain the possibility of losing control over the experience arises. Aesthetic attention is even more difficult to sustain when the pain is of nonaesthetic origin. I think this is what Beardsley had in mind when in his defense of the idea of aesthetic experience he referred to music

that, according to a rock impresario, was "intended to vaporize the mind by bombing the senses." But, says Beardsley, "when the experience is *largely* [my emphasis] painful, when it consists more in blowing the mind than in revitalizing it [the latter being what Eaton thinks good aesthetic experience does], when it involves no exercise of discrimination and control [values that are also central to Eaton's concept of the aesthetic], we must frankly say that what it provides is not much of an *aesthetic* experience, however intense it may be. And so its goodness, if it has any, cannot be strictly artistic goodness."[15] We may say the same thing about works of art that feature inherently objectionable images. Such works may have some value, but since it is usually not aesthetic, they have little or no capacity to occasion aesthetic experience. On the other hand, when an artwork's intrinsic features induce a positive response, the tendency is to award it high praise. To be sure, leaving the determination of aesthetic merit to percipients' reactions may seem too subjective, but Eaton says it is an empirical fact that, in our culture at least, people respond favorably to certain features of things and not to others. Debates about the character of artworks and their intrinsic properties are thus also debates about what our culture is willing to accept as positive and negative features, which explains why we have disputes about the effects of obscenity and pornography. Our culture tends to question the art status of a work that displays a disproportion among medium, form, and content—as happens in pornography and propaganda where the scales are tipped toward either objectionable or ideological content. When a society begins to accept features of artworks that it previously disapproved of, then one can infer a sea change has occurred in cultural values.

If we compare Eaton's definition of art and her characterization of aesthetic experience with the theories of Beardsley, Osborne, Goodman, and Kaelin, we find that they share several features. But Eaton's approach is distinctive in not locating the aesthetic exclusively in a psychological state of gratification (Beardsley), the energizing of percipience (Osborne), understanding (Goodman), or aesthetic communication (Kaelin). True, she accepts the subjectivity of aesthetic experience as a fact and acknowledges the important role feelings play in aesthetic experience; the delight taken in art obviously has an affective component. Her theory also accommodates at least some of Beardsley's criteria of aesthetic experience; for example, object directedness, which presupposes some object or presence to which response is made and which encompasses the perception of intrinsic features

that are working or have worked themselves out in fitting and appropriate ways; detached affect, which permits one to remain in control of an aesthetic situation, an important point in Eaton's theory; and active discovery, which derives from both perception of and reflection about intrinsic features. Osborne's assertion that mental processes are unusually activated, heightened, and amplified by aesthetic experience is also compatible with Eaton's theory—the greater the number of a work's worthwhile intrinsic features the greater the intensity of the percipience it evokes and the greater its aesthetic value. And her theory, I think, accommodates as well Goodman's interpretation of the function of art as the provision of understanding and Kaelin's emphasis on aesthetic communication. (Goodman's notion of understanding, for example, which involves seeing a work in terms of the world and the world in terms of a work, may also be likened to Beardsley's active discovery.) When Kaelin explains the experience of Picasso's *Guernica* as the mind's scanning the surface and depth counters of the painting (Eaton's intrinsic features worth experiencing) and receiving from them an idea of the work's import (in this case, another instance of man's inhumanity to man), he is in effect agreeing with Eaton that experience consists of both perception and reflection.

Eaton differs from the theorists discussed in this section when she locates the aesthetic in the special ways we treat works of art; we preserve and exhibit them, support their creation and performance, but most of all we take delight in them and, with some notable exceptions, talk about them in special ways. If I understand Eaton correctly, she says that if we discuss the intrinsically worthwhile features of artworks (recalling what she means by intrinsically worthwhile features) in a vocabulary (including such terms as form, medium, and content) traditionally used by art historians, art critics, and art theorists, then we enable inferences to be made regarding whether a response has in fact been aesthetic and whether it has been positive or negative. It thus becomes possible to decide whether a person has had an aesthetic experience and whether it was favorable or unfavorable. As she says in *Aesthetics and the Good Life*, her "characterization of the aesthetic does provide a method for investigating and verifying aesthetic value. It should thus be of help to people engaged in solving practical aesthetic problems"(150). That is, it should be of use to teachers of art and those engaged in research.[16]

Eaton does not claim originality for her theory—for example, it fits comfortably with the general notion that a work of art is usefully regarded

as an artifact that has the capacity to induce a high degree of aesthetic experience—but I think it is original in several ways. One is her synthesis of formalist and contextualist theories; another is her ability to take account of developments in art since midcentury without avoiding the question of aesthetic value. She also counters some current trends by favoring the retention of important distinctions. Finally, Eaton provides insights into the relations of aesthetic and ethical values; her characterization of the rational and moral life enables her to construct a basis for rational judgments of artistic and aesthetic value. An aesthetic theory that could not do these things would, I believe, have limited use for educational purposes.

I have discussed Eaton's theory at greater length because I think it recommends itself to educators in need of a rational justification of art education that combines the best of traditional theories while incorporating relevant aspects of contemporary thinking. (I hope my endorsement of Eaton's contextualism will put an end to the mistaken identification of my own position with formalism, or with modernism insofar as it implies a commitment to formalism.) I refer once more to Osborne's admonition that philosophers should address aesthetic questions with the advancement and progress of humanity in mind. I believe it is heeded not only by Osborne himself but also by Beardsley, Goodman, Kaelin, and Eaton, each of whom can be interpreted as supplying material for a justification of art education. Consider some of the ways.

Beardsley contributes to the achievement of humanistic objectives and to a solution of the justification problem by telling us how to distinguish superior from flawed works. His criteria of aesthetic experience help us to discern those works that have the capacity to vitalize rather than anesthetize the mind.

Osborne's contribution consists in his description of the quality of percipience excellent art is capable of engendering in contrast to the impoverished experience afforded by amusement art. Also helpful are his discriminations among styles of vanguard art and the reasons he gives for preferring those that present significant new ways of viewing reality. The art of Monet, Cézanne, Matisse, and Picasso, he believes, is far more likely to endure than the work of latter-day conceptual artists.

Goodman's case for art's cognitive character has the effect of diminishing the distance between the two cultures of scientific and artistic understanding. This helps to establish the seriousness of aesthetic studies in a way that should make justifying art education less difficult. In art (as

in science), writes Goodman in *Languages of Art,* "the drive is curiosity and the end enlightenment;" the primary purpose "is cognition in and for itself; the practicality, pleasure, compulsion, and communicative utility all depend on this" (258).

Kaelin contributes to humanistic objectives and the progress of humanity by stressing the important role that art plays in establishing aesthetic communication among a free people. Artistic and aesthetic encounters exemplify the human values of openness, relevance, autonomy, and freedom that are all vital to the efficacious functioning of the institution of art. Only a highly educated and aesthetically literate society can ensure that conditions of aesthetic freedom and communication will prevail and not be controlled by nonaesthetic considerations.

Eaton contributes to our understanding of the special role that art plays in the human career by indicating how aesthetic experiences are an important part of a rational and moral life. Her analysis of the relations of aesthetic and ethical judgments is especially helpful because it shows how to distinguish better from poorer art and aesthetic from nonaesthetic experience.

One result of the foregoing discussion of aesthetic encounters as worthwhile experiences is the realization that there is no need for a theory of art education to decide whether engagements with works of art can be considered a form of knowledge (which is different from asking whether knowledge is needed properly to perceive works of art or whether perception itself is cognitive). It is sufficient for art-educational theory and justification to recognize that in addition to providing occasions for aesthetic gratification and delight, stimulating perception and reflection, and intensifying expression, art also creates new perspectives on the world and self that count as humanistic understanding. In comparing the accounts of aesthetic experience by the five theorists examined here, I found little disagreement among them regarding the important benefits to be derived from contemplating works of art: works of art at their best afford a fresh outlook on the world that enables us to see the familiar in an unfamiliar light and to perceive unsuspected connections among things that help us organize and reorganize our experience. Their individual philosophical orientations, methodological assumptions, and categories of description and explanation notwithstanding, all of the writers concur on art's capacity for enrichment and renewal.

One should, of course, distinguish between the proximate and prospective values realized through encounters with art. Proximate values

are the immediately felt and reflected-on qualities available in aesthetic experience as it unfolds. Prospective values are objectives served or desirable traits strengthened as a result of aesthetic experience, for example, percipience, imagination, and sympathetic understanding in general. A task for art education research is to achieve a better understanding of the connections between proximate and prospective benefits. Establishing a firm linkage among different kinds of values is, however, not crucial to a justification of art education. One can argue convincingly that aesthetic experience is a special form of human awareness that serves individuals in ways other forms of awareness do not and that it accordingly contributes to the actualization of worthwhile human potential. A life devoid of activated aesthetic capacity is only partly fulfilled, and societies and their educational systems are seriously deficient if they permit the young to pass through schooling without helping them to realize a significant part of their humanity.

In response to those who favor teaching the social and political uses of art, it may be pointed out that cultivating the disposition to have aesthetic experiences can produce a positive effect on the melioration of social problems. Persons with educated aesthetic proclivities are less likely to tolerate assaults on human sensibility and the environment and more inclined to strive for a higher level of culture and quality of life. I am less confident that art education can address social problems *directly*. What is more, I am persuaded that any single-minded concern with the politicization of art and art education would have serious consequences. I recall the words of the American historian Richard Hofstadter in whose *Anti-intellectualism in American Life* we read that "if there is anything more dangerous to the life of mind than having no independent commitment to ideas, it is having an excess of commitment to some special and constricting idea." The intellectual function, he said, and I add the pursuit of political interests, "can be overwhelmed by an excess of piety expended within too contracted a frame of reference."[17] Partly for this reason I have attempted to accommodate not one but several perspectives on the nature of art and aesthetic experience. I accept the important truth in Morris Weitz's influential "The Role of Theory in Aesthetics"; he said that it behooves us to entertain a range of aesthetic theories because "their debates over the reasons for excellence in art converge on the perennial problem of what makes a work of art good."[18] I understand the theories of Beardsley, Osborne, Goodman, Kaelin, and Eaton in this spirit, as contributions to the critical dialogue about excellence in art and art education.

75

5

The Marks of Excellence

There were, and perhaps still are, people who used to maintain that the word masterpiece was merely the expression of a personal opinion deriving from whim and fashion. This belief seems to me to undermine the whole fabric of human greatness. In four thousand years human beings have committed many follies. Cruelty and intolerance fill the pages of history books and often, as we read about the past—and, for that matter, the present—we are aghast, and feel like withdrawing, as men did for almost four centuries, into some form of life where isolation is achieved by painful discipline. But just when we are beginning to despair of the human race we remember Vézelay or Chartres, Raphael's *School of Athens* or Titian's *Sacred and Profane Love,* and once more we are proud of our equivocal humanity. Our confidence has been saved by the existence of masterpieces, and by the extraordinary fact that they can speak to us, as they have spoken to our ancestors for centuries.

Kenneth Clark

Michelangelo and Raphael, Rubens and Rembrandt, Van Gogh and Cézanne are not only objects of art-historical study or investments or status symbols for collectors. They are centers of attraction and repulsion to be loved, admired, criticized ,or rejected, living forces with which we get involved. They are culture heroes, Gods of our secular Pantheon, beneficent or baleful, serene or capricious, but like Gods they must be approached with respect and humility for

they can light up for us whole areas of the mind which would have been dark without them.

E. H. Gombrich

Great art gives us an interpretation of life which enables us to cope more successfully with the chaotic state of things and to wring from life a better, that is, a more convincing and more relevant meaning.

Arnold Hauser

The words of these distinguished scholars have special import today when the problems of modern society weigh heavily on people's minds. It may seem that this is not the time to speak of aesthetic experience and the appreciation of artistic excellence. But, as Monroe C. Beardsley remarked in his presidential address to the American Society for Aesthetics, if we postpone such discussion we will have conceded that the struggle for civilization is unimportant, and such a decision would make it much more difficult for later generations to carry on the debate. "It is not," he wrote, "as though we were shutting our eyes to reality by resolving to continue our aesthetic dialogue, but rather that we refuse to let certain important things be lost sight of."[1] Accordingly, this chapter continues the discussion of aesthetic experience initiated in the preceding chapter by concentrating on those marks of excellence that lend works of art the potential to provide occasions for aesthetic experience. Before continuing, I restate my belief that the general goal of art education is the development of a disposition to appreciate excellence in art, where the excellence of art implies two things: the capacity of works of art at their best to intensify and enlarge the scope of human awareness through aesthetic experience and the features of artworks in which such a capacity resides. What now are the marks of excellence in art?

Books about art often reproduce a range of visual objects capable of arousing and stimulating human response: not only paintings, sculptures, graphic art, photographs, and frames from films but also works of architecture, objects of craft and industrial design, quilts, posters, advertisements, and cartoons. Excellence has been achieved in all of these forms of visual art. But obviously not everything can be studied in a program of art education. While examples of different kinds of art should be shown and discussed in the course of attempting to develop a sense of art in the young, the concern in an excellence curriculum is ultimately with examples of

artistic excellence enshrined in traditional and modern art. I will let one instance stand for many. It would be inappropriate to discuss in the same terms run-of-the-mill mortuary art and Michelangelo's justly renowned sculptures in the New Sacristy in S. Lorenzo in Florence. That Michelangelo's works have far greater capacity to occasion rewarding aesthetic experience is beyond reasonable doubt. And the reasons are readily apparent: Michelangelo's sculptures stand out in virtue not only of their powerful presence, technical brilliance, formal complexity, and symbolic expression, but also of their profound sense of humanity, all features that compel and sustain response. Accordingly, the seated figures of Giuliano and Lorenzo de' Medici and the reclining allegorical figures of Dawn, Day, Dusk, and Night are superior examples of artistic excellence.

Moreover, in talking about appreciating excellence in art I have in mind the excellence not just of Western artworks but of the art of non-Western civilizations and cultures as well. The task of including the latter is being made easier as histories of art increasingly become world histories of art. Typically, the great artistic achievements of any tradition, not only set standards for subsequent artistic production; they also provide challenges to artists attempting to forge new aesthetic values. Certain features distinctive of great art—for instance, unified variety—have exerted influence beyond the world of art as a number of writers have taken the artwork as a model for thinking about life itself. When John Dewey wanted to dramatize his vision of unified experience—that is, experience with minimal disjunction between means and ends—he turned to works of fine art. Indeed, a significant tradition of modern philosophical thought dating from Friedrich Schiller's *On the Aesthetic Education of Man* and running through Herbert Read's *The Redemption of the Robot* to Dewey's *Art as Experience* speaks persuasively of the possibility of human existence approximating the forms and qualities of art.[2] Admittedly there are those who look askance at the suggestion that masterworks should occupy a strategic position in art education and who would instead favor making creative activities the heart of aesthetic learning. But such activities are neither sufficient for developing a comprehensive sense of art nor conducive to appreciating artistic greatness. Certainly at the secondary level there should be no serious problems in acquainting adolescents with exemplary artistic achievement, but even during the earlier years something can be done in this direction, as many have discovered who have attempted to expose very young students to outstanding works of art.

My own experience satisfied me on this point. Some years ago I worked with a group of fourth- and fifth-graders over a two-month period during which I showed works of art that conventional wisdom would judge to be of little or no interest to children of that age. My purpose was twofold: to encourage these young people to discover something about a work's subject, form, and expressiveness and the interanimation among these features, and to see if they could achieve such perceptions with traditional as well as modern works of art—for example, not only with twentieth-century abstract art but also fifteenth- and sixteenth-century Renaissance painting. These 9 and 10 year-olds, far from finding Renaissance works remote from their interests, saw them as full of action, spectacle, color, and adventure. Show interpretations of St. George and the Dragon, say, by Uccello, Raphael, and Tintoretto, and young minds will respond. The children even recognized some of their own moods expressed in portraits of young people painted by Renaissance artists. In short, neither the sensory and formal qualities nor the expressive content of much traditional art is necessarily lost on the young. Of course, younger students are capable of only a rudimentary and not a mature appreciation of art; but works only partly appreciated at one time can be re-encountered and experienced more discerningly later on if the curriculum has a spiral organization. Indeed, I think that until the field of art education makes the appreciation and understanding of mature, serious art its primary goal, it will have difficulty justifying itself and securing the public support it needs. I further believe that this goal will meet with favor in the schools and will be accepted by the public as well.

To repeat, the excellence of art is here understood as both art's capacity to have positive effects on human experience and the properties that give rise to this capacity. It must be conceded that historically the worthwhileness of an artwork has usually been defined by the particular purpose the work was meant to serve. Since prehistoric times art has performed a plethora of functions that have been studied and documented by investigators with diverse interests. Historians trace the evolution of art, interpret its meaning, and classify works into period styles. Philosophers speculate on the import of art in the life of man, attempt to grasp its essence, and try to clarify its basic concepts. Sociologists study the interactions of art and society. Psychologists probe the dynamics of artistic creation and appreciation. The reasons for the existence of art and for studying it are legion, and theories of art have

accumulated to such an extent that we are now beginning to get theories of theories.[3] The point is that the complexity of art and the large number of its functions caution against facile generalization. Indeed, there is truth in Arnold Hauser's remark that just about anything that can be said about art in one context can be contradicted in another. Art may be at once form and content, an affirmation and a deception, a form of play and revelation, purposeless and purposeful, personal and interpersonal, and so forth. Counter examples keep defeating the theorist who would make generalizations about Art with a capital A.[4] Yet despite this profusion and confusion, a body of literature can be singled out that insightfully and helpfully addresses the question of the marks of excellence and that it would therefore be to the advantage of teachers of art and trainers of teachers to ponder. This literature discusses excellence in art in terms of both formal qualities and human values.

With the intention of discovering to what extent the criteria of excellence in past and present art have substantial objective referents, Jakob Rosenberg in his *On Quality in Art* compares a number of master drawings and prints by major and minor artists from the fifteenth to the twentieth century—from Martin Schongauer and Leonardo and their schools to Picasso and Kandinsky and their lesser contemporaries.[5] Rosenberg limits his study to drawings and prints because qualitative differences are easier to detect and reproduce in these art forms, but he thinks that with appropriate qualifications the same qualities can be found in painting, sculpture, and the decorative arts. Rosenberg analyzes examples of both representational and nonrepresentational art.

What are his conclusions? It comes as no surprise when Rosenberg says that qualities of formal organization and expressiveness are highly important in both representational and nonrepresentational works of art. Both kinds of art reveal sensitivity, articulateness, consistency, selectiveness, vitality, a range of accents, richness of formal relationships, intensity, expressiveness, a sense of balance, and a feeling for the medium. Even though nonrepresentational works lack subject matter, they nonetheless manifest such important qualities as inventiveness, originality, suggestiveness, economy, and gradation and integration of design. Qualities like these, says Rosenberg, constitute the artistic value or degree of excellence of particular works—a judgment that, far from being an expression of personal opinion, in fact reflects the consensus of aesthetically intelligent observers.

Two examples from the seventeenth and twentieth centuries convey the flavor of Rosenberg's method. Commenting on a drawing by Rembrandt titled *Lamentation* and a copy of it attributed to Rembrandt (until the original was discovered), Rosenberg writes that the pen-over-pencil copy is a meager skeleton of Rembrandt's pen-and-wash sketch. Among the qualities of the superior Rembrandt drawing is "enormous richness," which was achieved mainly through the variation of tonal accents and their interrelationships. Such accents and relations contribute not only to the clear suggestion of forms in space and their envelopment by light and air but also to the sensitive expressiveness of the figures' faces, glances, and gestures. Rosenberg describes the passage around Christ's left hand held by St. John as intricate yet clear, while characterizing the comparable passage in the copy, which lacks fine gradations of line and tone, as empty. Similar contrasts of degrees of richness are found in other passages of the original and the copy that bear on each work's greater or lesser articulateness, subtlety, and expressiveness (185-86).

Moving to the twentieth century, Rosenberg compares two abstract prints, one by Picasso and another by Albert Gleizes. He points out that the Picasso has an animated and coherent pattern in which controlled repetition and variety and contrast of colors and shapes "are combined with a high degree of integration and gradation and a well-balanced distribution of attraction" around a central form. "Light and dark, cool and warm colors, striped and punctuated patterns are not merely poured out and loosely combined, but are selected with high economy and expressively related within a tightly organized design" (224). Though the Picasso may appear simple, it achieves intensity of expression and a telling character through its complex formal relationships. The slightest change in the composition would disturb its overall balance. In contrast, a similar work by Gleizes is a mere aggregate of colors and shapes, "a jumble of details that lack any strong organization or clear articulation of accents." Its monotonous quality is produced by dull repetitions of vertical movements and the closeness of colors. Nowhere apparent are the "striking yet graded contrasts of the Picasso, its clear-cut quality, the more expressive variety of its shapes, and its vigorous economy" (225). These are but two comparisons among many made by Rosenberg that merit reading for their instructive value.

In "Quality in Painting," Sherman E. Lee, a noted historian of Asian art and erstwhile director of the Cleveland Museum of Art, writes that as a result of recent scholarship in several disciplines we "have arrived, if

belatedly, at a position where one can dismiss as irrelevant any discussion of the relative excellence of say, Michelangelo and Cézanne, of sculpture and painting, of Chinese or Greek Art."[6] Lee does not assert the impossibility of objective judgments of artistic excellence; but he holds that excellence should be determined through comparisons of works within kind. (Yet even this is not easy; Lee makes an important point when he says that certain kinds of qualitative judgments are grounded more in prior value commitments and personal preference than in objective analysis.) Earlier I mentioned that there is no question of the superiority of Michelangelo's sculptures for the tombs of the Medici Chapel over run-of-the-mill mortuary sculpture. I now add that one need only compare Michelangelo's *Tomb of Guiliano de' Medici* and Antonio Rosselino's *Tomb of Leonardi Bruni* in S. Croce, also in Florence, to see the difference of quality within kind. Since one respondent to the original version of *Excellence II* chided me for having introduced the language of excellence in kind without following up on it, I take this opportunity to do so here by referring to some of Lee's illuminating examples.

Among groups of works of comparable kind and intent, Lee prefers the finest examples of Greek vase painting over similar neoclassical works of the late eighteenth and early nineteenth centuries, Renaissance painters (for example, Raphael) over their early nineteenth-century imitators, the Nazarenes; Ming Chinese porcelain over the porcelain works of Renaissance Florence; and a Ma Yuan scroll painting over another probably painted a hundred years later. As for works produced in the same period, he ranks an illuminated manuscript by a sixteenth-century Persian master higher than one by an artisan from the same workshop and selects Rubens's *The Artist and His Wife* over van Moor's *Burgomaster of Leyden and His Wife*, Rembrandt's *Jewish Bride* over Aaert de Gelder's painting of the same subject, Rembrandt's *Three Trees* over a copy by James Bretherton, and a Mondrian over a Fritz Glarner. What is apparent from these comparisons is that comparison of excellence within kind is not limited to work done by artists from the same century or period.

Many of the qualities discussed by Lee are discernible only to the connoisseur's eye and tend to be found in a work's details and nuances. "Nuances," says Lee, "often are literally the differences between night and day, the victor and the also ran" (195). But not just the nuances and details in themselves are important; so are the ways in which they cooperate in the

fusion of paint, design, subject, and meaning—a collaboration that, according to Lee, is preeminently evident in the works of a painter like Giorgione. The more complex the painting, the easier it is to detect nuances. They are more difficult to locate in works like those by Mondrian and Fritz Glarner, which are produced on the principle of "less is more." Even though both these artists valued precision, logic, and meticulous taste, Mondrian's best works reveal a "rigorous consistency," "subtlety," a sense of "pure presence," and a "completeness" that the Glarner work lacks. Lee thinks this is partly due to Glarner's inscribing rigid geometrical forms within a circle, in contrast to Mondrian's use of rectangles. Glarner's work thus has an unfortunate quixotic character. Also consider now Lee's comparison of two Chinese scroll paintings and Rembrandt's *The Three Trees* with a copy of it. Lee writes about a Ma Yuan painting titled *Spring* (from the Sung Dynasty of the thirteenth century) and one done a century later titled *The Lonely Traveler,* in the style of Ma Yuan:

> Observe only what the Chinese consider the highest criterion for judgment, brushwork. Almost any single stroke in the Ma Yuan has a suppleness, a beginning, middle and ending, a varied life of its own; almost any single stroke in the other seems an extrusion from a tube, endless, seamless, characterless. The mechanical and repetitive "axe"-shading of the rock of the very right edge of *The Lonely Traveler* should be compared with the "axe" strokes of the fold in the rock of the lower left of the Ma Yuan. Or simply, by western standards now, feel your way with the stream and then try to move with the zigzag path in the smaller painting. Is there really any question that higher quality resides in the scroll by Ma Yuan? (193)

And on Rembrandt's *The Three Trees* and a copy by Bretherton:

> The overall quality of a work of art—its emotional or visual tone, whether harmonic or dissonant—is just as decisive a factor in judgment as are the most minute nuances. Bretherton's direct copy, even forgery, of Rembrandt's most famous landscape etching, *The Three Trees,* can be painstakingly proved to be different from the original. One needs only patience and the ability to count the strokes and calculate the directions of the etcher's needle. But the closer one looks at details, without going back to their relationships to the whole, the more one is amazed at the stroke-by-stroke veracity of Bretherton's almost psychopathic adherence to the

original. It is in the general effect, the bloom of the work, that the qualitative differences are most revealing. The billowing thunderhead cloud at the left becomes a papery puzzle in the copy; the flatlands, so flat and yet well placed in space by shadowy light, are slightly more tilted in Bretherton's page and are starkly lit, destroying one's belief in their flatness and recession. What is feathery foliage becomes lumpy. What is mysterious and evocative in one becomes inky and descriptive in the other (202).

The qualities of formal organization and expressiveness are major determinants of artistic excellence, but they are not the whole story, as Kenneth Clark points out in his essay *What Is a Masterpiece?*[7] Clark discusses several works ranging from Giotto's *Lamentation over the Dead Christ,* Raphael's *School of Athens,* and Rubens's *Descent from the Cross* to Rembrandt's *Night Watch,* Courbet's *Funeral at Ornans,* and Picasso's *Guernica.* What do works like these have in common? Why do they continue to claim our attention? Each masterpiece, says Clark, answers these questions in its own way, but certain features of excellence recur.

Masterpieces of art are great exemplars of artistic value because they fill the imagination and express a profound sense of human values. They make no concessions to mere visual appeal and reveal the supremacy of the artist in their masterly design and finality of form. Most importantly, masterpieces disclose the ways in which artists have reworked traditional ideas and forms in order to make them expressive both of themselves and of the times in which they lived while retaining a significant link with the past.

Masterpieces fill the imagination in part because of their complexity and expressive intensity, the latter being further magnified when there is an important story to tell. If the story is tragic then the work is likely to move us even more deeply. This is not to deny the existence of numerous masterpieces that celebrate the joys of life; it is simply to say that the achievement of excellence of the highest order usually presupposes a profound commitment to human values and an effort to understand the human condition.

In terms reminiscent of the ones used by Rosenberg and Lee, Clark finds the excellence of masterpieces in their inspired virtuosity, supreme compositional power, intensity of feeling, masterful design, uncompromising artistic integrity (even down to the smallest details), imaginative power, originality of vision, and, once more, in their profound sense of human values. Of all the major characteristics of masterpieces Clark speaks of two as especially noteworthy: "a confluence of memories and emotions forming

a single idea, and a power of recreating traditional forms so that they become expressive of the artist's own epoch and yet keep a relationship with the past" (10-11).

Are there masterpieces of modern art? Or are we too close to our own time to have made any definitive judgments? It depends in part on what the term "modern art" means and the period during which one thinks modern movements occurred. For example, there is now the notion of "postmodernism" to contend with, which suggests that modernism has run its course. However convinced one may be that high degrees of excellence have been achieved in the art of the last 150 years, one enters the postmodern terrain with less assurance. Certainly the case of "the modern masters"— say, from Manet through Picasso—presents no problems. We recall Cézanne's successful effort to find a vision genuinely his own that combined the palette of the Impressionists and the seventeenth-century French painter Poussin's sense of form. And while, as Rosenberg pointed out and Clark emphasized, traditional masterpieces typically tell great stories, Meyer Schapiro has persuaded us that Cézanne managed to invest still lifes and landscapes with the same high seriousness that the old masters accorded classical and biblical themes.[8] In the case then of Cézanne the major characteristics of masterpieces are present. And the same can be said of Picasso. Not only the *Guernica* but also his interpretations of Velázquez and Delacroix reveal Picasso's ability to rework tradition in a contemporary idiom that expressed himself and his era.

Yet there are works that reject traditional criteria of artistic excellence, repudiate qualities of formal organization, articulateness, sublimity of expression, and, at a certain point, artifactuality itself. Surely we are on radically different ground or watching a different plot unfold when we witness artists resorting to what seems like mere vandalism, shock, and destruction—all ploys of the avant-garde. When this happens we are in need of reliable guides; let it be Harold Rosenberg, who was one of the major art critics of the mid-twentieth century.[9]

According to Rosenberg, the avant-garde—and he is now talking about Impressionism, Post-Impressionism, and Cubism, as well as Surrealism, Dada, Pop, Op, and their variants—had above all the quality of *freshness,* which it achieved in numerous ways. Scorning noble and historic subject matter and the kinds of compositions that used to contain it, Impressionism, to take but one example, sought to capture the transitory qualities of light and atmosphere of scenes from ordinary life. In the case

of Surrealism, Dada, and Futurism, however, the avant-garde searched practically everywhere for ideas and suggestions—the past, the present, psychoanalysis, radical politics, the mysteries of science. Committed to brandishing the new, it startled and shocked with dark and somber foreshadowings of things to come and was often savage, ruthless, and violent. With a penchant for destructive acts against established artistic conventions and revered customs, it delighted especially in offending the middle class. This sort of vandalism was perpetuated by subsequent avant-gardes; for example, if traditional picture making prized permanence, spatial illusion, and artifactuality, latter-day vanguardists created self-destructing objects and works that banished illusion and the conventions on which it depends. Art could now be merely an idea or intention in the artist's mind, however boring or absurd. Indeed, a "work" could consist of nothing more than an artist's notarized statement to the effect that he had withdrawn all aesthetic quality from one of his own creations. The desired offensiveness could further be achieved by exhibiting people literally in the flesh, and in happenings and live theater nakedness and bizarre eroticism became common fare. Even self-mutilation was being asserted as an artistic act. An inversion of order or no order at all became the order of the day, reductionism and radicalism key gambits, and the banal something of a banner.

A program of constant change and shock could not, however, maintain its effectiveness. Efforts at aesthetic freshening and renewal soon succumbed to the imperatives of fashion. This meant that a work's acceptance often depended more on aggressive marketing techniques than on any inherent aesthetic value it might have. Vanguardism died when it became institutionalized in the museums and history books where it has ceased to be a dynamic force for change and was transformed into the thing it had rebelled against—an object for contemplation and study.

Rosenberg is helpful in teaching us to perceive the freshness of early avant-garde art. He describes the extent to which it served modern art well through its appropriations and transformations of the past and present. Yet he failed to distinguish between two rather separate tendencies of modernism.

In *The Age of the Avant-Garde,* Hilton Kramer points out that one arm of the avant-garde showed a greater appreciation of past artistic accomplishment and felt, however unconsciously, an obligation to work through artistic traditions in order to express new aesthetic values.[10] Picasso and Matisse were two artists whose works revealed the continuity

of culture and the renewal of its deepest impulses—a characteristic we already had occasion to identify as distinctive of the creators of masterpieces in any age. Marcel Duchamp represents the second arm of the avant-garde whose radically rejecting gestures toward the conventional idea of art culminated in acts of anti-art. Kramer thinks the radical arm of the avant-garde, which stresses constant change and revolt and is often politically motivated, has received inordinate attention. He believes that as we gain distance from the heyday of the avant-garde and as its shock waves subside, we are beginning to realize that it is the more traditional (he calls it progressive) and not the revolutionary strand that constitutes the major plot of modernism. Vanguard revolutionary art did more than repudiate tradition. Because of its flashiness and determination to steal the show, it was also able to convert a large following to its program. This had the effect of deflecting attention away from countless works that had formerly been regarded as artistic treasures. In Kramer's view, the rediscovery of such works has therefore become a major task of criticism (19). If Kramer is correct in saying that the more traditional tendency of modernism represents its best and most valuable contribution, then, with appropriate qualifications, many of the traditional criteria of artistic excellence are still relevant, and there is no need in our discussions of contemporary art to make significant exceptions to our observations about the nature of excellence.

But what about the new art form of film? Must we not modify our notions of artistic excellence in assessing the quality of this twentieth-century medium? Perhaps. On the one hand, a number of writers stress that even films that aspire to high seriousness and artistic quality are limited in the degree of excellence they can achieve. This, they say, is attributable to the very nature of the film culture and the imperatives under which it operates—movies must make money—and some have claimed that the most that can be accomplished in films are fine failures.[11] On the other hand, Stanley Kauffmann—though cautioning that the term "classic" must be considerably hedged about when applied to films, not only because of the insufficient lapse of time needed for reliable judgment but because of the inherent dynamics, cultural context, and economics of movie making[12]— believes that in principle the art of film is no less capable of attaining excellence than any other art form. Nor does he think films should be subjected to any but the highest standards, which alone make the notion of a fine failure intelligible.

We find that the criteria of excellence Kauffmann discusses are similar to those used in judging more traditional forms of art: films are good or excellent because of their inventiveness, imaginative energy, dramatic content, technical competence, and,more germane to the medium, dialogue, and characterization, capacity to transform literary into cinematic values, psychological complexity, and spiritual power. Since the medium of film is largely photographed reality and inherently suited to dramatizing and symbolizing human experience, the ultimate criterion of judgment for Kauffmann is moral. Kauffmann seems to expect no less from film than what Lionel Trilling expected from literature: a knowledge of the self and of the right relations of the self to others and to culture. "To the degree," writes Kauffmann, "that a film clarifies or exposes a viewer to himself, in experience of the world or of fantasy, in options of action or of privacy, to the degree that he can thus accept a film as worthy of himself or better than himself, to that degree a film is necessary to him; and it is that necessity that sets its value" (378).

If Kauffmann underlines moral criteria it is not because he thinks aesthetic standards are irrelevant, for *how*,that is, the artistic means by which a work invites us to think about ourselves, is extremely important. Any number of films convey the message that the use of violence implies concomitant responsibilities, but only a truly fine film, as Martin Dworkin has pointed out, will fix this fact vividly in our imaginations.[13] And it is the aesthetic properties of films that do it for us. As Kauffmann further emphasizes, good films possess a quality that we came upon in our discussion of masterpieces—the reworking of tradition in a contemporary idiom. In terms that recall Clark's, Kauffmann writes that Antonioni used his immense talent in his *L'Avventura* "to make the film respond formally and morally to our changing times, yet without forsaking what is still viable in the tradition" (387). The same can be said of many other outstanding films. Owing to the medium's relative youthfulness as an art form, it is also typical that critics may pay attention not only to a film's moral cogency but also to the ways it reveals new potentialities of the art form—when, for example, editing and color or special effects are used in novel and dramatically successful ways.[14] In "Basic Film Aesthetics" Francis Sparshott writes that a film's failure to exploit imaginatively the potentialities of the medium is in fact a good reason for lowering one's estimate of the film.[15] But film enjoys no critical dispensation. If it is to achieve excellence, says Kauffmann, it cannot be immune to what he calls summit judgments.

So far we have been discussing primarily Western works of art, with a brief reference to the artistic excellence of Eastern art. We have been doing so, moreover, in the language of Western aesthetic theory and criticism. But does the discussion of artistic excellence in Western terms make any sense in the case of primitive art; of the art of traditional West African, Oceania, and pre-Columbian Meso-American art; as well as other non-Western cultures, past and present? This is a question H. Gene Blocker asks in his *The Aesthetics of Primitive Art,* which is the first serious philosophical analysis of such art.[16] The question is an important one; for it is clear, says Blocker, that at least until modern times primitive cultures did not have, and some still do not have, such concepts as art, work of art, aesthetic experience, artistic excellence, and so forth. These concepts are lacking because of the highly interdependent nature of cultural functions in primitive societies in which all aspects of life are intricately interlocked rather than fragmented, as they are in nonprimitive cultures.

There is not space here to summarize Blocker's extremely interesting book. But he answers the questions whether primitive art is *primitive,* which is to ask whether it has defining features, and whether primitive art is *art,* which is to ask whether it submits to judgments of artistic excellence, in the affirmative, with appropriate qualifications. He does not, of course, endorse any of the negative connotations of the words "primitive" or "primitive art" but says that no other terms are as useful for his purposes. On the basis of recent scholarship and his own extensive knowledge of primitive cultures and their arts, Blocker concludes that there is enough similarity between Western concepts of art—for example, the notions of aesthetic consciousness and artistic excellence and the attitudes of members of primitive cultures toward their art—to warrant saying that the stylistic features of primitive art in general "provide the potential for a unique sort of artistic excellence." The best works of primitive art have "a directness, a presence, a monumentality expressive of continuity and stability, a contained spiritual presence or power, whether firmly contained in a cool aloofness or barely contained in a fierce aggressiveness, and resulting in a quality ranging from arresting to terrifying."

Speaking more specifically of two traditional wood carvings from West Africa, one in the Mende tradition and the other in Oyo Yoruba tradition, Blocker says of the former that it has "a spiritual quality of calm, serene, dignified, aloof, timeless eternity" which is a function of the figure's half-closed eyes and mouth and "the tense, generally forward-leaning body,

alert, poised, legs bent, in a rhythmic interplay of planes, lines and surface texture." In the Yoruba work Blocker points out its "calmly restrained dignity" and "cool spiritual power contained and controlled in a formally beautifully executed piece." In short, the carving has "a wonderful balance of sharply articulated bodily parts and subtle indications of other bodily parts" (314-15). Qualities like these would not be present, says Blocker, were it not for the existence of aesthetic consciousness, for often such qualities are redundant to the piece's efficacy in a ceremonial function. Blocker also points out that within primitive societies it is often the more skillfully crafted and expressive works of primitive art that are preferred. It is possible, in other words, to detect degrees of artistic excellence and to discuss innovations and creativity within a tradition of primitive art.

The discussion of this section should leave little doubt about the meaning of excellence in art. Each writer—Jakob Rosenberg, Sherman E. Lee, Kenneth Clark, Harold Rosenberg, Hilton Kramer, Stanley Kauffmann, and H. Gene Blocker—contributes to our understanding of artistic excellence. Indeed, apart from viewing works of art themselves there is no better way to renew one's faith in the powers and delights of art than to read what perceptive writers have to say about art's special qualities. What we have learned is what many theorists have discovered in their efforts to clarify the nature of the critical evaluation of art: judgments of art tend to feature cognitive, moral, and aesthetic reasons. Rosenberg's and Lee's criteria are mainly aesthetic, Clark's aesthetic and cognitive, Kauffmann's moral, and Blocker's formal, technical, and expressive. In judging excellence in art, then, we use both aesthetic and nonaesthetic standards.

Further insight into the nature of the criteria of artistic merit is provided by Osborne. In "Assessment and Stature" he writes that we praise a work of art mainly for three reasons: for strictly artistic reasons, or for a kind of artistic virtuosity evident in the completed product; for its capacity to provide aesthetic satisfaction in a responsive beholder, which is to say for a work's capacity to sustain perception in a distinctive mode of attention; and for its stature, or for the ways in which a work performs well any number of what he calls subsidiary functions, not least of which is its ability to suggest imaginative models for thinking about the world and human nature.[17] Nelson Goodman also believes that works of art function most effectively "when by stimulating inquisitive looking, sharpening perception, raising visual intelligence, widening perspectives, bringing out new

connections and contrasts, and marking off neglected significant kinds, they participate in the organization and reorganization of experience, and thus in the making and remaking of our worlds."[18] Dewey likewise proposed that art contributes to the organization and reorganization of experience, and on this note we return full circle to the notion that excellence in art consists of its capacity to occasion worthwhile experience by intensifying and enlarging the scope of human awareness.

It might be said that in talking so much about the excellence and qualities of works of art we have given natural phenomena undeservedly short shrift. Should not efforts to develop an appreciation of nature's beauties also be part of any program of art education? Undeniably, the term excellence tends to imply human agency, so that it strains ordinary usage to attribute aesthetic excellences to nature directly. Yet such cavils would be unconvincing to many artists who found their inspiration in nature—as one can readily realize by going through Kenneth Clark's *Landscape into Art.*[19] And so nature is not excluded after all: it is a source of artistic excellence via the interests, perceptions, and works of artists like Breughel, Rubens, Poussin, Constable, Courbet, Monet, Turner, Cézanne, Van Gogh, and others. When discussing the works of such artists, teachers need only move back and forth between art and students' experiences of nature and make the appropriate distinctions. What is more, a modest literature on environmental aesthetics is now available that teachers can draw on.[20]

What writers emphasize when they try to develop in others an understanding and appreciation of art is, of course, largely conditioned by the cultural climate of their time, which is usually a mixture of traditional and contemporary thinking about art. There is nothing inevitable, however, about either the ideas themselves or the direction they take, and the fact that certain ideas happen to be on the minds of many people does not necessarily make them the best ideas. Interest in art today is largely political in nature, and it expresses itself in theories that tend to concentrate on the social and economic aspects of art. This approach to art may yield some illuminating discussions, but if pressed too far it produces a value reductionism that is ultimately inimical to art education; inimical because it devalues aesthetic considerations. Instead of taking the measure of a work of art in terms of its artistic virtuosity, capacity to afford aesthetic experience, and stature—the latter *possibly* involving an account of a work's political import as part of an *overall* assessment—a reductionist stance fails to do justice to art's plenitude of values as well as to those qualities that constitute a work's capacity

to elicit aesthetic experience. A work of art should be more than an ideological message center delivering information about the social and power relations in a society. Aesthetic intelligence and experience become irrelevant when ideology is the principal concern and when, as Hilton Kramer has remarked, the intention is "to deconstruct . . . every art object . . . into an inventory of its context and thus remove the object from the realm of aesthetic experience and make it a coefficient of its sources and its environment."[21] (Much of what is written today under the banner of aesthetic criticism is in truth cultural criticism with a Marxist flavor that often goes by the name of critical theory.) In short, extra-aesthetic political or ideological values are never enough for assessing excellence in art. For it is the qualities of complexity, formal organization, and dramatic intensity that are crucial for defining art's aesthetic achievement; they make art the special thing it is. I am not dismissing the extra-aesthetic or nonaesthetic values of art out of hand but am only relegating them to their proper place. Since an excellent work of art holds different kinds of value in a dynamic equipoise, the critical task is to keep them all in view while assigning to each its due significance.

Once more, we come back to the question whether art is primarily cognitive or aesthetic, or both cognitive and aesthetic, and perhaps moral as well. When confronted with the diverse purposes works of art may serve, some writers tend to acknowledge the plurality of functions and then proceed as if no serious attempts had been made to narrow the possibilities. That is to say, they give the standard response that art is cognitive, moral, and aesthetic and leave it at that. But it can make a difference to art education whether one thinks works of art exist primarily to be understood and to provide knowledge or whether their function is to lend a certain character or quality to experience. That some of our most respected writers on this matter hold conflicting views should therefore not be lightly dismissed.

An essentially aesthetic view of the function of art may follow Dewey's line of thought. In his *Art as Experience* Dewey describes how a dramatic organization of elements can make any ordinary experience into a truly noteworthy one—*an* experience. Such an experience is distinctive mainly for its inner dynamics and consummatory value, that is to say, for its *aesthetic* quality. The way *an* experience unfolds and feels is more important than any cognitive residue it may yield. Experiences having aesthetic character, Dewey says, really go nowhere; they produce no conclusions that can be used in further inquiry, the purpose of which is to

produce still more understanding. This is not to say that knowledge, ideas, and judgments play no role in artistic or aesthetic experience; they do, but it is not overt or conscious. For the person having *an* experience is dominated by a feeling, or pervasive felt quality, that the elements and components of the experience are cooperating and cohering unusually well. In this respect, but not in others, Dewey's idea of art is essentially noncognitive.

If we think of the function of art as preeminently cognitive, we might follow Nelson Goodman's lead. In his *Languages of Art* and elsewhere, Goodman speaks of art's ability to transform and reorganize our conceptions of the world, a view that derives from his theory of symbolic systems which posits characters that may function more or less efficaciously. Goodman has little to say about the quality of experience that art affords other than that feelings are engaged cognitively in responses to art.

Osborne's remarks cited earlier in this chapter seem to suggest that he thinks art accommodates both cognitive and noncognitive functions. But his main emphasis is on the energizing of percipience. And although Beardsley in his later writings paid greater attention than he had previously to the cognitive character of aesthetic experience, his view of art's main effect remains largely noncognitive; that is, works of art are better suited to providing high degrees of aesthetic gratification than to generating knowledge or understanding in the strict sense.

To avoid confusion, it should be realized that the term cognitive is often used in two senses that should be kept separate. In one, a process sense, cognition is taken to play a role in all perception. Perception may therefore be called the conceptually mediated component of aesthetic experience. The second is a result sense of cognition. It refers to the humanistic import or insight provided by an art object and encompasses a work's symbolic character and meaning.

Although the issues surrounding the relations of the aesthetic and the cognitive are far from resolved, educators may at different times have valid reasons for stressing one as well as the other. But as I indicated, in an age when political interests and extra-aesthetic considerations figure so prominently in discussions of art and art education, it may be wise to resurrect the aesthetic aspects of art. Such an emphasis does not commit us to a narrow aestheticism. Even though aesthetic experiences tend to separate themselves from ordinary ones (otherwise there would be no distinction), they nonetheless overlap other types of experience and have a potential impact on values other than the aesthetic. It is thus reasonable to assume that

a cultivated disposition to regard art aesthetically can contribute to the development not only of aesthetic percipience but of percipience generally; to the stretching not only of dramatic imagination, but of imagination generally; and to the appreciation not only of artistic complexity and possibility, but of variety, difficulty, complexity, and possibility generally. Readers may decide for themselves whether their motives for attending exhibitions of paintings by Matisse or Picasso, shows of sculptures by David Smith or Louise Nevelson, or festivals of films by Bergman or Hitchcock are mainly cognitive, aesthetic, or moral, or some combination of these. Is art sought out mainly for understanding and learning or for a fresh experience—or both? Do experiences of the arts significantly influence other aspects of human life? In the notes to *Excellence in Art Education* I mentioned these possibilities by referring to the views of several writers. I now promote these remarks to the text.

In "Art and Education," William Arrowsmith, a classical scholar who also writes about film, states that "from Homer to Greek tragedy to the Roman moralists to Plutarch to the Church fathers to Montaigne to Bunyan to Emerson, the single most pervasive function of art has been precisely education."[22] Likewise, in *The Fire and The Sun: Why Plato Banished the Arts,* Iris Murdoch, a novelist and philosopher, asserts that "art is far and away the most educational thing we have, far more so than its rivals, philosophy and theology and science." She also says in the same passage that "of course, art has no formal 'social role' and artists ought not to feel that they must 'serve their society.' They will automatically serve it if they attend to truth and try to produce the best art (make the most beautiful things) of which they are capable."[23] Deemphasizing the cognitive or pedagogical function of art, Kenneth Clark in "Art and Society" expresses his belief "that the majority of people really long to experience that moment of pure, disinterested, nonmaterial satisfaction which causes them to ejaculate the word 'beautiful'; and since this experience can be obtained more reliably through works of art than through any other means, I believe that those of us who tend to make works of art more accessible are not wasting our time."[24] Yet, to continue the dialectic, Francis Sparshott in *The Theory of the Arts* thinks that "people certainly do produce and study works of art as sources of knowledge or understanding or illumination or something of that cognitive sort." Indeed, he says, "It certainly seems strange to say that one goes to an exhibition of a serious artist in search of pleasure—we go to learn, to seek enlightenment."[25]

By now, however, one thing should be quite apparent: the question of excellence in art cannot be decided without taking into account aesthetic theory. If, as with Plato and Tolstoy, one thinks that the principal use of art is to help moralize people, then one will judge art mainly with regard to its moral effects. If, like Goodman, one thinks the principal function of art is cognitive, that is, to contribute to our understanding, then one will base judgments of art on the degree of a work's symbolic efficacy. Or, still further, if, along with Osborne, Beardsley, Kaelin, and Eaton, one takes the foremost (which is not to say the only) function of art to be aesthetic, then one will judge art excellent when it possesses the capacity to induce a high level of aesthetic experience and sustain interest in the aesthetic mode. If one is basically a pluralist open to all the possible functions of art, one will move among points of view and thus follow the advice of Morris Weitz: "Deal generously with traditional theories of art, and by implication contemporary ones as well, for each, though having limitations, contains serious recommendations to concentrate on certain criteria of excellence in art."[26]

This concludes the discussion of excellence in art. In addition to explanations of aesthetic experience and qualities of art, it has had the effect of qualifying the principal reason Santayana gave for studying the past: to avoid reliving its mistakes. This reason will not suffice for the study of artistic excellence. We do not return again and again to the masterpieces of the past in order to prevent ourselves from committing what Ortega y Gasset, in a frame of mind similar to Santayana's, called the ingenuous mistakes of history. We do it to honor rare moments of human accomplishment, moments that can "light up for us whole areas of the mind," make us "proud of our equivocal humanity," and help us wring from life "a more convincing and more relevant meaning."

6

Elitism and Populism

Art can thrive only insofar as the practitioner or appreciator looks
beyond himself and assumes some standard for the thing made
It is "popularized" art, art as a mere commodity, that in its lack of
standards and its glorification of easy and stereotyped availability,
is the enemy of distinction. And of *distinctions*.

<div align="right">

Robert Penn Warren

</div>

Elite, elitist, elitism, carrying their true associations with choice or
the best, are words that deserve respect and allegiance, particularly
from those in hot pursuit of excellence.

<div align="right">

Sherman E. Lee

</div>

Elitism in a just cause has its merits. . . .The best endures in the
accomplishment of the masters.

<div align="right">

Bernard Malamud

</div>

Of all the topics addressed in *Excellence in Art Education* the discussion of
elitism proved to be the most controversial, and misunderstood. Some
misunderstanding was due to the chapter's having been reprinted in a
number of journals without benefit of the larger context in which it was
imbedded. And while many readers made complimentary comments about
my defense of beneficent elitism and call for a combination of beneficent

elitism and beneficent populism, others either missed the point of a beneficent elitism or ignored my remarks about populism. I understood "beneficent elitism" to refer to the right of all members of a democratic society to have access to excellent things, in contrast to a situation in which experiences of excellence are reserved for a superior class believed alone in their ability to have them. And by "beneficent populism" I meant a critical grounding that would keep even a beneficent elitism from becoming too esoteric and impressed with itself. The new title of the chapter, Elitism and Populism, indicates an intention that will become clearer as we go along.

Excellence in Art Education concentrated on the secondary years of schooling and emphasized developing an appreciation of excellence in art and all that this entails in the way of art-historical and art-critical learning. Understandably, then, the study of artistic exemplars and masterworks of art received major, but by no means exclusive, emphasis. For most reviewers, this emphasis obscured my recommendation to include units of studio work as well. Furthermore, my discussion in this chapter of excellence within kind, a topic that was not sufficiently developed in the original version, opens the door to considering work in different categories that is good and thus worth attending to. Indeed, once the idea of examining something from an aesthetic point of view is accepted, it should be fairly easy to appreciate aesthetic value wherever it occurs, not only in works of art but also in the environment and in objects of daily use. The scope of the discussion has thus been broadened beyond masterworks. In the discussion of a K-12 curriculum in chapter 9, for instance, I argue that art that is good in kind might be incorporated into an arts program as a way of dealing with the inability of very young students to study exclusively masterworks—however appropriate it is that children should at least be familiarized with such works both in class and through museum visits. And even the later years with their pronounced emphasis on art-historical and art-critical studies will offer opportunities to stray from a concentration on masterworks to do other things. I indicated, for example, that during an examination of the art of landscape it would be appropriate to initiate discussion of some of the similarities and differences between the aesthetic value of works of art and of nature.

To the belief that the study of masterworks enshrined in the cultural heritage is not only elitist in a maleficent sense but also sexist and racist, I respond by repeating what I said in *Excellence in Art Education:* good art transcends its creator's original intentions and ideology and communicates

across the centuries. As Hannah Arendt put it in her impressive *The Human Condition:*

> The proper intercourse with a work of art is certainly not 'using' it; on the contrary, it must be removed from the whole context of ordinary use objects to attain its proper place in the world. By the same token, it must be removed from the exigencies and wants of daily life, with which it has less contact than any other thing. Whether this uselessness of art objects has always pertained or whether art formerly served the so-called religious needs of men as ordinary use objects serve more ordinary needs does not enter the argument. Even if the historical origin of art were of an exclusively religious or mythological character, the fact is that art *has survived gloriously its severance from religion, magic, and myth* (emphasis added).[1]

Two final observations made by critical readers of *Excellence in Art Education* were that the discussion was hierarchical in some negative sense and that the study of acknowledged works of quality inhibits the young from making their own judgments about art. If "hierarchical" is intended to mean that some artworks are more rewarding to spend time with than others and that our best guides to what is worthwhile in art are persons experienced in and knowledgeable about the arts, then I suppose the term hierarchical applies. But the same is true of just about every other subject studied in school that pursues the quite defensible aim to acquaint the young with outstanding accomplishment. Moreover, far from inhibiting personal judgment, familiarity with the qualitatively superior is the surest means of providing students with criteria by which excellence and worthwhileness have been and are still being assessed and through which young people themselves are enabled to make more sensitive and informed judgments of their own. This is what, in my view, makes the study of excellence empowering, not the reverse. Students will further discover during their historical and critical explorations that criteria of quality are not immutable; they undergo change over the centuries. This means that there will come a time for young people when they have to decide for themselves what they are willing to consider artistically worthwhile. Indeed, it may be argued that as our age slips ever deeper into a cultural recession, the need to recall past instances of greatness becomes more urgent. Knowing what human beings have accomplished inspires confidence regarding what human beings might attain.

Although some of the questions raised about the original version rested on misreadings, I have nonetheless profited from them. They provide me with an opportunity to restate what I did and didn't say and explain more clearly what I intended. Of all the chapters in the original version, however, the chapter on elitism is the one that from my point of view needed the least editing and rewriting; hence it appears much as it did in the original, with only slight editing and some additional interpolation and notes.

Is it elitist in a maleficent sense to stress excellence in art and art education? Is it acceptable to the democratic egalitarian ethos to speak of things eminently superior and good of their kind? Is it consistent with democratic values to recognize and reward excellent performance? I argue that the pursuit of excellence is not elitist in any condemnatory sense and that commitment to and praise of excellence are traditional democratic virtues.

That it is still necessary to raise such questions attests to the pervasiveness and intensity of the conviction that excellence and democratic values are somehow incompatible. It is not, to be sure, a belief that is consistently held. In many areas of life the ideal of excellence and the recognition of excellent performance are taken for granted: artists and writers earn awards for outstanding artistic, scholarly, and journalistic accomplishment, exemplary athletes achieve well-deserved fame, and talented entertainers receive the accolades of their peers and publics. Yet when it comes to matters of education and schooling, and particularly arts education, derision often greets those who recommend that the best that has been said, written, and created should be of central importance. It is strange, then, that many who are willing to accept the fact of excellence and its recognition in many other areas of endeavor balk at emphasizing excellence when it comes to the teaching of art. Misgivings suddenly surface about making value judgments and the appropriateness of admiring exceptional performance. To shore up their doubts, skeptics resurrect old nostrums and marshall them against the argument for high standards. Despite the debates over matters of taste that are in fact going on everywhere, they maintain that there can be no disputing of tastes. Oblivious to the truism that masterpieces from past ages often transcend their origins and speak to subsequent eras, anti-elitists declare that traditional art is irrelevant and has nothing to say to persons living today, especially to members of the working class and ethnic groups. There seems to be some apprehension that behind the promotion of excellence lurks a sinister intention to superimpose the values of one group

over those of another, a fear that, to repeat, appears to be more pronounced among art teachers than among teachers of other subjects in the curriculum. It has even been suggested that emphasizing excellence in education is nothing more than a vile strategy to oppress minorities and eradicate student creativity. This chapter intends to lay to rest such unfounded fears.

Consider first some of the points anti-elitists make. Even if, they might say, discussion of artistic exemplars has something of the effect this essay claims for it, is it really necessary? Should not students have at least one opportunity in the school day to express themselves freely and make decisions on the basis of their individual interests, and should not this opportunity be provided by the art class? And what about theories that stress art as a form of play? Did not Schiller himself in *Letters on the Aesthetic Education of Man* say that man is truly free only when he plays? Is there not after all something to the notion that tastes cannot be disputed? Is it not true that experts disagree among themselves and that their judgments cannot always be relied on—for example, that they look foolish when works they had certified as originals are later found to be forgeries? Is the relevance of the past really a foregone conclusion? Should not student interests and the values and backgrounds of various groups figure somewhere in planning curricula and teaching? Questions such as these deserve to be considered carefully; some preliminary remarks are, however, in order.

Although the notion of elitism is often opposed to that of populism, as in the phrase "elitism versus populism," I think it is more useful to seek an accord between them. Such a confluence would express a more suitable view of the arts and arts education in a democratic society, for the reasons that follow.

Elitists are not necessarily hidebound traditionalists who instinctively turn away from popular, minority, and vanguard art. Nor do self-styled populists necessarily rule out the study of traditional masterpieces; their intention may be simply to include today's popular art in the range of works young people study in school. Neither do the differences between the elitist and the populist invariably turn on the importance each assigns to standards; populists may favor the development of critical standards but, again, in connection with the study of works they assume are of more immediate interest to students.[2] Certainly the distinction between elitism and populism cannot be based on what is popular for seldom has the public shown a greater interest in "the old masters." A more promising approach to the matter is to recognize what is valuable in both elitism and populism.

In order to do this, it is necessary to make some distinctions.

To begin with, we are justified in condemning *closed elites* that permit membership solely on the basis of a person's wealth, class, or social standing. But not all elites are like this. There are *open elites* of demonstrated merit that control admission by insisting on adherence to professional standards. No advanced society can exist without such elites, and even less developed societies depend on them. The professions of medicine, law, and engineering are examples of open elites. No matter that professionals make mistakes from time to time, it is still for sound reasons that we prefer certified engineers to design the bridges we cross and licensed physicians to write our prescriptions. Nor do we want to dilute professional standards. Professional elites come under scrutiny only when they set arbitrary admission criteria, insist on unearned benefits, or tend toward unwarranted exclusiveness. If trust in the professions is somewhat guarded today it is because they too, like so many other sectors of society, are in occasional need of remoralization, that is, a recentering of their efforts on social responsibility and human values.

If we think of elitism in terms of open elites and acknowledge their indispensability, then the term elitism loses many of its negative connotations. Having acknowledged the need for beneficent elites, we may proceed to a discussion of cultural elitism. Stuart Hampshire has stated that an elitist is a person who believes four propositions. The first is

> that there is a tradition of great, and of very good and interesting work, in each of the liberal arts, and that there is good reason to expect (with some qualifications) that these traditions are being prolonged into the future. Second, that at any time a minority of otherwise intelligent persons, including artists, are deeply interested in one, or more, of the arts, and have devoted a considerable part of their lives to their involvement with them, and to thinking about them. The judgments of artistic merit by such persons, who are not difficult to recognize, are the best guides to artistic merit that we have; and in fact they usually tend towards some consensus, with a periphery of expected disagreement. Third, that enjoyment of one or more of the arts is one of the most intense and most consoling enjoyments open to men, and also is the principal source of continued glory and of pride and of sense of unity for any city, nation, or empire. Fourth, very often, though not always, a good artist does not create his own public within his lifetime and needs support, if he is to work as well as he might.[3]

Little comment is needed on the first proposition: good work has been and is being done; so we pass to the second one. It points out that not only connoisseurs, art historians, and art critics constitute the elites that make distinctions of value among works of art, but artists also participate in the formation of critical opinion. The historical record abounds with their judgments of past and contemporary work; indeed, evaluations made by artists are often the harshest of all.[4] What is more, with some notable exceptions, the judgments of critical elites have been remarkably stable; they tend to withstand the test of time. There is now a core of classics and masterpieces that is largely accepted by those whose primary concern is with matters of culture; controversy is less about the core than about its periphery. And movement in both directions between periphery and core does not occur haphazardly; it is attended by intensive critical debate. Witness, for example, the controversy generated by the so-called canon wars.

It is difficult to disagree with Hampshire's third proposition: the experience of art at its best is one of the most vivid and often most consoling forms of human gratification. It is precisely this kind of gratification that the writer Rebecca West had in mind when she spoke of the intense emotion, deep and serene, that she felt when in the presence of artistic greatness. Such emotion, she wrote, "overflows the confines of the mind and becomes an important physical event," yet it "does not call to any action other than complete experience of it." Likewise, Kenneth Clark describes this satisfaction in terms of heightened perception, possession, self-discovery, and incandescence.[5] (Chapter 4 contained a fuller discussion of the kind of gratification works of art yield.)

Further, it is obvious that works of art dramatically illustrate cultural continuity, are symbols of civilization, and expressions of national and civic pride. Nations and cities build and maintain museums and performing arts centers for more than purely aesthetic reasons. Next to its record of humanitarianism and compassion nothing reflects more positively and tellingly on an era than its cultural achievements and the attitude taken toward them. The identities of New York, Chicago, Los Angeles, and Washington, D.C., are as dependent on these cities' museums, works of public art, symphony orchestras, and ballet companies as they are on their financial districts and sports facilities.

It is a popular misconception, moreover, that elitists yearn only for the art of past golden eras and turn their backs on contemporary art. As their writings attest, cultural elitists of the sort Hampshire talks about easily

traverse cultural spaces and periods. "Style and Medium in the Motion Pictures" by Erwin Panofsky, a distinguished art historian, is one of the most anthologized essays on film. William Arrowsmith, a classical scholar, discovers value in both Homer's *Iliad* and Alain Resnais's film *Hiroshima, mon Armour,* believing the latter to be an unconscious imitation of the ancient work. Meyer Schapiro finds something important to remark in both Romanesque sculpture and modern painting. Leo Steinberg is fascinated with the perplexities not only of Michelangelo's but also of Jasper Johns's work. Charles Jencks, the British architect, theorist, and critic, defines postmodernism as the intermingling of modernism with traditional ideas of Western humanism. And if, like Hampshire and Robert Penn Warren, we include artists among the elitists, we discover numerous instances of painters and sculptors who looked for inspiration and artistic challenges to the masters of the past: Cézanne who wanted to redo Poussin in the presence of nature; Picasso who was intrigued by the relations of reality and illusion in the art of Velázquez; Frank Stella who became preoccupied with the spatial volumes of Correggio, and so forth.[6] In short, the elitist's supposed domination by the dead hand of the past is a myth. Artists and others undertake journeys into the past not only for the purpose of enjoying the intrinsic values of the travels themselves but also for receiving help with understanding contemporary problems. Consequently, we should not regard scholarship and artistic inquiry of this kind with suspicion but should instead discover ways to impart its insights to the young.

Elitists therefore are correct in setting store by critical judgment and believing that it is proper for tastes not only to be disputed but to be cultivated as well That tastes differ and are contested is obvious; at issue is the proposition that assertions made in behalf of one's taste should be subject to rational scrutiny.[7] The proposition is, I think, defensible; persons often welcome help in thinking about their preferences and upon reflection may well decide to alter their opinions, and subsequently their tastes. Hampshire even goes so far as to say that to treat people as if they already know what they want or ought to learn is in effect to treat them as less than human. Thus, our reticence about disclosing what we believe valuable in art does no service to the young, and will not help them overcome their indecisiveness. Learning to appreciate the excellence of art is, after all, part of learning to become self-sufficient in the cultural domain. That domain, we should remember, contains not only a cultural heritage that, being both revolutionary and conservative, constitutes the fruits of systems of thought and

creativity, but also the critical tools for appraising these fruits. When young people are armed with the standards of judgment and the perspectives available in the cultural heritage, they may be less susceptible to the stereotypes of pseudo-art and better able to demand better art. Certainly there can be no doubt that the standard of taste prevailing in a society is important for cultural progress for, by determining what people will tend to appreciate, it will also affect what artists create. William Faulkner once remarked that a low level of the writing produced in a society may not be entirely the fault of writers and that literature may not improve until readers do. He therefore urges us to be concerned about the health of that sector of the cultural environment that is composed of the general ability and skill of readers.[8] Do not the same kinds of questions apply to the general abilities and skills of percipients of visual art?

The elitist says that the enjoyment of excellent art is one of the higher forms of human enjoyment, not necessarily *the* highest, but one that nonetheless ranks importantly among the features of the good life. The elitist is also correct in this belief. If the pursuit of happiness is a democratic right, then providing the young with opportunities to appreciate art for its capacity to induce worthwhile experience is hardly undemocratic. Failing to acquaint the young with some of humankind's finest achievements would be irresponsible.

In summary, nothing in Hampshire's four propositions suggests that elitism is necessarily maleficent. Nothing implies that elitists hold themselves socially superior or are insensitive to minority or ethnic art, contemptuous of popular culture or contemporary art, or antidemocratic. Certainly there is no indication that access to excellence and the cultural heritage should be restricted to certain groups or that a taste for the best cannot be acquired by people from all walks of life. Much of the criticism levelled at elitism therefore does not necessarily apply to it. While it is possible to speak of harmful, undemocratic elitism, it is *beneficent* elitism that Hampshire characterizes—an elitism that prizes knowledge of the cultural tradition, the value of cultural continuity, acts of critical judgment, and excellence. It would be an exceedingly crimped view of human nature that asserted such values are beyond the ken of the large majority of persons. I now turn to a discussion of populist beliefs.

Although one frequently encounters the terms "populist" and "populism" in discussions of art and art education, I know of no well-formulated theory of

cultural populism in the literature of art education that is rooted in serious populist thought. From a number of writings, however, it is possible to infer that a populist believes one or another of the following propositions, and perhaps some populists believe all of them.

One proposition asserts that works of art are so totally the products of the conditions and prevailing ideologies of a certain time and place that they are inaccessible and irrelevant to anyone whose outlook was not shaped by similar circumstances. Persons can find meaning only in works from their own time, or better, from their own social class. This leads to a second proposition: those who stress the study of traditional exemplars of art commit acts of political oppression. They alienate people from their cultural roots, denigrate their individual preferences, and deprive them of a sense of self-worth and pride. From this proposition a third proposition derives that accepts a thoroughgoing relativism in matters of artistic judgment. It holds that there are no defensible criteria by which one work of art can be judged superior to another. The fourth proposition follows from all the others: people should be given the kind of culture they want and not what others think they should have. These propositions present a sharp contrast to the ones on elitism discussed by Hampshire. How well do they stand up to critical examination?

Concerning the alleged inaccessibility of artworks to persons whose class and background are different from the interests of those for whom works of art were originally made, it is worth noting the following. Kenneth Clark's examination of the art-historical record reveals that, true, art has usually been made by an elite for an elite to celebrate the values of an elite— that is, an elite of skillful artists and artisans who produced works that celebrated the values of the dominant groups in a society. Created by an elite for an elite, says Clark, but nonetheless enjoyed by the large majority of people. In the Middle Ages the populace of a city often followed with great interest the career of an artistic commission and gladly joined in the festivities that attended the work's dedication. The reaction of the four-teenth-century citizens of Siena to the completion of Duccio's great altar-piece, the *Maestà,* is a typical instance cited by Clark. If one were to look for a comparable reaction in modern times, one might mention the pride expressed by the residents of Reggio di Calabria in the classical sculptures discovered in the waters off southern Italy. Interest in these so-called Warriors of Riace spread nationwide and generated a debate regarding whether the works should be housed in Florence, where more people could

106

see them, or remain in their place of discovery; Reggio di Calabria finally won out.[9]

As the next chapter will indicate, the inaccessibility thesis contains a kernel of truth. Neither we nor our successors will ever be able to experience the classical monuments of antiquity or the religious art of the Middle Ages in the ways the people of those times did. Nor can we recapture the excitement elicited by the Renaissance humanists' rediscovery of ancient texts. Still, it is an incontestable fact that the classic works of the past—its exemplars of sculpture, painting, architecture, and decorative arts—have proven their power to move and delight generation after generation. I offer one compelling illustration of this assertion. In discussing the problems of developing students' appreciation of Christian art, Nelson Edmonson refers to the example of the Byzantine icon known as the *Vladimir Mother of God* (c. 11th-12th centuries), which depicts Mary and the Christ Child, and asks why he, an agnostic, is not only able to appreciate the work's formal qualities but is also moved by its expressive meaning. After all, the work was mainly intended to serve a religious purpose: the veneration of icons offered the faithful a means of approaching the goal of receiving grace and the fulfillment of God's prophetic vision. But, writes Edmonson, whatever the icon's religious function and meaning, for him it "manifests mankind's remarkable creative ability to focus in one potent image, and thereby raise to a shared consciousness, the common human condition of suffering alleviated by love." Persons of all beliefs or of no belief at all can experience "a sense of being an integral factor in a larger human drama, of having, as it were, an extended historical companionship."[10] In short, being highly condensed tokens of the radical complexity of human experience gives works of art the ability to transcend dogma and their own time. Edmonson thus provides yet another example of what was said in chapter 4: Art at its best reveals the variousness of life and expresses a deep sense of human values. We respond to the recognition of a shared humanity. I think this is essentially what E. H. Gombrich had in mind when in defending the tradition of general knowledge in an age of specialization he described the value such artists as Michelangelo and Raphael, Rubens and Rembrandt, and Van Gogh and Cézanne have for us today.[11]

Another proposition of populism, that all aesthetic judgments are expressions of personal preferences and thus unreliable indicators of quality and stature, strikes a responsive chord in many, but it requires an effort of self-deception to maintain it consistently. The discussion of the marks of

excellence in chapter 4 provides ample testimony in behalf of the possibility of delivering convincing judgments of quality. The difficulty of gaining consensus on criteria of excellence in the case of contemporary art does not rule out the possibility of achieving sound and reasonable estimates of aesthetic value. Populists conveniently ignore those clear-cut cases where refusal to acknowledge superior attainment flies in the face of common sense. There are, after all, good reasons why such terms as novice, amateur, immature expression, hack work, and pseudo-art came into the language; all refer to performance that falls beneath a standard. Thus, rather than casting aspersions on the opinions of those who know quality when they see it, we should welcome it for its assistance in opening our own eyes.

What about the charge of political oppression? Granted all of the above, is it not still the case that one group of persons—those possessing expert qualifications—is imposing its values on others who are being persuaded, initially at least, to accept things pretty much on faith? First of all, the choice of terminology prejudices matters. "Imposition" with its connotations of the forcible and illegitimate is misleading. Curriculum decisions are often the result of a democratic decision-making process that involves legitimate parties to the deliberations. And the trend in education today is to encourage more participation in this process, not less. To be sure, experts should not be extended any special political prerogatives. If we permit them to influence decision making, it should be because we have decided that their ideas are helpful in setting and realizing worthwhile goals. The charge of political oppression would in fact lose much of its plausibility if instead of stressing imposition we spoke convincingly of providing access, if instead of fearing the suppression of individual interests we emphasized the liberating of young minds from nature for culture, and if instead of denouncing the wielding of authority we spoke of empowering the young in matters of understanding and appreciation. When these goals and results are taken into account, the language of political oppression assumes a strained quality. Placing within the grasp of persons that which has the capacity not only to intensify their experience but also to enlarge the scope of their awareness can hardly be called authoritarian.

Regarding the populist proposition that people should receive the kind of culture they want, it may be reiterated that people, especially the young, are often uncertain of their tastes and need to know something of the range of what there is to be enjoyed and admired before they can make up their own minds. (In this connection, John Goodlad's remarks in his *A Place*

Called School may be recalled.) Even some postmodern revisionists acknowledge this point.[12] It certainly is presumptuous to assume that, having been provided an opportunity to understand and appreciate quality, the large majority of persons will turn their backs on it. In any event, it would make a mockery of schooling to ground an excellence curriculum in the encouragement of untutored personal preference.

If, however, we are to combine the values of elitism and populism, we should also acknowledge certain virtues of populism. Populism is the watchdog that keeps elitism on its guard and prevents it from becoming too impressed with itself. It is a viewpoint that casts its net of relevance over a large area and reminds us that excellence is not found exclusively in one's own cultural heritage but in other cultures and civilizations as well. Populists not only express a sincere regard for the arts of all people, they also remind us that the arts of everyday living make rightful claims on our attention. These virtues should not be overlooked in an excellence curriculum in art education. To repeat, what is wanted is a synthesis of beneficent elitism (an open elitism in a just cause) and beneficent populism (a populism that endorses access to excellence for all). Such a synthesis would emphasize the popularization and humanization of knowledge and the pursuit of excellence by means of providing access to the best and would thus be truly worthy of a democratic society.

To gain a better appreciation of the values of democratic cultural elitism, we might pause briefly to look at the elitist-versus-populist controversy in Great Britain, whose history of class distinctions and conflict lends a special asperity to the controversy there.

Like their American counterparts, British populists celebrate the "art of the people," by which they usually mean the art of the working class. Believing that it is more important for people to appreciate the culture of their own group than to pay homage to traditional culture, populists consider efforts in this latter direction as fraudulent. British opinion on cultural matters tends to be heavily coated with the ideology of the political far Left. Yet even admirers of British working-class culture admit that populist advocates often misinterpret the aspirations and capabilities of working-class people. The basic mistake, writes Richard Hoggart—himself of working-class origin and a respected member of the political Left—consists in confusing sincerity, good intentions, and humane social services with art and artistic merit. In "Excellence and Access" he says that in British populist writing art is assimilated almost exclusively to community social activities

(with the consequent effect of devaluing individual artistic creation and its appreciation), while at the same time the concept of art is expanded to include practically everything (which nullifies the need for making distinctions and has the effect of discrediting truly exceptional and excellent things). But Hoggart points out that, historically, the British working-class tradition of adult education has attested to ambitions that supplement and even transcend communitarian values. "Among its many great qualities," he writes, is "the belief that people should be able to stand up and reach for the best and the most demanding" and that given opportunities to stretch their capacities ordinary people will reveal "far more abilities than either a closed elitism or an ill-thought-through communitarianism had realized. So they have a right to the best, no less."[13] Hoggart's remarks derive special force because they were made by a representative of the political Left, the traditional champion of populism. But Hoggart parts company with the extreme Left, expressing impatience, nay anger, with its views on culture. His observations, I think, apply as well to some of those in this country who promote a communitarian ethos. They have the same tendency to substitute social reform for the study of art and the appreciation of artistic merit.[14]

Hoggart's animadversions also call to mind Charles Frankel's discussion on the new and the old egalitarianism. Frankel, who was a philosophical liberal in the best sense of the word and understood the nature of democracy better than most, pointed out that the new egalitarianism attempts to replace the principle of equal opportunity with the demand for guaranteed equality of results. Yet he remembers an older ideal of egalitarianism that, while also valuing equality, recognized the importance of differences, partisan feelings, and even social stratification. This former orientation implied, among other things, the capacity "to tell the genuine article from the fake" and to understand "the need in every society to give public recognition to things noble and excellent lest everything in the society's culture be regarded as disposable."[15] In other words, the old egalitarianism was able to acknowledge certain realities without subverting the principle of equality. Arthur Schlesinger, Jr., echoed this sentiment when he wrote that liberalism is not only political and economic but also cultural and moral. Its concerns are expressed by Whitman, Emerson, Thoreau, and Melville as much as by Jefferson and Jackson; in short, they rest "with all those who insisted on holding America (and themselves) up to stringent standards."[16]

When traditional egalitarianism emphasized access to excellence and paid the majority the compliment of believing them capable of high achievement, it was merely echoing the great ninteenth-century cultural critic (and school inspector) Matthew Arnold. *In Culture and Anarchy* Arnold wrote that the true apostles of equality have been those "who have had a passion for diffusing, for making prevail, for carrying from one end of society to another, the best knowledge, the best ideas of their time; who have labored to divest knowledge of all that was harsh, uncouth, difficult, abstract, professional, exclusive; to humanize it, to make it efficient outside the clique of the cultivated and learned, yet still remaining the best knowledge and thought of the time, and a true source, therefore, of sweetness and light."[17] There can be no better ideal for democratic culture and education. Lawrence A. Cremin, the eminent historian of American education, even went so far as to suggest that a commitment to the popularization and humanization of knowledge in the Arnoldian sense defines the genius of American education.[18]

In summary, things "noble and excellent," "access to excellence," "stringent standards," and "the *best* knowledge and thought of the time" all find a place of honor in a discussion of excellence in art education.

It follows that short shrift should be given to the demand that "the people's choice" or "the students' choice" should take precedence over expert experience and knowledgeable opinion (a claim made practically nowhere else in the curriculum, certainly not in mathematics or science education). It not only imputes an unrealistic level of maturity to developing minds but also takes a condescending view of young people's potential for improving their knowledge and taste. This point is well understood by Sir Roy Shaw, a good Arnoldian and erstwhile Secretary-General of the British Arts Council, whose sympathy is also with the political Left. Like others, he points out that populist impulses are often latently elitist in the maleficent sense inasmuch as they seem to imply that certain groups, presumably those with weaker constitutions, must be given a watered-down and undemanding art, with high culture being reserved for others.[19] Hilton Kramer remarks similarly that the populist's hostility to high art is a form of elitist contempt for the masses that persists despite ordinary people's daily demonstrations of an appetite for serious art.[20] Indeed, those who grew up as members of subcultures in whose behalf populists purported to be speaking and who were given the opportunity to cultivate a taste for the best have realized the truth of Hoggart's and Shaw's observations and the error of communitarian

thinking. Marva Collins, a teacher of minority children in Chicago, also knows it, and her students are learning it.

Perhaps no one has made a more eloquent case for the compatibility of artistic excellence and democratic values than Robert Penn Warren in his 1974 Jefferson humanities lecture titled *Democracy and Poetry.*[21] Since Warren, this country's first Poet Laureate, intends "poetry" to include not only literature but art in general, his views fittingly round out this chapter.

Having said that at the heart of a democracy's efforts lies the development of selfhood in the sense of a significant felt unity within the self, Warren addresses a frequently heard denial of any necessary relation between art and democracy, a denial grounded in the fact that nondemocratic societies often produce good and even excellent art.

Warren agrees the relation is not necessary but contingent, for art is inextricably tied to selfhood and individual expression, both of which are most freely pursued within a democratic political system. Warren points out that even in a nominally democratic society such as fifth-century Athens, which self-consciously celebrated aristocratic ideals, a concept of self emerged that established man as the measure of all things. He goes on to assert that a unique sense of selfhood is present in all great art irrespective of the kind of society in which it was created or that society's pervasive ideology. We sense it in the expression of a universal aesthetic impulse to create order and form.[22] True, individual self-expression has not been overtly prized in all ages, nor is it honored by all cultures today; but even in medieval art, as Meyer Schapiro points out in his study of Romanesque sculpture, one can detect a strong personal presence. Hence, when Warren suggests that all great art is the result of a universal aesthetic impulse as well as an expression of individual selfhood, he in effect confers relevance on the entire cultural heritage. He helps us to appreciate why William Arrowsmith could say that the cultural heritage literally trembles with relevance.

Warren goes on to explain how in advanced democratic societies it is becoming increasingly difficult to keep alive and realize the ideal of selfhood. New determinisms—economic, psychological, technological—are casting doubt on the viability of the concept of self and are encouraging persons to think of themselves as puppets of larger controlling forces. But this may be an unnecessarily pessimistic assessment of the human estate, and the difficulties may not prove insuperable. For Warren also believes that if we can ever learn to use leisure time to invigorate rather than dissipate the self, modern society will be able to create a dynamic favorable to the realization of genuine selfhood.

Warren thinks that in a society given to the growing standardization of practically every aspect of life, art performs two crucial functions: one is to provide the self with opportunities for the unique expression of its energies in artistic creation and aesthetic appreciation; the other is to serve as a valuable critic of society's dehumanizing tendencies. Good art not only describes the conditions and consequences of dehumanization but through its example and vision offers alternatives to them.

It was to be expected that in an essay on art and democracy Warren would ultimately address the question of elitism. Since excellent art represents a superior achievement and its effects tend to be commensurate with its quality and stature, Warren assumes that art enjoys elite status. But its elitism is obviously beneficent. Nowhere outside art can we find a more impressive and heroic attempt to sustain and nourish those qualities Lionel Trilling called variousness, possibility, complexity, and difficulty—qualities so needful to a society in danger of yielding to excessive standardization and the temptations of abstract ideological thinking. In short, says Warren, art is a realm of human endeavor that democracies ignore at their peril. The completed art object is valuable not only as a vital affirmation and image of the organized self but also as "a permanent possibility of experience" that "provides the freshness and immediacy of experience that returns us to ourselves" (72).

A final observation: If the belief that the ideal of excellence in art education is undemocratic is baseless, so is the objection that it takes the fun, excitement, and playfulness out of aesthetic learning. It has been said that playfulness and piety are the two faces of any kind of intellectual activity, including artistic creation and aesthetic appreciation, and some may wish to fault my discussion for tipping the scales too much toward piety. While acknowledging the insights provided by play theories of art from Schiller through Huizinga to Herbert Read, I have played down the use of "play" because of its associations with the nonserious and trivial. Yet, although I think there is something to the notion that an artwork should be approached in a suppliant mood, I don't believe aesthetic experience necessarily requires awestruck seriousness. The aesthetic experience of art is characterized not only by a feeling of solemnity but also by exhilaration, not only by intense concentrated attention but also by a certain detachment from practical and pressing preoccupations, not only by the difficult task of making conflicting stimuli cohere but also by the gratification that derives from having done so. Furthermore, art further provides a much-needed

leavening and counterpoise in an inherently pragmatic or instrumentally oriented society whose technological imperatives tend to have an adverse impact on aesthetic values. If anyone is taking the joy and delight out of the experience of art, it is the extremist who insists that the teaching of art subserve a radical political agenda.

In concluding this discussion of elitism and populism it is worth pointing out that while democracies value the common man, they do not value what Ortega y Gasset called the commonplace mind, a mind that not only knows itself to be commonplace but also proclaims the right to impose its commonplaces wherever and whenever possible.[23] Arnold also realized that with the coming of mass-democratic society the freedom and energy of large numbers of people would be wasted unless they were employed in the service of an aspiration higher than that of being ordinary, that is to say, unless they were employed in the service of the best possible self.[24] The potentiality for becoming uncommon is what is important. Art is a perpetual reminder of the possibility of transcending the ordinary; it constantly calls us away from a pedestrian existence.

7

Multiculturalism and Cultural Particularism

> The Socratic type is the type committed to a rigorous examination
> of the faith and morals of the time, giving pride of place to those
> convictions which are widely shared and rarely questioned. . . . There
> may be an element of perversity in all this. However that may be,
> for people of this type it is a point of honor to swim against the
> stream.
>
> Walter Kaufmann

My intention in questioning certain assumptions about the role of
multiculturalism in art education is not to be perverse or to swim against the
stream of current thinking merely for the sake of doing so but to gain a better
understanding of the place of multicultural studies in art education. In a
global context "multiculturalism in arts education" suggests the study of the
arts of all civilizations, Western and non-Western. In the national context
of the United States the term usually implies that greater attention should be
paid to the cultural expressions of ethnic and minority groups. But if this
were all that multiculturalism denoted today there would be no major issue,
for histories of art are increasingly histories of world art, and school
textbooks are being rewritten to reflect the contributions to American life of
groups previously given little or no consideration. One can only applaud
such efforts.

What makes multiculturalism a matter for serious concern are the efforts of extremists to use multiculturalism to undermine the significance of Western civilization by claiming that Western traditions are the cause of most of our modern problems. Moreover, an increasing number of writers believe that considerations of ethnic origin, class, and gender are more important than any others in making educational policy decisions. Some even go so far as to abandon multiculturalism and cultural pluralism in favor of a cultural particularism that lays stress on racial differences and separatism.

But even if we reject extreme positions, as I think we must, the idea of multicultural understanding raises several interesting and challenging questions. Just what do we mean by "multiculturalism," "multicultural understanding," "multicultural education," and "multicultural arts education"? What proportion of a curriculum should be given over to multicultural aims and objectives? What kinds of methods are appropriate for studying the arts of different cultures and groups? How much knowledge and expertise are required to do so? Most of all, how can we avoid producing merely a shallow appreciation? Things like these were on my mind when some years ago I attempted to come to terms with the problems of cultural diversity in an international context.

My thinking about cultural diversity was stimulated by participation in a number of world congresses of the International Society for Education through Art (INSEA), an organization whose formation was influenced by Sir Herbert Read and whose founding president was Edwin Ziegfeld of Teachers College, Columbia University. During the 1970s and 1980s I also spoke at various foreign universities and polytechnics in England, Australia, Canada, Holland, Italy, and Japan where I discovered not only that people were attempting, with varying degrees of seriousness, to come to terms with the problems of cultural diversity but also that they generally failed to make some necessary distinctions.[1] Since I am not a social scientist and tend to look at things from a humanist's point of view, I found some ideas of the late Walter Kaufmann useful for my purposes.

Kaufmann was a professor of philosophy at Princeton University who taught and wrote widely on the nature of philosophy, tragedy, religion, and existentialism. In *The Future of the Humanities* he addressed the crisis of the humanities in higher education and concluded that they must be taught differently lest humanity itself become dehumanized.[2] In particular, he thought humanists in higher education should clarify and redefine the goals

of the humanities and achieve consensus on appropriate methods of teaching them. He was convinced that most professors and students do not know how to read a classic text and that if the humanities neglect to engender this capacity they have lost their *raison d'être*.

What Kaufmann says about reading classic texts in higher education also applies to the teaching of literature and the arts in the schools. Many school teachers and students do not know how to engage serious works of art. This ignorance, plus the overemphasis in art education on child art and creative activities, is partly responsible for widespread aesthetic illiteracy—although the latter is usually explained by reference to society's refusal to place a high value on the arts.

I follow the direction suggested by Kaufmann and first locate the study of cultural diversity within the purposes of teaching the humanities. Kaufmann states that these purposes are four: the conservation and preservation of the greatest works of humanity, the teaching of vision, the development of critical thinking, and, especially at issue here, the examination of alternatives. Alternatives are to be studied principally for their potential to foster the critical spirit that enables one to detect in alternatives what speaks for and against them and what, consequently, reinforces or contradicts one's own ideas.

In a chapter titled "The Art of Reading," Kaufmann likens reading a classic text to visiting a foreign country and searching consciously for culture shock. He distinguishes four ways of reading—exegetical, dogmatic, agnostic, and dialectical—only the last of which he believes is consistent with the goals of the humanities. Drawing an analogy to multicultural studies allows us to speak of exegetical, dogmatic, agnostic, and dialectical ways of confronting different cultures.

The Exegetical Reader and the Exegetical Multiculturist. Exegesis is associated with the interpretation of biblical texts and has a long and venerable history. Although Kaufmann thinks this method of reading has limitations, he acknowledges the importance of its function and the insights it affords. The method is limited by its being based on the assumption that the interpreter, the exegete, possesses the truth contained in a text and therefore has an obligation to interpret and communicate it to the uninformed. Typically, exegetical interpreters first select a major text, endow it with authority, and then read their own ideas into it, especially those to which they are emotionally committed. Consequently, exegetical readers receive

their own ideas back clothed in the text's authority. But because emotional identification with the text tends to precede close reading, there is potential for a biased rendering. Many people, and not scholars alone, read in this fashion. The point is that exegetical readers do not seek an alternative experience that might question their own values and beliefs but search instead for confirmation of preconceived notions and feelings. This tendency closes off the possibility of genuine existential encounters and risks self-deception and arbitrariness. In short, exegetical readers insulate themselves against culture shock by playing it safe. They are like travelers who stay at the Hilton wherever they go because things there are familiar and comfortable.

Exegetical multiculturalists make similar mistakes. They first endow not a text but a different culture with superior merit and authority, then read their own sentiments and allegiances into that culture, and finally have their own outlook reflected back to them, reinforced. The next step is to instruct the uninitiated. Typically, exegetical multiculturists extol the qualities and virtues of a different culture in order to criticize their own. They tend, for example, to call critical attention to the adverse effects that advanced technologies have had on aesthetic values and the quality of life by highlighting the functional interdependence among all aspects of existence sustained in a different society—say, to the way aesthetic considerations permeate life in Malaysian societies. To establish the contrast, they will chastise technologically advanced civilizations for having institutionalized the aesthetic impulse in cultural organizations—museums, galleries, performing arts centers, and so forth—the selective policies of which, they claim, has encouraged cultural elitism. (The fact that in advanced societies persons of all classes take pleasure in going to museums and attending musical performances and plays is conveniently overlooked.)

Exegetical multiculturalists tend to ignore yet another possibility: close and unbiased scrutiny of a preferred culture may reveal practices and values that in good conscience cannot be endorsed. Even a culture that one admires for its ostensibly communitarian and collectivist ethos may yet contain subtle and not so subtle class distinctions. A society noted for its aesthetic way of life may still suppress personal autonomy, self-expression, and individual development. In short, exegetical visitors to foreign cultures may have blinded themselves to the whole picture. However much they may yearn for the integration of aesthetic values with ordinary living, exegetical multiculturalists are unwise to denigrate cultural institutions that appear to

them to separate art from life. For it is these institutions that are largely responsible for conserving and replenishing the aesthetic wealth of a culture, a wealth embodied in some of the finest creative and spiritual achievements of the human race. Francis Haskell, an art historian, has pointed out that without museums, libraries, and concert halls, many of these artistic monuments would have been lost forever. Many artifacts, moreover, have now been in art-institutional contexts longer than in their original ones and have consequently taken on a life of their own.[3]

Little more needs to be said about exegetical multiculturalists. They are a familiar type of participant in conferences and world congresses where they exhibit their supposedly enlightened sensitivities and expound their presumably superior wisdom. Yet their capacity for self-deception and personal embarrassment is often as great as the ethnocentrism of hidebound cultural chauvinists. (The latter's "my culture first and foremost" attitude is now regarded as something to be cultivated, which reflects the dramatic social changes that have occurred since the early days of anthropology. But more about this later.) Exegetical multiculturalism, in sum, is educationally limiting because it subverts one of the main objectives of teaching the humanities—to help persons think critically, weigh alternatives, and judge for themselves.

The Dogmatic Reader and the Dogmatic Multiculturalist. Dogmatic readers assume that their own culture is superior and that all others fail to pass muster. They and their counterparts, dogmatic multiculturalists, are quickly dealt with. Both groups avoid experiencing culture shock and studying alternatives seriously for what it can contribute to self-understanding. In their "my country right or wrong" posture they resemble vulgar jingoists. One observes this attitude mostly in government and business leaders who believe that the world would be much better off if all "underdeveloped" nations would simply adopt the economic and technological capabilities of "advanced" ones. This kind of patronizing stance is also taken by some dogmatic multiculturalists toward societies that they consider backward or primitive. The preferences of multicultural dogmatists, grounded as they are in flawed and indefensible arguments, do not lead to insight and illumination.

Perhaps one more observation might be permitted. The vice of cultural chauvinism has been imputed almost exclusively to Western societies, which are accused, among other things, of being smugly superior,

ethnocentric, and imperialistic. Yet even a superficial familiarity with world history confirms that chauvinistic feelings, rather than being confined to the West, are rather well distributed throughout humankind.

The Agnostic Reader and the Agnostic Multiculturalist. Agnostic readers, who embody Kaufmann's third type of attitude toward a text, avoid the principal error of exegetical and dogmatic readers—that is, the mistake of reading preconceived ideas and judgments into a text. In this respect the agnostic attitude is preferable, though lack of bias alone does not insulate it from criticism. Agnostic readers assume that their inability to possess the whole truth about something obliges them to suspend all judgment; they thus consider questions of value and assessment beside the point. Yet closing themselves off from dimensions of value makes it impossible for agnostic readers to have the most complete and undistorted encounter with a text. Actually, their neutrality of opinion is seen to stem less from a desire for fairness than from their indifference to certain aspects of a text. Those aspects that do interest them are either antiquarian, aesthetic, or microscopic. The antiquarian interest is like the stamp collector's; the aesthetic interest (in Kaufmann's use of the term) reflects a penchant for beauty and style, or for primarily surface phenomena; and a microscopic interest focuses on a part rather than the whole—or, to use Kaufmann's example, on the specialized study not of the leech but of the leech's brain. To recall the foreign-visitor analogy and extend it to agnostic multiculturalists, they are like travelers who not only stay at the Hilton because everything is comfortably familiar but who take their chief delight in the picture postcards and souvenirs they purchase.

Now souvenir-hunting multiculturalists deserve some credit for being interested in learning something about societies foreign to them; otherwise they would not take the time to visit them. Typically, however, in their haste they permit themselves only brief glimpses at things along the way, which defeats the purpose of exposure to a different culture, namely, discovering what its study might contribute to self-understanding. Agnostic multiculturalists are prevented from experiencing culture shock and exploring alternative values by their concentration on things either old, rare, or merely strange, on surface qualities, or on a tiny part of the whole. They are indifferent to cultural characteristics that those with a larger perspective would find especially valuable in and distinctive of a particular group of people—for example, how its members view the world from their special

vantage point. Agnostics thus remain secure in their own opinions and preconceptions, incurring no risk to the self. For such an attitude, we reserve the term parochial.

Agnostic multiculturalists are also easy to spot at art education conferences. They are the casual, relatively disengaged participants who have collected hundreds, perhaps thousands, of children's drawings and paintings from around the globe and who indulge an essentially botanizing interest in children's artworks. To them matters of cultural context, values, and so forth, are at best of secondary interest. Charming though their attitude may be, it hardly qualifies as genuine understanding as it precludes the pursuit of self-knowledge that is derived from the contemplation of cultural differences. Information provided by agnostic multiculturalists is often so superficial as to be more misleading than educative. We do well, then, to set exegetical, dogmatic, and agnostic attitudes aside in order to entertain a fourth kind, the dialectical attitude.

The Dialectical Reader and the Dialectical Multiculturalist. Because of its association with Hegelian and Marxist analysis, or with mere scholastic cleverness, the term "dialectical" is perhaps not the best choice for what Kaufmann means. "Critical" might have sufficed were it not too vague for Kaufmann's purposes. What he wants to emphasize by using "dialectical" is a demanding and significant encounter with a text. In the context of the discussion of this chapter, this can be extended to mean a demanding and significant encounter with the arts of a different culture.

A dialectical encounter with a text has three components: the Socratic, the dialogical, and the historical-philosophical. This triad of considerations is consistent with Kaufmann's belief that the serious reading of a classic text is essentially a voyage in search of culture shock for the purpose of self-examination. It means nothing less than taking seriously the Socratic maxim that the unexamined life is not worth living. Dialectical reading assumes that neither the reader nor the author of a text is omniscient but that, since both are intelligent beings, they can jointly attempt to transcend their limitations by engaging in a common quest. This means that the reader addresses the voice of a text as a "You" and aims at a perspective outside currently existing consensuses. The resultant culture shock is a precondition for self-understanding.

In its dialogical aspect, dialectical reading requires readers to make a conscious effort to discern the distinctive voice of a text, however much

that voice may disturb, challenge, and offend their sensibilities. Readers have no prior commitment to a text's authority nor predisposition to make the text conform to their own beliefs. Dialectical reading is thus nonauthoritarian. It is through such deliberate study that consciousness is raised and clarified. By "raising consciousness" Kaufmann understands "the liberation from parochialism and cultural conditioning, the freedom that is born when the awareness of a multitude of alternatives issues in the creation of new ways" (64).

The third component of dialectical reading—the historical-philosophical element—is necessary to discover the intention of a text's author. In the case of a classic text this is not easy and calls for careful reading and rereading. At this point, Kaufmann asks his readers to envision three concentric circles.

Careful reading requires that readers begin with the innermost circle, which is the text itself and ostensibly the locus of its intention and distinctive voice. It is as if Kaufmann is endorsing the advice of Matthew Arnold who said that the critic's task is to try to see a text as in itself it really is, with as little distortion and bias as possible. As Lionel Trilling once put it, this is the simple courtesy we extend to a text, even though we realize that total objectivity is unattainable.[4] For further assistance in discerning the intention and meaning of a text, one moves beyond the innermost circle, the text itself, into the second concentric circle, where the task becomes one of relating the text to the writer's other work and career. The purpose of this inquiry is to discover the writer's spiritual personality, peculiar cast of mind, and style of thinking. One also takes note of the weight of a particular text in a writer's artistic production. The serious dialectical reader does not stop with the discovery of the writer's persona. There is still a third concentric circle to explore, and this involves the study of a writer's background, artistic development, and the views of other readers. It should be apparent not only that these three concentric circles of inquiry overlap but also that one travels back and forth among them.

To reiterate: the attitude of the dialectical reader is neither presumptuous nor indifferent. It is perhaps best described as the "nervous wariness" that Irving Howe identified as Trilling's way of approaching a serious work of literature. Trilling, he said, "would circle a work with his fond, nervous wariness as if in the presence of some force, some living energy, which could not always be kept under proper control—indeed as if approaching an elemental power. The work came alive and therefore was never quite

knowable, alive and therefore even threatened the very desires and values that first made one approach it."[5] This passage characterizes the spirit of the dialectical encounter more accurately than Kaufmann himself did and goes to the heart of what he means by it.

Kaufmann believes that the best method to shed a narrow ethnocentrism is to study texts and artworks from very different cultures. But this is not, I think, always necessary. Past periods and epochs in one's own cultural heritage will also serve since they are often as puzzling and inaccessible as alien civilizations. Our own past is frequently a foreign country in which we travel as tourists.[6]

Another reference to Trilling is apposite at this point. In a course he taught in the 1970s on the novels of Jane Austen he discovered that his students had great difficulty in comprehending and sympathetically participating in the world inhabited by Austen's characters.[7] The students confined their responses to what Kaufmann calls the innermost circle of the complete act of reading, the text itself, and even there they achieved only partial understanding. What is more, they were literally at a loss to appreciate anything in the novels' outer circles, for example, the symbols and codes that governed life in Austen's time, including attitudes toward family relations, being and doing, and duty—standards of conduct that readers of Austen's own time would have taken for granted. Because of his students' inability to identify with the behavior of Austen's characters, Trilling had to devote considerable time to supplying relevant background information.

For Trilling's students, then, Jane Austen's early nineteenth-century world was literally a foreign country. Although the students professed an interest in reading Austen to garner whatever insights they could in their own quest for self-definition—a desire consistent with dialectical reading—their limited knowledge prevented them from fully engaging her works dialectically. Not only that; I infer from what Trilling relates that the students' wish to read Austen (five years earlier, in 1968, they had been demanding to read William Blake) also reflected an exegetical attitude; they were interested in reading their own ideas, values, and needs into Austen's works in order to receive them back invested with Austen's authority. They seemed especially captivated by the green world of trees and forests of Austen's novels that provided a setting for her characters' actions. This experience prompted Trilling to reflect on a major assumption of modern literary criticism: that one reads best by sympathetically identifying with the characters of a story

and by imaginatively participating in their worlds.

To gain an alternative approach to understanding the people and values of a different world, Trilling turned to the writings of the anthropologist Clifford Geertz. After reading Geertz's studies of foreign cultures, Trilling remarked on Geertz's method for entering into the workings of an alien society. In "From the Native's Point of View," Geertz says that "in each case I have tried to arrive at this most intimate of notions not by imagining myself as someone else—a rice peasant or a tribal sheikh, and seeing what I thought—but by searching out and analyzing the symbolic forms—words, images, institutions, behaviors—in terms of which, in each place, people actually represent themselves to themselves and to one another."[8] The lesson Geertz's procedure teaches is that in order for outsiders to be able to appreciate what is going on in another culture they must possess considerable background knowledge. They also need a fundamental familiarity with the codes, symbols, and norms of their own culture as a basis for comparison and contrast.

In another essay, "Person, Time, and Conduct in Bali," Geertz provides a description of a Balinese artistic performance, which may be examined for what it can tell us about Balinese values and our own:

> Artistic performances start, go on (often for very extended periods of time when one does not attend continually but drifts away and back, chatters for a while, sleeps for a while, watches rapt for a while), and stop; they are as uncentered as a parade, as directionless as a pageant. Ritual often seems, as in the temple celebrations, to consist largely of getting ready and cleaning up. The heart of the ceremony. . . is deliberately muted to the point where it sometimes seems almost an afterthought. . . . It is all welcoming and bidding farewell, foretaste and aftertaste. . . . Even in such a dramatically more heightened ceremony as the Rangda-Barong. . . [one experiences] a mystical, metaphysical, and moral standoff, leaving everything precisely as it was, and the observer—or anyway the foreign observer—with the feeling that something decisive was on the verge of happening but never quite did.[9]

To one wedded to Western presuppositions about aesthetic experiences and their emphasis on the Aristotelian unities—for example, on beginning, middle, climax, and end—nothing could be more foreign than Balinese artistic performances. Where Western dramatic presentations are faulted if they are too long or if they drag, Balinese performances seem to be largely indifferent to temporal considerations. Where a Western dramatic produc-

tion intentionally creates tension and suspense and punctuates the action with points of heightened interest, the Balinese counterpart appears to lack focus and direction. Where Western drama characteristically resolves conflicts and tensions, Balinese drama deliberately attenuates and mutes the action. There is no forward propulsion to speak of, no gathering of momentum toward an exciting conclusion. Like Balinese life itself, Balinese art and ritual lack movement and climax, or they lack climax because they lack movement. Accordingly, to take Balinese artistic performances at what to Western audiences appears as their face value would be to miss their point. A proper understanding would require first determining and then moving back and forth through Kaufmann's concentric circles—from a performance to the various contexts of Balinese culture.

To be sure, according to Geertz all these differences do not gainsay what is apparent even to the naive percipient—that Balinese life is pervaded by aesthetic considerations. The Balinese pay great attention to form and style and attach considerable significance to pleasing others aesthetically. But Geertz points out the importance of realizing that aesthetic form and style play a distinctively uncommon role in Balinese life. In Bali, art is one of the means by which all aspects of personal life are stylized to the point where anything characteristic of the individual—of the self behind the mask or the person behind the facade presented to the world—is intentionally obliterated. Physically, says Geertz, people come and go, "but the masks they wear, the stage they occupy, the parts they play, and, most important, the spectacle they mount remain and comprise not the facade but the substance of things, not least the self."[10]

It is difficult to imagine a more striking contrast to the Western ideal of selfhood, an ideal that places so much importance on self-fulfillment and the development of personality. We need only recall the classical notion of excellence with its stress on the encouragement, achievement, and recognition of outstanding accomplishment. Far from requiring the negation of the self, the classical ideal insists on its intensification through that perfection of thought and action that allows the individual to stand out against others. The Western concept of self typically exhorts individuals to engage fully in life's contest, to partake in competition, seek success, and risk failure—a primordial struggle for which Jacob wrestling with the angel is an appropriate image and of which the dissolution of the self through aesthetic etiquette is the exact antithesis. In Balinese culture, then, we confront a radically alternative view of selfhood, or, as it were, of an absence of such, which

provides an opportunity for critical reflection about one's own attitude toward individuality.

Trilling engaged in precisely this kind of critical reflection when he pondered the adequacy of traditional methods of literary criticism. For him it was not a matter of imitating the outward appearance of members of a different culture. (The road taken, for example, by the youth culture of the 1960s whose mode of dress prompted Saul Bellow to liken the university campus to the back lot of a Hollywood studio, or the path followed by some advocates of Afrocentrism who encourage blacks to adopt a traditional African look.) Rather, for Trilling the problem was more basic and essentially structural: the actual possibility of life approximating art. Deeply knowledgeable about his own intellectual and cultural traditions, Trilling pointed out in his discussion of Jane Austen that such a prospect is actually not as foreign to Western intellectual beliefs as might be thought. Toward the end of his essay he writes:

> We of the West are never finally comfortable with the thought of life's susceptibility to being made into aesthetic experience, not even when the idea is dealt with as one of the received speculations of our intellectual culture—sooner or later, for example, we find ourselves becoming uneasy with Schiller's having advanced, on the basis of Kant's aesthetic theory, the idea that life will be the better for transforming itself into art, and we are uneasy again with Huizinga's having advanced the proposition, on the basis of Schiller's views, that life actually does transform itself into art: we feel that both authors deny the earnestness and literalness—the necessity— of which, as we of the West ultimately feel, the essence of life consists.

In what were perhaps some of the last words he wrote, Trilling nonetheless went on to say that "it is open to us to believe that our alternations of view on this matter of life seeking to approximate art are not a mere display of cultural indecisiveness but, rather, that they constitute a dialectic, with all the dignity that inheres in that word."[11] Had Trilling been a sympathetic reader of John Dewey's *Art as Experience,* he would also have found there a decided openness to the idea of integrating art and life. Dewey would doubtlessly have looked quite favorably on the penchant of the Balinese people for introducing the aesthetic into practically all aspects of life. His particular conception of aesthetic experience, however, with its dramatic Aristotelian organization

of elements, would have been incompatible with Balinese cultural preferences.

I hope it is clear by now what Kaufmann means by the dialectical reading of a classical text and what I mean by a dialectical engagement with the arts of a different culture, either a non-Western civilization or a past period in our own. Trilling, who can be said to exemplify Kaufmann's ideal dialectical reader, was no exegeticist or dogmatist. And he was hardly agnostic in Kaufmann's sense of this term. In his dialecticism he remained hospitable to alternative visions of the self. The student of the arts of other societies should be no less so. Even if it happens that familiarization with another culture has added little to one's concept of selfhood, something else has been gained: an increased awareness of one more of the myriad ways in which individuals live out their lives.

I conclude that a study of cultural diversity that is less than dialectical and is undertaken primarily to advance a political agenda holds potential for distortion and self-deception. I have further cautioned against attempting to navigate a different society without a thorough knowledge of one's own. But this warning also spotlights an anomaly: we are being urged to undertake multicultural studies at a time when a shockingly high level of cultural illiteracy about our own society is becoming apparent. Not having troubled to acquaint ourselves with the concentric circles of our own cultural world, we are being asked to traverse the concentric circles of other cultures.

It would be possible to end the discussion of multiculturalism at this point. I've emphasized both the possible benefits of multicultural studies and the vices multiculturalists are prone to, and I have said a few words about pedagogical method. But because extremist views continue to have influence and are rarely and only reluctantly criticized, I continue the discussion with references to writers who have raised the kinds of questions apt to promote reflection about the role of cultural diversity in a democratic society. That is to say, I offer some ideas in the spirit of the epigraph to this chapter: to encourage Socratic dialogue. Readers may decide for themselves whether there is any merit to the ideas put forth.

In "Pluralism as a Basis for Educational Policy: Some Second Thoughts," published in 1975, Mary Ann Raywid, a philosopher of education, anticipated much of what has recently come to pass.[12] Raywid offered her remarks in the general context of discussing the peculiar psychic pain that afflicts modern existence, a feeling of rootlessness and nonbelonging

that is intensified by an awareness of powerlessness in the face of large and impersonal social structures. She hypothesized that this unease prompts people to turn to cultural groups in search of identity, security, and a sense of empowerment and that this accounts for much of the appeal of what in the mid-1970s was called the new ethnicity.

Drawing on social theory and conceptualizations of ethnicity, Raywid explained that the "new" in the new ethnicity consisted of the extension of earlier ways of establishing identity through religion and nationality to ways that stress racial and gender differences. Theorists of the time claimed that the new ethnicity was characterized by a shared feeling of peoplehood that manifested itself in the communication of subtle expressions of inner life, particularly with regard to reflections, imaginings, and historical experiences rather than ideas and words. Most crucial was a common history or ancestry. In contrast to melting-pot theories of assimilation, analyses of ethnicity tended to emphasize difference. What European immigrants really wanted, theorists claimed, was not a redefinition of themselves but the opportunity to pursue their old ways free of the aggravations that plagued them in their native lands. This position conflicted with the one holding that the unique circumstances of American life offered immigrants a chance to create a new kind of person, not an Irish-American, an Italian-American, or a Polish-American, but an American with a distinct national character. The new ethnicity rejected such a view; it insisted that people can be held together only by a mystical ethnic bond, which requires taboos on certain sentiments and behaviors. Groups in which such a bond exists cannot properly be considered voluntary associations, for they exact too much conformity and vigorously resist outsiders. Neither could one simply make a pretense of being a member or go only half way. Increasingly, ethnic groups would gravitate toward insular pluralism, or toward what Diane Ravitch would later call cultural particularism.

Raywid acknowledged that cultural pluralism has made significant contributions to American civilization; it not only helps to preserve cultural traditions but also provides career opportunities for group members and fosters in them a sense of self-worth and importance. But she questioned whether pluralism was the proper remedy for the psychic pain of modern existence. Might it not have some unwanted consequences for both the individual and society? Raywid wondered, in other words, whether pluralism could really work, and she was particularly troubled by its emphasis on ascriptive rights in the place of achievement. In 1975 she wrote:

Cultural pluralism apportions functions and statuses within society by ascription in contrast to achievement. Such an arrangement is logically implicit in the promise the group makes its own, reserving all functions to be performed by group members. The selection occurs, then, by virtue of birth. We have associated democracy and the open society with the ending of privilege by birthright—and with the insistence that the individual be able to make his or her own way. . . . Yet the new ethnicity seems not only to be returning to ascribed statuses, but bent on legitimizing and extending them to an unprecedented extent. Its success seems evident in the spread of Affirmative Action programs and quota systems barring status assignment on a strict achievement basis that is sex-blind or race-blind, and instead pursuing justice via what has been called "see-saw discrimination"(92).

Raywid also raised the question of the efficacy of cultural pluralism, the extent to which, for example, it might prove to be socially maladaptive. Is it congruent with the demands of the larger society in which members of ethnic groups must live, work, and raise their children? What will be the individual and social consequences of insisting that persons with different ethnic identities maintain a closer allegiance to their ancestors than to the realities of contemporary metropolitan life? Is there not even an incipient totalitarianism in a return to ritualistic tribalism, with its subordination of the individual to the group and its demands for deference, loyalty, and obedience? In short, Raywid worried that anti-individualism and anti-humanitarianism would be among the unintended and unwanted consequences of the new ethnicity.

At stake are more than possible adverse effects of ethnicity on individuals, for social cohesion itself is at risk. Just as too much uniformity undermines democracy, so does excessive pluralism. In terms that anticipated E. D. Hirsch's concern about the decline of cultural literacy and its effect on social unity, Raywid asserted that "it is obvious that society, community, even limited communication require the sharing of a minimal core of ideas and folkways" (93). She wondered whether the pluralists' emphasis on difference would jeopardize even this bare minimum. She was clearly worried that the centrifugal forces inherent in pluralism would deflect group members from participation in the larger society, an apprehensiveness that, as we shall see, is also expressed by Ravitch.

Raywid further believed that encouraging the young to define their selfhood in opposition to chosen enemies would probably lead to greater

social conflict. The new ethnicity would dissuade ethnic members from forming effective relationships beyond their in-groups, even though they will ultimately have to live a large part of their lives outside them. Consequently, Raywid did not see in the new ethnicity any potential for healing alienation and powerlessness. She even suggested that it may be just one more attempt to escape from freedom, for the effort to loosen the hold of the larger society in favor of the ethnic group actually creates a tighter bondage. The niche that surrounds and warms also imprisons and restricts.

Raywid was better at raising questions than at prescribing changes, yet she did make some recommendations. She called for new social forms that are not xenophobic and, instead of exacting loyalty or obedience from all members, would secure cohesion through common interests. An individual might participate in several such groups. She also called for universalism as a countermeasure to the harmful consequences of cultural separatism and particularism. By "universalism" she meant "the tendency . . . to stress the similarity and brotherhood of peoples, and to promulgate a common core of beliefs and common standards to which all can aspire and against which all should be judged" (97). In particular, she underlined the importance and inevitability of standards, of the necessity to make distinctions among better and poorer performances and to acknowledge hierarchies of value. Only an ill-conceived cultural relativism, she said, can hold that value distinctior are nonexistent or unnecessary. In the best tradition of humanist criticism, then, Raywid recalls her readers to the values of social cohesion, universalism, and judgment; such was her response to the unwanted consequences of ethnic enclavism.

Fifteen years later, in "Multiculturalism: E Pluribus Plures," Diane Ravitch, a historian of American education, acknowledged both the social injustices that have existed in American society and the progress that has been made in eliminating bias and discrimination against certain groups.[13] Today's history textbooks, she writes, "routinely incorporate the experience of women, blacks, American Indians, and various immigrant groups" (338). Although Ravitch, like Raywid, is clearly committed to the idea of a richly varied *common* culture, she assigns a more positive and strategic role to the language of cultural pluralism in her analysis because she wants to oppose it to an extreme form of ethnic thinking she terms *cultural particularism.* She takes the latter to be a form of ethnic fundamentalism that has all the faults Raywid ascribed to the new ethnicity but exceeds the latter in its ethnocentrism.

130

Ravitch writes that, in contrast to cultural pluralists, cultural particularists favor an ethnocentric curriculum the main purpose of which is to enhance the self-esteem and, supposedly consequent on that, the academic achievement of minority-group children. These goals are to be reached by establishing close ties to a group's land of ancestral origin—Africa for African-Americans, Central and South America for Hispanic-Americans, pre-Columbian America for Native Americans, and so forth. Unblinking in her description of this form of cultural particularism, Ravitch claims that it

> is unabashedly filiopietistic and deterministic. It teaches children that their identity is determined by their "cultural genes." That something in their blood or race memory or their cultural DNA defines who they are and what they may achieve. That the culture in which they live is not their own culture, even though they were born here. That American culture is "Eurocentric," and therefore hostile to anyone whose ancestors are not European. Perhaps the most invidious implication of particularism is that racial and ethnic minorities are not and should not try to be part of American culture; it implies that American culture belongs only to those who are white and European; it implies that those who are neither white nor European are alienated from American culture by virtue of their race or ethnicity; it implies that the only culture they do belong to or can ever belong to is the culture of their ancestors, even if their families have lived in this country for generations (341).

The import of such views is that the schools should not prepare children to live and develop their talents and abilities within a society that, though racially and culturally diverse, still possesses a common cultural core. Particularists "reject any accommodation among groups, any interactions that blur the distinct lines between them. The brand of history that they espouse is one in which everyone is either a descendant of victims or oppressors. By doing so, ancient hatreds are fanned and recreated in each new generation" (341-42). Raywid's worst fears of increased racial conflict and hostility would thus seem to have been realized.

Like Raywid, who perceived difficulties in the premises of the new ethnicity, Ravitch finds serious flaws in the arguments of cultural particularists. They ignore huge differences within cultures that result in part from intermarriage and linkages across groups. This makes meaningless the division of Americans into five neat categories (e.g., African-Americans, Asian-Americans, European-Americans, Latino/Hispanic-Americans, and Native Americans). Particularists further fail to realize the universal nature

131

and appeal of human accomplishment and the fact that persons can be inspired by models from all cultures and societies, not just by members of their own group. She refers, for example, to a talented black runner who said that she admired Mikhail Baryshnikov because he was a magnificent athlete who had superbly disciplined his body. Her appreciation of outstanding achievement, in other words, transcended race, class, and gender.

Ravitch shares Raywid's opinion that particularism is maladaptive. She thinks it is unlikely to serve the interests of those for whose benefit it is intended or to bode well for social peace and cohesion. And it raises insuperable curriculum and pedagogical problems. But perhaps most serious of all, it contradicts the principles and values of the Western liberal tradition. When cultural particularists, in the process of scorning the achievements and influence of European civilization, abjure the ideals of fairness, tolerance, and rationality, they attack the democratic social arrangements that alone could have provided them with a platform. They also display an unfortunate tendency to make hyperbolic claims and to denounce any criticism or questioning of their ideas as racist attempts on the part of a white majority to maintain power and cultural hegemony.

Ravitch asserts that reason, rational debate, and even scholarship are not the primary concerns of cultural particularists. Their aggressive efforts to gain professional advantage and influence are pure power plays. Yet the crusade against Eurocentrism cannot go unanswered, and Ravitch explains why there are good reasons for Americans to retain close ties with Europe. Quite simply, many of our cultural roots, our social, intellectual, moral, political, and religious traditions—and, I would add, our artistic traditions—are European. Eighty percent of Americans, she says, are of European descent, and English is the principal language spoken in this country. Collectively, all of this has created a common culture that it has been the purpose of American schools to transmit to the young in order to make them effective members of society. So, while Ravitch defends the importance of cultural pluralism in our type of society—as evidenced in her work with the history curriculum of the state of California—she also believes that

> educators must adhere to the principle of "E Pluribus Unum." That is, they must maintain a balance between the demands of the one— the nation of which we are common citizens—and the many—the varied histories of the American people. It is not necessary to denigrate either the one or the many. Pluralism is a positive value,

but it is also important that we preserve a sense of an American community—a society and culture to which we all belong. If there is no overall community with an agreed-upon vision of liberty and justice, if all we have is a collection of racial and ethnic cultures, lacking any common bonds, then we have no means to mobilize public opinion on behalf of people who are not members of our particular group. We have, for example, no reason to support public education (353).

Ravitch centers on extreme Afrocentrism in her discussion of multiculturalism not only because of what she considers to be its fatal flaws, but also because of its potential for generating what she calls "multiple-centrisms" and the intensification of divisiveness. She is also emphatic in stating that sound scholarship should precede the rewriting and implementation of curriculums. Truth, she insists, is not a function of power, dogmatic theories of racial superiority, and a free-wheeling relativism. Only a continuing search that leads to the constant revision and correction of knowledge is defensible.

In a follow-up discussion of her "E Pluribus Plures" article, Ravitch acknowledges that in her original remarks she should not have spoken of multicultural particularism, for whereas multiculturalism implies pluralism, cultural particularism rejects it.[14] The confusion arises because particularists often voice their beliefs in multicultural forums. Ravitch now thinks that because of its extreme ethnocentrism and dogmatism, cultural particularism is better described as cultural fundamentalism. Yet she asks that we not allow ourselves to be misled by such fundamentalist thinking. Knowledgeable people do not confuse culture and race, cultural affinity and cultural identity, cultural origin and cultural predestination. They recognize the multiple interests evident within a given cultural group, the tensions and conflicts that often divide its members, the syncretistic value of all cultures whose members intermingle among themselves and with others outside the group, and the universal features of cultures.

As for universalism, Ravitch fixes its meaning tellingly through the metaphor of a round table at which representatives of all groups can take their seats without suffering discrimination, so long as they keep in mind that the table itself is the democratic political tradition.

It is the galaxy of political ideas and values that include liberty, equality, and justice. It is the complex of democratic practices that requires us to respect basic human rights, to listen to dissenters

instead of jailing them, to have a multiparty system, a free press, free speech, freedom of religion, freedom of assembly, and free trade unions. It is a tradition shaped by the Enlightenment, by James Otis, Thomas Jefferson, Horace Mann, Ralph Waldo Emerson, Abraham Lincoln, Frederick Douglas, Elizabeth Cady Stanton, Susan B. Anthony, Samuel Gompers, John Dewey, Jane Addams, A. Philip Randolph, Franklin Delano Roosevelt, Martin Luther King, Jr., Bayard Rustin, and millions of other people from different cultural backgrounds. [15]

To avoid any misunderstanding of my discussions of Raywid and Ravitch, I emphasize that I am not suggesting, nor are they, that changes aimed toward an improved understanding and appreciation of cultural diversity are unimportant. Ravitch notes with satisfaction that new scholarship has been responsible for correcting past mistakes and filling in lacunae in curricula. What both authors question is whether some of the proposed reforms will be as efficacious as their advocates suppose. Once more, an especially important feature of Ravitch's writing is her insistence that accurate knowledge and scholarship should underpin curriculum recommendations. It is a test she believes many particularist claims fail to meet; they are too controversial and have not been subjected to adequate criticism and debate.

To sum up. Raywid realized nearly twenty years ago that educational policies promoting cultural diversity can have a significant impact on schooling in the United States. She understood that the new ethnicity constituted a response to alienation and powerlessness but doubted that these conditions could be alleviated primarily through the cultivation of ethnicity. She understood that the emphasis on ancestral origins and ethnic differences might well generate hostility toward others outside given groups and that the elevation of ascriptive rights over individual merit could prove maladaptive. Perhaps most importantly she perceived the seeds of totalitarian thinking in an ethnic enclavism that values group loyalty and solidarity more highly than individual freedom and achievement. Raywid further anticipated E. D. Hirsch and the alarm he felt on discovering a slippage in the general background knowledge shared by Americans that was already serious enough to threaten the ideal of a common culture. Ravitch's more recent analysis is valuable because it indicates how much of what Raywid dreaded has actually happened. Ravitch also provides a terminology for further debate; she suggests cultural fundamentalism as a term for the phenomenon Raywid had called insular pluralism.

Raywid's and Ravitch's discussions of multiculturalism stayed close to home, so to speak. To broaden the horizon somewhat, a view from abroad is introduced that also questions one of the most basic and unexamined assumptions of multiculturalists. In "Art, Culture, and Identity," John Wilson, a British philosopher, critically examines the belief, emphatically subscribed to by multiculturalists, that the best way to achieve a secure sense of self is through a strong identification with one's cultural origins.[16] Wilson begs to differ and recommends instead a culture-free education grounded in what is valuable and worthwhile in art and in culture more generally.

Wilson first defines his key terms. By "art" he understands anything that can be viewed aesthetically, that is, with a keen interest in an object's elegance, charm, beauty, and so forth. The things that reward such an interest most gratifyingly are works of art. Experiencing works of art aesthetically means not being preoccupied with their material dimensions or with their cognitive, moral, and political values. Aesthetic experience is important because it is a basic form of human life. If, he says, "we take 'the aesthetic viewpoint' in a sufficiently wide and sufficiently pedestrian sense, then that viewpoint is something we are landed with. All people . . . order their lives and surroundings, sometimes, for nonutilitarian purposes and purposes that are not directly connected with enterprises like religion or politics" (90). As for "culture," Wilson accepts what has become one of the word's standard meanings, the rules, practices, forms of life, styles, and values—including aesthetic activities and values—that characterize human social groups. The notion of "identity," on the other hand, suggests something more personal and individual, a feeling of being psychologically secure that may derive from a network of cultural experiences to which persons have become accustomed. Yet, as will become clear, Wilson doubts that a sense of psychological security ought to be grounded solely in one's own culture and asks whether it may not be dangerous to tie one's identity so closely to cultural features that are inherently fragile and changeable.

Wilson makes three points. Like Raywid, he thinks that finding one's identity primarily in one's cultural origins may be less important than discovering it in other values. In the construction of a self-image, religious beliefs, family values, economic security, political activity, physical or artistic prowess, and so forth, may account for more than ancestry. Giving prominence to such outward aspects of a person as skin color or indicators of social class would also be misplaced. The personal, psychological

elements in an individual's make-up are likely to be more significant than, for example, elevated social status, which is no guarantor of contentment. It is not, Wilson acknowledges, that cultural and social considerations are negligible; they may loom large at a certain time in a person's life, and perhaps everyone needs to live through a developmental stage that pays special attention to them. But ultimately, given their susceptibility to rapid change, cultural and social factors may not be reliable ingredients of a stable identity.

Wilson's point may be illustrated by a reference to the sensitivity expressed by some ethnic groups about matters of terminology (what they wish to be called) and outward appearance (how they wish to look) and their insistence that what they decide on be respected. But the fact that the many members of such groups ignore recommendations of this kind suggest that to them external signs of ethnic identity are less important than other things. In short, Wilson is critical of the attitude that treasures whatever a person calls "mine"—these are my ancestors, my social practices, my art, and so forth—because it provides no assurance that the things prized in this reflexive, unthinking way are true, worthwhile, or valuable. For what is true, worthwhile, and valuable transcends race, class, and gender.

An education seeking to transcend values that are bound up with particular cultures would in a sense be culture-free. Although it would not represent considerations of culture, race, and gender as unimportant, it would remind individuals that they cannot build a significant sense of self without coming to realize the limitations and shortcomings of such categories. On the other hand, if individuals committed themselves to transcendental values like the good, the true, and the beautiful, their selfhood would not be confined but liberated for the pursuit of really worthwhile things.

> Any educator, indeed any serious person, ought on reflection to realize that identity or security ought not to be sought in one's culture, that all of us have to be weaned and helped away from our cultures toward what is truly valuable and in a transcendental culture-free way, and that it is at best patronizing and trivial, at worst crippling and cruel, to encourage particular cultures to adore themselves in mirrors. Instead of feeling narcissistic (or guilty) about one's culture, one should have something better to do. Art . . . is one of these better things (96).

Wilson clearly recognizes the interdependence of his three concepts. Culture—not restricted to ancestral culture—is the all-embracing context within which persons strive to achieve identity, a context that includes activities we know as art and that may for some people be important determinants of self. Wilson misleads somewhat when he claims elegance, charm, and beauty to be defining features of works of art—unless, that is, he assumed beauty to include what Marcia Eaton calls deep delight. But his concern in this instance is not with fine discriminations among terms but with marking the distinctive character that the aesthetic lends to experience.

To repeat, although Wilson grants that ancestral origin can play an important part in shaping a person's identity, he does not think it is the most important determinant. He would, I think, endorse Raywid's suggestion that identity should not be sought exclusively within one's primary cultural group but instead in new social groupings that encourage members to agree on things that unite rather than divide them. Wilson would also be at one with Raywid in her concern about some of the possibly unwanted consequences of cultural pluralism and the new ethnicity, and with Ravitch in her apprehensions about the potential divisiveness of cultural particularism.

The question of multiculturalism has individual, social, and political dimensions. The challenge to a theory of education is how to help individuals achieve a sense of self and psychological security in a society that values both individual freedom and social cohesion and in which the pursuit of one worthwhile goal does detract from or depreciate other valuable objectives. The problem for arts education within a general education curriculum is how to determine the weight that should be given to the artistic interests of different cultures and groups in a society heavily influenced by Western European traditions. I discuss some of the possibilities in chapter 9.[17]

8

Modernism and Postmodernism

Modernism remains a vital force in the life of art today . . . both as a high ideal and as the basis of our established culture, yet it now faces a challenge unlike any it has met within this century. . . . The outcome to be expected from this state of affairs is neither foregone nor entirely foreseeable. It will be determined, first of all, by the works of art which artists create in response to this historic situation. But it will also be shaped to some degree by the discussion and debate that attends to their creation and reception.

Hilton Kramer

Most people have heard of Post-Modernism and don't have a very clear idea of what it means. They can be forgiven this confusion because Post-Modernists don't always know and, even when they think they do, often find themselves disagreeing. Like the Modernists before them, they are sometimes divided over central issues: whether their activities and program represent a fundamental break with the recent past and a negation of Modernism, or alternatively, a reweaving of this tradition with strands of western humanism.

Charles Jencks

The remarks of Kramer and Jencks invite attention to the obvious prominence to which the terms "modernism" and "postmodernism" have been elevated in current talk about art and, inevitably, in art-educational writing

and debate. But the harder I try to pin down what authors and speakers mean by "modern" and "postmodern," the more convinced I become that the confusion created by these terms has rendered them unhelpful for substantive educational discussion.

To indicate some of the problems, I begin with Jacques Barzun's observations about the ways art and attitudes toward art have changed over the last 150 years. He found it useful to date the start of *modern* times at about 1450 with the Renaissance, the modern *era* at about 1789 with the French Revolution, modern *manners* at about 1890-1914 or the turn of the century, and *contemporary* times at about 1920. This seems a sensible way to think about modernity, that is, to divide it into phases. Barzun thinks that modern culture had its formative period from 1890-1914 and that since then there have been no really new ideas in art, just throwbacks.[1] On the other hand, Ihab Hassan, a cartographer of postmodernism, finds postmodernism prefigured by Mannerism, Romanticism, and Modernism. He thus traces the roots of postmodernism to the sixteenth century, the period of the Renaissance. Hassan also believes that Freud, Marx, and William James have had a major influence on postmodernism; yet the same claim could be made about the influence of these figures on modernism.[2] A thick book titled *The Modern Tradition* reprints selections not only from the writers just mentioned but also from authors often associated with postmodernism.[3] What is more, postmodernism can be understood not only as a deliberate reaction to modernism but also as something that simply happened next, the way Postimpressionism followed Impressionism. And to treat postmodernism as a unitary movement in opposition to modernism is to ignore its dual nature. Jacques Maquet for one thinks there are two postmodernisms: a radical postmodernism that rejects modernism and another than rejects radical rejection.[4]

In the entry for modernism in the *Dictionary of Modern Critical Terms,* Roger Fowler states that "modernist art is, in its most critical usage, reckoned to be the art of what Harold Rosenberg calls 'the tradition of the new.' It is experimental, formally complex, elliptical, contains elements of decreation as well as creation, and tends to associate notions of the artist's freedom from realism, materialism, traditional genre and form, with notions of cultural apocalypse and disaster. Its social content is characteristically avant-garde or bohemian; hence specialized. Its notion of the artist is of a futurist, not the conserver of culture but its onward creator.... Beyond art's specialized enclave, conditions of crisis are evident: language awry, cultural

cohesion lost, perception pluralized."[5] This explanation equates modernism with the period of the avant-garde from 1890 on, but also with many characteristics often attributed to postmodernism. Fowler goes on to say modernism consists of several styles, encompassing, for example, Postimpressionism, Expressionism, Futurism, Vorticism, Dadaism, and Surrealism. It is worth noting that on Fowler's view modernism is not necessarily committed to formalism; most of the works and styles he mentions are notable for their semantic aspects—for content, moreover, that is often explicit, critical, and political. Those who have criticized modernism for an alleged indifference to social messages and issues have set up a straw man.

If the *Dictionary of Modern Critical Terms* contains an entry for modernism but none for postmodernism, the *Encyclopedia of Contemporary Literary Theory* contains an entry for postmodernism but none for modernism. This is baffling; since postmodernism is often characterized as a rejection of modernism, one would think an identification of the enemy to be in order. In the *Encyclopedia* article Linda Hutcheon attempts to find common denominators among such writers as Charles Jencks, Frederic Jameson, Jean-François Lyotard, Brian McHall, Jean Baudrillard, John Barth, Charles Newman, Ihab Hassan, Terry Eagleton, and Andreas Huyssen, but she is forced to concede that "there is no agreement on the reasons for its [postmodernism's] existence or the evaluation of its efforts" (612). What makes defining postmodernism so difficult is that for every idea, tactic, method, or style supposedly associated with it one can discover its opposite. For example, postmodernists are said, on the one hand, to be politically committed and, on the other, to be nonpolitical; to be for dissolving boundaries between art forms and types of culture (e.g., high and popular) and for preserving distinctions; to be for the rejection of modernism (whatever that is) and for its reintegration with traditional humanistic forms; to be for deliberate ambiguity and indecipherability in artistic expression (hence, some would say, elitist art for initiates) and for clarity of artistic statement. And, as I will discuss in greater detail later, many of the devices and methods Hutcheon ascribes to postmodernists— for example, their use of irony and systematic inversion, their playful and irrelevant eclecticism, and their preoccupation with the vagaries of language and meaning—are not original with them. These preferences can also be found in the work of artists, writers, and theorists associated with modernism.

The ambiguity of "modernism" is compounded by the word's ability to stand for a perennial occurrence as well as for a discrete historical phenomenon. As a recurrent feature in the history of art, "modernism" refers to those moments when artists attempted to move beyond tradition to something that was new, "modern," for their own time. (This is what Barzun had in mind when he said the Renaissance marks the beginning of modern times.) As a historical concept, "modernism" refers to the era of the avant-garde in the twentieth century. But in both senses modernism has a forward-looking cast: both imply an impulse to create new artistic values.

But this is not the whole story of modernism. While the Futurists and Dadaists (and other groups with similar aims) represent the more future-oriented stream of modernism, there was another that, although still progressive, was more respectful of tradition. This stream included such artists as Matisse, Braque, and Picasso whose works represent the continuity of artistic culture and a commitment to the renewal of its deepest values. These artists were convinced, however unconsciously, that they had to master tradition before they could alter and extend it. "The impulse to act as the creative conscience of a usable tradition," writes Hilton Kramer, was "as much a part of the avant-garde scenario . . . as the impulse to wage war on the past."[6]

While some knowledge of the emergence, career, and fate of the twentieth-century avant-garde, then, is central to any understanding of modernism, one approach to an understanding of postmodernism is through the realization that it appeared on the scene when the avant-garde had ceased to exist because it no longer performed its self-assigned function. The artistic revolution the avant-garde had sought to bring about has been successfully concluded, and art is now being taken in several different directions by artists who no longer feel obligated to work their way through tradition. Yet this is only one fact about postmodernism and does not explain the variety of its manifestations.

I have perhaps said enough in support of the contention that the terms modernism and postmodernism are too slippery for serious educational debate. Their usefulness has been further impaired by their frequent functioning as counters in ideological disputes. What is more, to my knowledge the literature of art education is at this point still without a well-developed position on either modernism or postmodernism. But Michael J. Parsons and H. Gene Blocker have made a good start toward one in their *Aesthetics and Education.*

Parsons and Blocker draw a comparison between the premises of postmodernism (admittedly "not a single theory but a loose collection of different views and movements") and modernism ("itself a vast and complex phenomenon that covers many tendencies and takes different shapes in different art forms"),[7] but do not promise any very specific recommendations or comprehensive hypothesis. Rather, they intend to extract what they find relevant in each outlook for purposes of thinking about contemporary art education. Parsons and Blocker locate modernism within the period from about 1870 to 1960 and take it to involve a positive attitude not only toward artistic and social progress, a traditional canon of works, and objectivity of interpretation and judgment, but also toward universal values and the autonomy of art.

According to the two authors, modernism's understanding of the history of art as a story of artistic progress is predicated on its belief in a continuing artistic tradition in which artists attempt to find themselves. Depending on their disposition, artists either work in an existing style or attempt to go beyond it in the hope of contributing to the advancement of art. The important point is that the direction of art is set by a slowly changing tradition. Picasso's *Demoiselles d'Avignon* (1906-7) is a case in point; it is significant primarily because it is a transitional work that represents a shift in artistic perception and expression. Given this view of tradition, the task for art-historical scholarship and criticism is to define the tradition and decide which works deserve a hallowed place within it. Such choices ultimately define a canon. Parsons and Blocker provide two illustrations of what they mean by a direction in a tradition: one toward the increasingly naturalistic representation of the world (as described by the art historian E. H. Gombrich), and another, in the modern period, toward greater abstraction (as interpreted by the art critic Clement Greenberg). The definition and description of artistic traditions thus enable judgments to be made about creativeness in art and what constitutes high art.

Another of modernism's assumptions is that those works that occupy a key place in the tradition of art perform an important social role: they reflect social change and help integrate new values into society. By experiencing such works the audience for art develops new ways of seeing and feeling, which attests to the educative power of art. I will have more to say about this function of art later on.

The definition and description of a canon of works springs from the conviction that universal values exist and that objective judgments can be

rendered. The belief in the possibility of objective judgments implies two further assumptions. One is that good and relevant reasons can be given in support of interpretations of artistic meaning and of estimates of artistic value and that judgments about the artistic merit of artworks can therefore be rational. The second presupposition posits a world of stable artistic objects accessible for inspection to those with the requisite degree of percipience, that is, to those with relevant skills and contextual information. This last point is generally put by saying that a work of art makes certain demands that percipients must be prepared to meet and to take account of in any interpretation.

As for postmodernism, Parsons and Blocker think it is best understood through its critique of modernism. Its origins lie in European philosophy, and its theoretical foundations and style are largely alien to Anglo-American traditions of philosophizing. The first modernist assumption rejected by postmodernism is the idea of *a* tradition and *a* canon of great works. Postmodernists substitute for these the notion of multiple traditions and histories of art, none of which is inherently superior to any other. Pluralism and simultaneity replace monism and linear direction. Because postmodernists believe that politics rather than artistic or aesthetic considerations ultimately determine what is accepted as worthwhile in art, they launched the project of decanonizing works previously considered canonical on the basis of their supposed artistic excellence and historical influence. Postmodernists thus claim that works traditionally designated masterworks reflect the power and hegemony of the dominant group in a society. Since for postmodernists all human thought is ineradicably political in nature, the decision to study one tradition rather than another always flows from a desire for power and is thus arbitrary. A feminist art history, write Parsons and Blocker, "would be no more true than what we now have; it would simply represent a political decision to support a different social group" (55). The views just outlined explain the postmodernist's disposition to draw attention to art that has not been featured in the traditional canon. There being no objective grounds for choosing one kind of art or tradition over another—everything is a matter of political preference—the postmodernist opens the floodgates for a radical pluralism.

Parsons and Blocker do admit the truth (which implies *their* commitment to the notion of truth) in the postmodernist's claim that completely objective judgment of anything is impossible and that reality is a function of our interpretive schemas. But I add that the indispensability

of interpretive schemas for achieving understanding is not an insight peculiar to postmodernists. The idea of theory-dependent observation, that is, observation shaped by interpretive frameworks, has been around for some time. Blocker himself has written persuasively about the ways concepts configure reality and influence our experience of art.[8] Yet Parsons and Blocker do not go so far as some postmodernists do who deny that there are stable art objects whose conventions and properties are the means by which respondents make sense of them—along with, of course, the knowledge and experience that percipients bring to a work. Parsons and Blocker do not rule out the possibility of intersubjective agreement among persons sharing a conceptual framework or tradition. On their view, cumulative growth in understanding and appreciation is possible. Nor do Parsons and Blocker underwrite the extremes of reader-response theory (applicable also to viewer-response) according to which works of art are quite literally created by readers and perceivers. Rather, they acknowledge the existence of art objects and the constraints their features and contexts place on interpretation. According to Parsons and Blocker, so long as such notions as truth, rationality, and objectivity are not taken in an absolutist sense, they are still serviceable and need not be banished. Indeed, it's difficult to see how daily, ordinary life, let alone scholarship, could be carried on without them. In sum, postmodernists are simply unconvincing when they hold that artworks have so little presence or determinateness as to provide nothing but faint traces for the creation of the real works of art (or "texts" as postmodernists call such interpretations) by interpreters.

It remains to indicate some of the consequences for art education if it were to follow the path of extreme postmodernism. Comparative judgments of meaning and merit would be ruled out; the obvious fact that some performances are better than others and that some are even excellent could no longer be countenanced. Rendered useless would be the educative critic who assumes responsibility for pointing out features of works that are worth noting and taking delight in; abandoned would be the idea that a work of art is a humanly made artifact that has the capacity to induce aesthetic experience for the sake of its constitutive and revelatory values. Nor would it make any sense to preserve works of art in cultural institutions or expend funds on efforts to replenish aesthetic wealth, for extreme postmodernism literally denatures art and deprives it of every function it has traditionally performed. Despite all this, the premises of extreme postmodernism are reiterated at art education conferences and repeated in the literature of the field, to the dismay and puzzlement of many.[9]

Parsons and Blocker do not endorse extreme postmodernism, nor, I think, should the field of art education. Extreme postmodernism compromises any case that could be made for art education; since it posits neither a characteristic function nor a unique value for art, it provides no reason for teaching it. Art education is endangered enough; subscription to extreme postmodernism would be a death wish.

How, then, would one describe Parsons and Blocker's position? Although they have said that the question is not whether to accept either modernism or postmodernism but to use what makes sense in each, I think their discussion can be interpreted as a modified modernism tempered with some postmodern reminders. It might even be said that they have rescued modernism from its most radical critics. For, once more, the features Parsons and Blocker find acceptable in postmodernism are not ones, I think, original to it; and their rejection of other postmodernist features has the effect of reinforcing some of the basic premises of modernism. This is apparent when they write that "we should be skeptical of the more extreme claims about the failure of basic distinctions [e.g., between truth and falsity, reality and appearance, objectivity and subjectivity, etc.] and should continue to do what makes sense to us, not absolutely in all times and places but in our own time and place" (65).

The recommendation to use what makes sense to us and to allow us to go about our business prompts a brief consideration of another facet of postmodernism: the philosophical expression of it known as deconstruction. Joseph Margolis understands deconstruction as a tale that encourages humility in our quest for truth.[10] Its thesis, says Margolis, "is simply this: that proposals of *any* kind that presume to match language with reality (a reality independent of language and unencumbered linguistically)—so that the structures of the latter are correctly represented in the former, yielding truth—are forms of radical delusion" (91). He thinks that this thesis is reasonable enough and becomes suspect only when it degenerates into an exaggerated form of intellectual play. But of deconstruction generally he says that "*it literally does nothing*. Its best role is to nudge us from within, while we do what we do—what we cannot afford to ignore all the while the deep mortality to every possible way of understanding . . . sinks in" (94). Deconstruction thus does not yield a better philosophy, linguistics, psychoanalysis, or criticism. Its contention that there are numerous ways of configuring reality, all of them equally valid, amounts to nothing new. We

have read it in any number of philosophical, psychological, and theoretical works that stress ways of knowing, forms of understanding and representation, realms of meaning, and types of intelligence.[11] It seems to me that deconstruction is distinctive not for the novelty of its assumptions but for the playful, ironic, irreverent style in which they are usually stated by exponents—often, though not always, in pursuit of a political agenda. This style of presentation appeals to certain kinds of intellectuals and political fellow travelers but is inappropriate for serious discussions of such matters as education.

To add a personal note: if theory-dependent ideas of observation and interpretation are at the heart of deconstruction, then I first encountered and accepted them in the late 1950s and 1960s when I became interested in the nature of scientific and historical explanation. This interest influenced my selection of writings for *Aesthetics and Criticism in Art Education* (1966).[12] Prior to that time I had become familiar with the tentativeness of truth claims in the writings of John Dewey. From Dewey I learned that the most we can hope for in the way of knowledge are warranted assertions. We are able to uncover inadequacies in our understanding, but absolute certainty will always elude us. I have always been convinced that the accent must be on the *quest* for truth, not on arrival at an ultimate resting place.

It is one thing, however, to recognize what is true in deconstruction (although ironically deconstructionists deny the possibility of truth) and to place that insight in proper perspective by assigning it a cautionary role; but it is quite something else to be indifferent to deconstruction's political, even revolutionary, dimension. I'll call this dimension deconstruction*ism*; it is deconstruction flexing its political muscle. The chief proponents of deconstructionism are the new celebrities of academia who benefit greatly from its largesse and command prestigious positions. Their status and glamor are not lost on prospective members of the professoriate who realize early in their graduate studies which intellectually correct road will take them to successful careers in higher education, especially in the humanities. These matters aside, my concern here is with one of the deleterious effects of deconstructionism, namely, a radicalized and politicized conception of art education.

One feature that should make deconstructionism most unacceptable to educators is its abandonment of the empirical ethos in favor of what Frederick Crews calls "theoreticism," or "frank recourse to unsubstantiated theory, not just as a fact of investigation but as anti-empirical knowledge in

its own right."[13]Heralding it as freedom from fact, theoreticism encourages the manipulation of data, the substitution of subjective impressions for objective findings, and what can only be called outright fabrication. David Bromwich remarks that basic errors of interpretation, which ordinarily would defeat the credibility of a thesis, no longer prevent its publication, for writers' interests and motivations no longer lie in contributing to knowledge but somewhere else.[14] But once the empirical checks on scholarship are lifted, almost anything can be asserted. If the research community of art education were to subscribe to theoreticism, it would literally discredit any pretension to professional status the field now has. The NAEA's research agenda for the future, or any kind of empirical research, would be rendered meaningless. Not only that. M. J. Wilsmore writes that "deconstructionist skepticism, taken to its logical conclusion, would deny the existence of art altogether. It ceases to express itself within the artistic forms of humanism and ends in nihilism."[15] The deconstructionist premises discussed earlier make it easy to understand why Wilsmore reached this conclusion. She is one of a growing number of critics who are exposing the internal contradictions of deconstruction.[16]

Since empirical research and its findings do not preoccupy deconstructionists, what does? It is "the work" or "text," which deconstructionist analysis regards at least three ways: (1) as a collection of signifiers that refer only to other signifiers, all of which are inherently ambiguous and therefore permit only misreadings; (2) as an instance of the cultural reproduction of the power and authority relations in a society; and especially (3) as a reflection of such authority relations (and we are talking essentially about Western works and texts) that are a function of race, class, and gender. Now once a work has been analyzed and dissected under all these categories, there isn't much left of it that can be called art or aesthetic value or that one could take delight in (which is why Marcia Eaton disagrees with Marxists and deconstructionists: they deny that there is anything special about art or the way we treat it).[17]

I've said that deconstructionist analysis is practiced primarily in departments of English and literature where its principal target is traditional literary criticism. But from English departments it is finding its way into other areas of study, for example, communications, feminist and ethnic studies, law, art history, and educational theory, including the theory of art education. By undermining assumptions that are taken for granted by traditional criticism, deconstructionists hope to strike a telling blow against

Western civilization's core values, that is, its commitment to truth, rationality, objectivity, meaning, and communication. Deconstructionists see these core values as the results of what they call logocentrism (also called phallocentrism) and thus as reflections of a white male, patriarchal, Eurocentric bias, and they denounce this bias for its inherent racism, sexism, and elitism.

One reason given for academia's susceptibility to politicization (more in evidence now than when *Excellence in Art Education* was published) is the recent bankruptcy of Marxism and other socialisms.[18] This collapse has sent intellectuals in search for a new target on which to vent their adversarial impulses. The new approach settled on is one that creates havoc with linguistic structures. The hegemony of the state will be dissolved through dissolving the hegemony of language. By exposing language as an oppressive yoke, deconstructionists seek to change the status quo toward a freer, more humane, and presumably socialist society. The politics of deconstructionism is obviously not the politics of the streets and barricades or of revolutionary parties and workers' collectives; it is a politics of language. The terminology may be different from the days when Marxism held open sway in English and humanities departments, but the strategy is the same: tenured radicals, and those hoping to gain tenure, teach their doctrines and either convert or exact compliance from students whose academic careers they hold for ransom.

Modernism and postmodernism may now be compared with respect to the enemies each attacks. The assault that deconstructionism, the political arm of postmodernism, has launched on the allegedly Eurocentric dominant class may be said to be a continuation of the war on the middle class waged by the artists and writers of the modernist avant-garde. The avant-garde's hatred of the bourgeoisie escalated into a comprehensive critique not only of middle-class tastes and manners but also of the entire commercial system managed by that class. The method of attack was savage ridicule—*épater le bourgeois*—or shock the stuffed shirts. Deconstructionism, on the other hand, concentrates its antagonism less on manners and morals than on the imputed oppression of language and social structures. The difference between the earlier artistic avant-garde and its contemporary deconstructionist counterpart lies in the latter's penchant for irony and linguistic play that is at odds with, and helps disguise, the seriousness of its political aims. But it is, as already indicated, precisely this dual aspect of deconstructionism—

revolutionary intent combined with disingenuous insouciance—that attracts academic intellectuals. They play scholastic games within the safety of the institution they defame and detest even while it showers them with rewards that they eagerly accept. At least members of the avant-garde took risks with their livelihoods and often had rough times.

I've used the words "bourgeois" and "bourgeoisie," and it will be helpful to examine their meanings in some depth. Today, of course, the terms have only negative associations. I have often asked colleagues how they would class themselves but have found no one who—despite an above-average income and level of consumption—admitted to being bourgeois, or middle class. For to do so would imply subscription to philistine tastes in matters of culture, conventional morality, and the capitalistic system of production and exchange; worst of all, it would suggest conformity and a lack of social passion. But since it can be said that the French avant-garde's contempt for the bourgeoisie continues unabated today in certain forms of postmodern art and the adversarial disposition of deconstructionism, it is worth trying to discover the real identity of the enemy in question. Is there a human type who is the intrinsic bourgeois, or is the bourgeois a strictly historical phenomenon? Is the bourgeoisie identifiable as a unified class? Are its values truly reprehensible? Or is it possible that the bourgeois has merely been a convenient scapegoat for modernists and postmodernists alike?

Let Jacques Barzun, a cultural historian and critic with great expertise in the history of modern French culture, once more be our guide. His *The Use and Abuse of Art,* published in 1974, remains relevant and was indeed prescient in ways Barzun could not have realized. His aim is to examine Art (with a capital A) as a force in contemporary society.[19] He writes "that if art has importance, it is because it can shape the minds and emotions of men. It can enlarge or trivialize the imagination. If it can do so much, it affects the social fabric as well as individual lives for good and evil" (17). In the course of discussing art as a power, Barzun examines a number of what he calls thought clichés that have shaped modern attitudes toward art, one of which bears directly on the topic at hand—the bourgeoisie as the object of continuous criticism from the ninteenth century to the present.

Barzun's remarks about the bourgeois occur in the course of an interpretation of modern art that features discussions of art as religion, art as destroyer, and art as science. I will concern myself with the first two topics, for they identify two sides of the same coin: each illustrates a strategy in a

joint campaign to rid society of bourgeois taste and morality. Art taken as religion travels the higher, more spiritual road by proclaiming that the experience of art is a superior, transcendent experience. The idea of art as destroyer is the more revolutionary of the two, trying to employ various means to usher in a new social order. As Barzun puts it, the transcendental artist and the revolutionary artist fight side by side against the same enemy, the bourgeoisie that manages the world of business and commerce. Thus in his novel *Mademoiselle de Maupin,* Theóphile Gautier, a French poet and painter, rails against the bourgeoisie. "By Gautier's definition," writes Barzun, "the bourgeois is stupid, stubborn, crass in emotion, selfish in behavior, totally insensitive to beauty, passionate only about the useful and the profitable [and] fit only to manufacture chamber pots" (36-37). Such disgust and scorn, echoed by countless artists, poets, composers, novelists, and intellectuals, facilitated the emergence of what Barzun calls the Art Epoch in which art now reigns supreme. Similar sentiments seized a literary "Who's Who" of modern authors. Barzun cites George Bernard Shaw for an encapsulation of the new religion of art. In *The Doctor's Dilemma,* Shaw has the painter recite the following credo on his death-bed: "I believe in Michelangelo, Velázquez, and Rembrandt, in the might of design, the mystery of color, the redemption of all things by Beauty everlasting, and the message of Art that has made these hands blessed. Amen. Amen" (46). But recitation of a credo was not enough; action was called for. Hence there came into being the abolitionist phase of the avant-garde with its campaign to clear the field of the infidel, the bourgeoisie. (I will join Barzun in the use of his term "abolitionists" to refer to those in active opposition to the bourgeois system and its values.) The zenith of abolitionism occurred during the years from 1890 to 1914, a period that, to repeat, Barzun considers the most formative for modernity and one on whose ideas the Art Epoch, in which we still live, continues to feed.

The social ideas of the bourgeoisie having been equated with filth and rubbish, the problem for abolitionists became how to sweep it all away. A literal army of destroyers, says Barzun, combined to do the job. Artists from England, France, and Germany were in the advance ranks, guided by a general staff consisting of the creative geniuses and critics of the time: Ibsen, Nietzsche, Swinburne, Walter Pater, Oscar Wilde, George Moore, Rémy de Gourmont, Samuel Butler, Anatole France, H. G. Wells, Romain Rolland, Clive Bell, and Roger Fry, to name some of the more illustrious. Ultimately this horde of abolitionists combined to demolish the Victorian ethos of the bourgeoisie.

How was the war won? With proven methods: ridicule, exaggeration, and systematic inversion. The latter consisted of showing that everything was the exact opposite of what it seemed. Thus reason was supplanted by unreason, love by hate, and ideals by selfishness—all examples Barzun garnered from Shaw's writings. In other words, the accent was on the negative, which ultimately, writes Barzun, "perpetuates itself as a habit of thought—it becomes the highest form of self-consciousness—and it destroys everything in the most direct way, not by physical means, but by corrosion of the seat of faith and action, the human mind" (51). What is more, Barzun believes that inversion leads to subversion: reiterate often enough that an entire civilization is vile and you set the stage for anarchy and radical change. (The image of abolition by systematic inversion is, I think, an apt description of the methods of the deconstructionists among us. Influential voices in academia today are droning the message that nearly nothing is right about Western civilization.)

The villain in Barzun's piece is French Symbolism, which he thinks had a prominent part in shaping contemporary views of culture. Why Symbolism? Because it revels in enigmas, allusions, suggestions, evocations, and mysteries—everything that stands in opposition to the clearly definable, tangible, and down-to-earth. In Symbolist theory the only reality is the reality of art. It is not true that Symbolists were against life; it was merely that they saw art as life itself, providing all of its most exalted moments. Art, in short, was thought to be the source of spiritual value and nourishment for the soul.

Barzun's analysis acknowledges that abolition is neither the only strand in modern art nor expressed solely through Symbolism. In literature, for example, the style of Naturalism pursued the same goal of criticizing society by describing its failings in such graphic detail as to produce revulsion against it. "The naturalistic novel," writes Barzun, "exhibits the underside of society. Its aim is to expose, to face the philistine with the horrors that his social organization creates and his complacency ignores" (56). A proper effect of such writings is the bruised soul, not catharsis. Barzun does not deny that the barrage of criticism by enemies of the bourgeoisie has had some positive, reformative effects; he is no apologist for middle-class smugness or capitalist excess. But as a historian and interpreter of culture, Barzun is more concerned to point out the abolitionists' exaggerations, oversimplifications, and hypocrisies and the ironies and unintended consequences they produced.

One of the ironies was the unanticipated commerical success of avant-garde art. The bourgeoisie gradually became inured to shock and accustomed to art designed to outrage. By buying vangard works as status symbols to decorate homes and offices, the bourgeoisie effectively rendered avant-gardists impotent to achieve their declared revolutionary objectives. More ironic still, some venture capitalists even began to draw parallels between their own daring commercial initiatives and the bold spirit that suposedly animated avant-garde artists.

An unforeseen consequence of abolitionism was that avant-garde artists set the style and manner for an entire class of the perpetually aggrieved, a class that is still very much with us. For whatever victories the avant-garde may have won in the art world, the attacks continue. In fact, writes Barzun, "The great grievance against the world now felt by many, almost without thought, is the grievance of the artist; or to put it more exactly, whatever the source and substance of the contemporary grievance, of the outraged protest, it regularly assumes the forms that artists have made canonical for the last hundred years" (58). What explains the persistence of the outcry? One reason Barzun identifies is the artists' need to hold someone responsible for the difficulties they experience, for their inability to achieve the recognition they think they deserve, and for the duties and responsibilities of ordinary life that keep interfering with their work; so middle-class society and "the system" are conveniently blamed. It is as if, says Barzun, artists yearn for a completely unconditioned existence. Another reason is society's failure to measure up to artists' expectations. The world has simply refused to conform itself to the early abolitionists' dream. Instead of becoming more socialist, most (though of course not all) societies have been moving toward liberalism, democracy, capitalism, and individualism. In brief, we live in an increasingly middle-class world. That being the case, it is important that we achieve a less distorted view of the bourgeoisie than its vociferous critics have presented, and Barzun helps us do that.

Barzun first draws the distinction already alluded to, that is, between the historical bourgeois as a member of a class identifiable at different times in history and the intrinsic or universal bourgeois as an individual with certain characteristics. He then discusses the nature of bourgeois values and indicates some of the consequences of the war against them.

"Bourgeois" means townsman, and historically, beginning well before the twelfth century, we find such people in the great urban centers of Europe; in fourteenth-century Italy, for example, they were artisans and

bankers in Florence and merchants and sailors in Venice and Genoa. The same was true in Holland, another maritime nation. In England and France they ran efficient bureaucracies and waged civil wars on each other. The bourgeoisie spurred on the Renaissance in Italy and in Holland created an atmosphere in which Rubens and Rembrandt could create their art. Because of its wealth and power the bourgeoisie was sometimes equated with the ruling class, and in fact the line between the bourgeoisie and the aristocracy became blurred as both classes intermarried and rich merchants purchased aristocratic titles.

The intrinsic or universal bourgeois was described by the French historian Taine as the petite or filthy bourgeois. But, as Barzun points out, this is only one of the type's manifestations. It is composed of creatures of low thinking and feeling who place a higher value on utility and materialism than on matters of the spirit, such as the love of serious art, and whose careers in government rendered them not only passionless, politically and religiously benign, abut also unimaginative, unenterprising, overly cautious economically, and generally vulgar, especially in their tastes for culture and home decoration. Taine had thus sketched the caricature to which later abolitionists would add their own touches.

But the caricature didn't capture the reality. As a member of the wealthiest and, in many societies, most powerful class, the bourgeois could hardly have been politically benign. As a business entrepreneur in control of the levers of commerce, the bourgeois was often daring and adventuresome. As a patron of the arts, the bourgeois frequently exhibited enlightened cultural tastes. Furthermore, the bourgeois of the English manufacturing class responsible for intolerable living and working conditions during the period of industrial expansion had little in common with the bourgeois who led the revolution in Russia.

In short, whether "bourgeoisie" and "bourgeois" refer to a social class or a character type, the many denotations and connotations of the words, that is, the great variety of manifestations and permutations they refer to, present too slippery a target for simple-minded assault by the avant-garde, modernists, or postmodernists. But one need not be content with having blunted the attack, for several things can actually be said in defense, indeed in praise, of the bourgeoisie.

Barzun points to the obvious: the battle against bourgeois values was destined to fail inasmuch as all modern societies literally take them for granted. These bourgeois values, moreover, are composite in origin, which

may help explain the breadth and durability of their appeal: from the aristocracy (many members of which were bourgeois-*cum*-nobles) comes the value of courtesy; from the artisan class, respect for work and workmanship; from tradesmen, the demand for peace and public order; from science, warranted assertions; and from political liberalism, democratic institutions and sentiments. Bourgeois values also contributed to the creation as well as to the love of great art. This said, we are now in a position to understand and appreciate the words of Albert William Levi, a philosopher of culture and the humanities, when he defends bourgeois values. Levi is not oblivious to the great harm caused by the excesses and vices of capitalistic entrepreneurship; but he thinks that such excesses do not necessarily constitute an indictment of bourgeois values themselves. His reading of modern cultural history convinced him that

> most of what we hold praiseworthy in moral fineness, intellectual achievement, and artistic excellence is due to the nourishment of the bourgeois spirit. Liberalism as the quest for freedom and the realization of the individual, humanism as the flowering of reason in sympathy and compassion, art as the perfection of form, are all since the 16th century the product of bourgeois energy and middle-class culture. To them we owe Vermeer, Rembrandt, and the great Dutch painting of the 17th century; the Austrian school of Haydn, Mozart, Beethoven, and Brahms; the essays of Locke and John Stuart Mill; Milton, Wordsworth, and Keats; the philosophy of Kant and Hegel; Manet and Cézanne; the novels of Balzac, Dostoevsky, Thomas Mann, and Marcel Proust; the poetry of Eliot, Wallace Stevens, and William Carlos Williams.[20]

Most of what has thus far been said about the relationship between the avant-garde and the bourgeoisie seems to imply an unbridgeable gulf, an unremitting enmity. This impression should now been meliorated. The antagonism often amounts to mere posturing on the part of artists, for there may be some similarities—as there certainly have been accommodations—between the camps, a possibility acknowledged by Barzun and given some interesting glosses by Joseph Epstein and Hilton Kramer. Both the avant-garde and the bourgeoisie can be seen as energetic, inventive, enterprising, serious, critical of tradition, and willing to take risks; in short, each group has been creative in its own way. It would thus appear that unregenerate abolitionists are beating a dead horse.

Epstein gives examples of how culture has done relatively well under capitalism and much less so under socialist or totalitarian regimes.[21] In democracies, artists at least know that they are in business for themselves and won't be incarcerated or murdered. Much of the recognition artists receive in modern bourgeois societies, moreover, comes from corporate patronage through foundations and charitable activities. Such patronage isn't necessarily prompted by guilt feelings or the prospect of pecuniary gain but by genuine pleasure in supporting the arts. It would be uncharitable to suggest that investment motives alone led the Rockefellers and others to collect art and then donate whole collections to museums. In their largesse modern capitalist philanthropists are much like the merchant princes of Florentine, Italy. Furthermore, there are few artists who turn corporate representatives away from their studios, especially when they have come to purchase work not even finished.[22] Artists know that recognition and success tend to be tied to a certain economic status. As for the artist's relation to the government, Epstein writes that "an artist who takes the taxpayers' money to attack the cherished beliefs of taxpayers and then pleads his rights as an artist to do so is pretty much in the position of the young man who murders his parents and then throws himself on the mercy of the court because he is an orphan" (35).

Kramer—though like Levi, Barzun and Epstein no uncritical admirer of the bourgeois or an apologist for unchecked capitalism—points out that in their attitude toward the avant-garde the bourgeoisie remained true to their liberalism. This liberalism implied tolerating alternative beliefs and trying to see some merit in the critique of bourgeois values. Many among the bourgeoisie came to repent their stuffiness and recalcitrant attempts to preserve what had become a moribund artistic culture. The bourgeoisie, then, had its reactionaries who clung desperately to tradition and its progressives who were more receptive to innovation. Similarly, Kramer explains, the avant-garde had a revolutionary side (its abolitionists) and a progressive side (its creative revisionists).

Since I believe that this last observation also applies to postmodernism, I am now in a position to return once again to that topic. I infer from the earlier discussion of postmodernism that it, too, has a revolutionary and a progressive side, a point that now can be made more explicit. As said, I take deconstructionism to be the revolutionary arm of postmodernism. In its hostility toward the rational values of the Enlightenment it mirrors the

earlier abolitionist avant-garde, especially the Futurists and Dadaists among them, and it employs the same methods of ridicule, exaggeration, and inversion. Further, its origin is essentially French.

The other, more progressive side of postmodernism is evident in the writings of Charles Jencks, a British architect, historian, theorist, and critic.[23] Jencks thinks that among the postmodern styles he has examined the one he terms Free-Style Classicism is the most fruitful. This style integrates modernist forms with traditional forms of humanism, especially in architecture, although Jencks also discusses painting and sculpture. Jencks's statements are in effect reminiscent of Kramer's discourse on the dialectic between the avant-garde and the bourgeoisie and Maquet's positing of the existence of two postmodernisms, one radical and one more conservative. Although the writings of Kramer and Jencks exhibit some important differences in outlook and style, I am interested in the similarities they share.

Writing as a critic, Jencks considers it his task to provide an interpretive framework that, while doing justice to the characteristics and values of new (postmodern) art, also sets present and past works into a new relation that alters the entire cultural landscape and the way we talk about it. Like Kramer, Jencks finds T. S. Eliot's influential essay "Tradition and the Individual Talent" useful for his purpose.[24] In this celebrated essay Eliot voiced, among other things, the belief that the creation of significant new artworks changes our perception of existing works and our understanding of the relationships among them. Jencks thinks of postmodern art and architecture as a reweaving of modernism with strands from classical Western humanism and therefore disagrees with those holding that postmodernism constitutes a rupture with the past or the negation of modernism. Instead, he discerns a creative dialogue between the immediate and the remote past.

> Since the end of the 1970s the majority of Post-Modern artists and architects have taken a diverse tradition and consolidated it with what I call Free-Style Classicism—a rich, broad language of form, going back to Greece and Italy, but also to Egypt and so-called "anti-classical" movements such as Mannerism. In effect they have returned to the archetypes and constants which underlie Canonic Classicism, those that are familiar to everyone who has looked at a Poussin or strolled through a Palladian house. The result is an eclectic mixture which freely combines elements of Modernism with the wider classical tradition (7).

The term "free" in Free-Style Classicism does not imply a lack of discipline or rules, nor does "classicism" suggest merely another revival of classical forms, another moment of perennially recurrent neo-classicism. Rather, it is a creative, inventive eclecticism that Jencks describes, one that combines ideas, materials, and forms in surprising ways. Nor does Jencks mean to say that Free-Style Classicism has preempted the field; other styles continue to flourish. Jencks is more interested in the general significance of a dialectic between modernism and classicism than in any particular fashion.

I pass over many of Jencks's interesting remarks about the various streams of postmodern classicism—five in painting and sculpture (metaphysical, narrative, allegorical, realist, and classical) and four in architecture (fundamentalist, revivalist, urbanist, and edectic)—(which recalls Parsons and Blocker's remarks that postmodernism is not one thing but many) and stress instead the importance Jencks attaches to tradition. Underlying a return to tradition, he says, "is the idea that, in its continuous evolution, the classical language has been transformed and ties generations together in a common pursuit" (317). That is to say, "Post-Modern Classicism evolved out of the modernist classicism of Le Corbusier, Mies, and Louis Kahn; Carlo Maria Mariani evolved from de Chirico; Kitaj and Hockney owe a debt to the Cubism and classical work of Picasso; and the work of Lennart Anderson and Milet Andrejevic springs from Morandi, Balthus and other Modernist painters" (329). Jencks calls postmodern classicists "born-again classicists," as if modernism's "tradition of the new" had grown stale and has now been replaced by a conception of tradition as an organic continuum.

There may be a superficial similarity, in intention at least, between the postmodernists' attitude toward the past, as interpreted by Jencks, and the uses of tradition made by Matisse, Braque, and Picasso, as described by Kramer. The difference, says Jencks, is that the postmodernists' relation to tradition is more paranoid; it is "equally determined to retain and preserve aspects of the past as it is to go forward; excited about revival, yet wanting to escape the dead formulae of the past. Fundamentally it mixes the optimism of Renaissance revival with that of the Futurists, but is pessimistic about finding any salvation point, be it technology, a classless society, a meritocracy or rational organization of a world economy" (349). Such doubts and oscillations could not be ascribed to either the revolutionary or progressive sides of the avant-garde. The Futurists knew precisely how they felt about the past (even though, as Kramer points out, their works showed some stylistic continuities): they preached destruction and violence and

advocated the demolition of museums. And the progressive side of the avant-garde did not, at least in their rhetoric, advocate a playful and ironic eclecticism; it was deadly serious. This earnestness was repudiated by the pop artists and practitioners of anti-art in the 1960s and 1970s, and when serious-mindedness returned to art in the 1980s and 1990s, it often took the form of blatant propaganda. The Whitney Museum Biennial exhibition of 1993, for example, represents a foul high-water mark of all that has gone wrong in recent art. Critics from widely separated points along the political spectrum deplored the show and were united in their condemnation. If proof were needed that a work of art is more than a vehicle for ideological messages and an art museum more than a venue for the display of political correctness, the Whitney show provided it.[25]

It will be helpful to recall the road traveled in this chapter. I offered reasons for my opinion that the terms modernism and postmodernism are not useful for substantive debates in art education—and now at the end of a long chapter I still believe that to be true After summarizing the discussion of modernism and postmodernism by Parsons and Blocker, I drew attention to the revolutionary and progressive sides of both the avant-garde and the bourgeoisie and added a description of the bourgeois and bourgeois values meant to correct the received stereotype. I also drew an analogy between the revolutionary and progressive sides of the avant-garde and the revolutionary and progressive sides of postmodernism, for example, deconstructionists as against free-style classicists, or latter-day abolitionists as against creative revisionsts.

9

An Excellence Curriculum, K-12

When we perceive the arts as "humanities" it is crucial that we interpret them as a demand that we pause, and in their light, reexamine our own realities, values, and dedications, for the arts not only present life concretely, stimulate the imagination, and integrate the different cultural elements of a society or of an epoch, they also present models for our imitation or rejection, visions and aspirations which mutely solicit our critical response.

Albert William Levi

The discussion of an excellence curriculum in this chapter differs from that in *Excellence in Art Education* in three ways: it discusses a K-12 excellence curriculum in the visual arts in contrast to an emphasis on an arts education requirement for the secondary years; it sets out in greater detail the teaching of art as a humanity, or from a humanities point of view; and it takes into account literature that has appeared since the mid-1980s as well as my own recent thinking.[1]

 Excellence in Art Education pointed out that the books by Goodlad, Boyer, and Sizer reflected an interest in studying schooling in its more global aspects, in contrast to a tendency to concentrate on its more discrete features. The latter approach, they believed, encourages excessive reductionism in thinking about teaching and learning. There was impatience, for example, not only with the mechanistic conception of human behavior exemplified by behavioral learning theory but also with the practice of

assessing effectiveness along only a few of the dimensions of schooling. Dissatisfaction with the shortcomings of behaviorism helped to bring about a cognitive revolution in learning theory that is yielding insight into the ways the human mind acquires knowledge. Unhappiness with excessive reliance on the quantitative measurement of educational achievement has generated a literature of educational evaluation that derives models from such diverse fields as anthropology, investigative reporting, and art criticism. Whether these new conceptions of educational evaluation will change established and entrenched modes of assessment—for example, standardized testing—is not certain. Yet their fundamental assumption must be acknowledged: educational evaluation is more than a numbers game.

An excellence curriculum acknowledges the need to go beyond the quantitative measurement of learning and school effectiveness. It also appropriates some of the insights of the cognitive revolution as an aid in justifying art education as an academic subject in the curriculum, which was one of the aims of the 1980s' excellence-in-education movement. An "academic" subject is understood here as one that has its own aims and values, methods, history of accomplishment, and critical issues. When I call art education an academic subject in this sense, however, I do not intend to deny a role for creative activities, feelings, and imagination in aesthetic learning. The discussion of aesthetic experience in chapter 4 should have made that clear.

My emphasis on art education as an academic field of study recalls the point made in *Pride and Promise: Schools of Excellence for All People,* discussed in chapter 1, that the development of intellectual power is the primary purpose of schooling. This bears repeating in light of Toch's study of schools discussed in chapter 3. There I also said that the development of intellectual power is not ensured by mere listings of basic concepts and skills; to a large extent it is necessary to specify content and its organization. An excellence curriculum therefore provides that at appropriate times the young will study certain kinds of art, for example (though not exclusively), masterpieces, exemplars, and often works that are excellent representatives of their kind.

I am *not* saying that this exhausts the content appropriate for study. The rich apperceptive mass needed for the appreciation of artistic excellence is built up not only through exposure to artworks but also through acquaintance with art history and many other things besides, including experiences that help develop a sense of the art world, to borrow a term from Arthur

Danto.[2] For it is the art world that determines the atmosphere in which one identifies and engages works of art, and entry into that world presupposes some knowledge of art's history, criticism, and theory. In more concrete terms, a sense of an art world is simply an interpretive framework for experiencing art. (Once more, my insistence on building a contextual framework for art experiences should acquit me of the charge of formalism that some reviewers of *Excellence in Art Education* had brought.) But of course the capacity to understand and appreciate excellence in art is developed gradually through phases of learning, each of which helps prepare the way for the next. This is why the idea of sequential learning is important in an excellence curriculum, a point that is also central to the Paideia Program and the idea of discipline-based art education.

An excellence curriculum then calls not only for teaching basic concepts, skills, and content, but also for organizing knowledge along predetermined lines and steering learning in a definite direction. Introductory and survey courses should precede exemplar appreciation, with the study of critical issues to follow. The same applies to teaching method. As the young move from phases of learning that center on creative activities and aesthetic perception to phases that develop a sense of art history, exemplar appreciation, and critical thinking, a full repertoire of teaching methods is brought into play: informal methods for guiding creative activities and the exploration of works of art and more formal methods for refining historical understanding, aesthetic appreciation, and critical thinking—in short, heuristic (problem-solving), didactic (imparting of information), coaching, and dialogic (Socratic) methods, among others.[3] There is no single method for teaching art, not even, as I once put it, the method of aesthetic criticism.

This section sets out to explore theoretical considerations relevant to a prototype excellence curriculum for art education against which other views and the reader's own conceptions may be compared. Given the realities of schooling today—budget reductions, controversy about the nature of art and its support, and conditions that seriously inhibit learning of any kind—my recommendations may seem unrealistic. I am convinced, however, that if art education is ever to be considered a serious subject in the curriculum, something similar to what I'm proposing will be needed. At a time when interest in school choice (among public schools or private schools) is increasing, it may well be that schools offering substantive programs in arts education will influence choice.

Discussions of what is involved in developing a disposition to appreciate the excellences of serious works of art quickly and necessarily lead into basic curriculum questions: what should be taught; how it should be taught and in which grades; how learning should be assessed; and, perhaps most importantly, how much of a segment of the school population should be captured by the art program. As to the last point, in a democratic society that regards access to excellence the right of all and not the privilege of a minority, an excellence curriculum for art education should be part of an education program that is both common and general. "Common" means that certain areas of study designed for the cultivation of worthwhile forms of human thought and feeling should be made available to all students, K-12. "General" implies the objective of developing interpretive understanding to roughly the same level in all students. From the premise that aesthetic learning affords possession of unique forms of understanding not provided for outside the arts, it follows that art education should be treated the same as other subjects, that is, as a separate area of study. To be sure, teachers of other subjects are free to use the arts toward their own, nonaesthetic ends, but in doing so they would not be engaged in art education or contribute to it. From antiquity on, serious art has been praised as one of humankind's supreme achievements and credited with powers to affect thought and action. We can cultivate and refine its appreciation only when we devote exclusive and sufficient time to it.

Although the idea that art is a distinctive form of human culture that has produced artifacts that, at their best, have the capacity to induce high levels of aesthetic experience has already suggested certain pedagogical considerations, many questions still remain to be answered. In particular, there remains the problem of the sequence and the various contexts in which aesthetic learning is to occur. Also unspecified is the degree of general learning to be aimed at or the length of time to be spent on various tasks. How much time should teachers allow for the creation of student works, the study of history and criticism of art, and the examination of the puzzles to which artworks often give rise? And there are other difficulties and ambiguities. For example, I've pointed out that art may be considered as form and content, an affirmation and a deception, purposeful and purposeless, personal and superpersonal, playful and serious, and so forth. How does one deal with these contradictions? Or consider the persistence of the maxim that there is no disputing tastes when in fact tastes are being disputed everywhere and at all times, and for good reasons. If one adds the multiple

164

perspectives that obtain on art and art education, how does one begin to put a curriculum together? What knowledge must one presuppose in curriculum designers, and ultimately in teachers of art and those who prepare them?

When one weighs different curriculum recommendations it is extremely important to try to discover whether their authors give evidence of a fundamental rapport with their subjects. Are writers primarily concerned with art and art education or with political, economic, social, and personal matters? The theorists of aesthetic experience and others discussed in this volume reveal the kind of understanding and love of art that make their positions attractive. Their sentiments and ideas stand in sharp contrast to those of writers whose interests lie elsewhere, quite possibly in objectives inimical to the serious study of art.[4]

The question of *what* should be taught sets two tasks: first, to describe the dispositions to be developed in art education and second, to describe the ideas and skills relevant to cultivating them. Doubtless art education strives to build certain general dispositions that schools attempt to foster through most of their activities, for example, the personal characteristics of being reasonable, compassionate, just, and civic-minded. But in addition to these generalized qualities, each subject requires for its mastery a range of more specific dispositions. In art education these would consist of tendencies to respect the discipline and craft of artistic creation, to comply with the demands of attentive perception, to appreciate the achievements of the cultural heritage, to attempt to understand ideas and feelings expressed indirectly or ambiguously in art, and to support and encourage artistic excellence. The point is that the most fundamental objective of art education is the development of dispositions relevant to the field, the most basic of which is the disposition to *use* in fruitful ways the acquired learning about art.

The most persuasive discussion of the uses of learning that I know of is contained in a book whose title is especially pertinent to the theme of this essay, *Democracy and Excellence in American Secondary Education*, coauthored by Harry S. Broudy, B. Othanel Smith, and Joe R. Burnett, with Broudy being the principal author.[5] After the authors' presentation of a case for a common, general education, Broudy analyzes learning in terms of the degree of mastery and appreciation to be aimed at within a subject or area of study. Broudy's theory of learning in this and his later writings asks us to consider what is involved in a nonspecialist's understanding of the basic situations of daily life—for example, reading a newspaper, following a

logical argument, contemplating a work of art, and making mathematical computations. Scholars working at the frontiers of their disciplines interpret situations by replicating, associating, and applying advanced professional knowledge for the purpose of solving complex, high-order problems. Ordinary, nonspecialist citizens grappling with life's perplexities also replicate, associate, and apply knowledge, but their knowledge is commensurate with the frames of understanding available to them. Ideally those frames will be adequate for ordinary situations, and they will have been built in substantive programs of general education. Applied to an excellence curriculum for art education, this means that students should be encouraged to develop the disposition to use their acquired frames of art-educational understanding in ways appropriate for generalists in order to interpret, understand, and appreciate the excellences of works of serious art. Young people are helped to achieve this goal because as receptive viewers they will be able to reap the benefits that worthwhile experience of serious artworks are capable of bestowing.

There still remain the questions of how to organize knowledge and skills and whether art education possesses a structure for doing so. The notion of a structure of knowledge, popularized by Jerome Bruner, evoked considerable interest in the 1960s and prompted art educators to ask whether their field qualified as a discipline with a characteristic order of ideas.[6] It soon became apparent that "structure of knowledge" functioned primarily as a slogan that stimulated educators and researchers carefully and systematically to examine the basic ideas of their respective subjects and to search for ways of teaching these concepts to young people.[7] In the natural sciences and mathematics, "structure" was usually understood to imply an order based on logical subsumption. Accordingly, the way one learned the structure of a field was by studying its logical organization of concepts. "Structure of knowledge," however, can also be less rigidly interpreted to refer simply to the ways ideas are organized for purposes of teaching and learning, and in this sense there can be several different organizations of knowledge in art education. I suggest one organization in this chapter.

In brief, the task is not to discover some preexisting structure of knowledge in art education that might be lying about waiting to be found, but to organize ideas and activities in order to achieve goals and objectives. The curriculum diagram in this chapter indicates relevant kinds of knowledge distributed throughout what may be called the aesthetic humanistic complex. This complex is composed of a number of contexts: the context

of artistic creation, which involves the making of art; the context of art history, which is devoted to the chronology, interpretation, and explanation of works of art in time; the context of aesthetic appreciation, which features acts of admiring responses to artworks; the context of critical judgment, which goes beyond acts of appreciation and emphasizes assessment of artistic value or merit; the context of critical analysis, which addresses perplexing puzzles and problems that often confound efforts to understand and enjoy art; and the context of cultural institutions on which works of art depend for their survival. Whatever knowledge is relevant to illuminating these contexts of study becomes part of the organization of knowledge of art education. This would include the disciplines favored by the Getty Center for Education in the Arts—artistic creation, art history, art criticism, and aesthetics—plus some others, for example, the psychology and sociology of art. What emerges from this brief discussion is that the field of art education does not rely exclusively on the knowledge of any particular discipline; it has a compound character and takes into account knowledge and skills from a range of disciplines that are relevant to teaching young people how to create, confront, and criticize serious works of art.

A second major curriculum problem concerns the question of *how* to teach a subject. This means that the characterization of an excellence curriculum and an explanation of its enabling organization of knowledge must be supplemented by a few remarks about the nature and role of the teaching method. I take leads from conventional wisdom, the nature of an excellence curriculum, and the literature on excellence in education.

In an excellence curriculum the transmission of important information about the arts can be accomplished, first of all, through conventional didactic teaching. If students are to learn to find their way around a portion of the art world, they require the services of a knowledgeable teacher. It is unrealistic and far too demanding to expect them to figure out everything for themselves—for example, the way the style of High Gothic architecture gradually evolved from its origins in Early Christian art, or Cubism from its origins in the late nineteenth and early twentieth centuries.

When, however, the goal becomes that of teaching students to appreciate excellence in art and to savor the quality of experience art affords, they must be allowed to spend considerable time on individual works in order to realize the particular merits of each. To have any meaning at all, quality in education must imply studying things in depth. For the objective in question, the teaching method of coaching is the most appropriate—more

specifically, coaching in appreciative skills. No doubt such coaching also entails imparting some information didactically as well as making use of the opportunities for problem solving and critical thinking offered by the more puzzling aspects of art exemplars. But, again, the emphasis in exemplar study is on appreciation.

In the course of learning to perceive the excellence of art, students will encounter a number of perplexing questions that can be clarified by use of what may be called dialogic (or Socratic) teaching methods. With such methods, instructors and students analyze problems and issues for the purpose of gaining a better understanding of their and others' basic assumptions and beliefs about art. This type of teaching aims at having students refine their critical thinking while they study the subject in question. Clearly, then, an excellence curriculum demands a variety of teaching methods: didactic, heuristic, coaching, and dialogic, among others.[8]

In addition to the problems of what and how to teach, there is the third basic curriculum question of *when* to present material, that is, what the order of learning should be. What precedes or follows what? What determines sequence, and how does one find out about it?

A conventional way of determining sequence is derived from demands made by the subject as well as by the realities of student learning. For two examples of the former I refer first to one of the important aspects of excellence in art—that exemplars of art reveal an artist's reworking of traditional ideas into contemporary forms of expression while maintaining a significant link with the past. To appreciate this fact, students need some prior acquaintance with art history, for without it they would have difficulty discerning aspects of both continuity and change. Similarly, without the backdrop of the past they could not see the point of the revolutionary strand of modernism, which was the self-conscious rejection of tradition.

So far as the demands of learning are concerned, in the lowest grades an excellence curriculum should accommodate the child's propensity for concrete activities and use relatively unstructured and informal teaching methods. These early years are the most popular with developmental psychologists intrigued by the problems of intellectual development. There are fewer mysteries at the secondary level, and taking for granted that teachers have a general familiarity with the characteristics of adolescence, they may teach their material straightforwardly. To repeat, the demands of the subject and of learning suggest the general way in which to arrange the sequence of learning for a K-12 art education curriculum. Those who would

dismiss the problem of the order of learning by pointing to what they regard as the notoriously nonsequential nature of art are shirking a major pedagogical responsibility.

It would of course be unwise to try to make every detail consistent with the demands of an excellence curriculum. Much must be left to the initiative and imagination of teachers and students. The theme of excellence, however, and the organization of knowledge relevant to developing a disposition to appreciate quality in art are sufficient indicators of what an excellence curriculum could be like.

In *Excellence in Art Education* I outlined units of study for the secondary grades, 7-12, and also indicated how visual art education could be part of an arts requirement encompassing a number of units. Here I outline a K-12 visual arts curriculum—in terms not of units but of segments consisting of introductory, intermediate, and advanced phases. I further attempt to make more explicit my reasons for describing an excellence curriculum from a humanities point of view. Since I take the purpose of art education to be the initiation of the young into the art world, I conceive the art curriculum as itinerary and the teaching of art as an activity devoted to preparing students to become well-informed, sensitive sojourners in the art world where they will encounter both traditional and contemporary artworks in various contexts. This image has the virtue of accommodating theories that emphasize the relevance of institutional and contextual considerations (for example, Kaelin's, Eaton's, and Danto's).

Both contemporary thinking about art education and philosophical reflection suggest the appropriateness of a humanities conception of art education that, in addition to creative activities, assigns importance to historical, critical, and philosophical studies. But what does this entail for an excellence curriculum? My position adopts—in addition to the humanistic slant already suggested by the writings of Walter Kaufmann as discussed in chapter 7—the redefinition of the humanities for today's world formulated by Albert William Levi who for much of his career was David May Distinguished University Professor of the Humanities at Washington University. Levi formulated his redefinition in response to a number of contemporary challenges to the humanities: the difficulties posed to humanistic scholarship and teaching by the inclusion of works from non-Western civilizations; the need of a democratic society to come to terms with an essentially aristocratic tradition of learning; the demand that the humanities

show a more convincing relationship between their stewardship of civilized values and human conduct; and the argument in favor of the distinctive claims of the humanities against those of the social sciences. A formidable agenda.

In an essay presenting a condensation of his redefinition,[9] Levi begins with a famous story from the Talmud about a learned Rabbi who, having fallen into enemy hands, was required under penalty of death to sum up the essence of the Jewish religion, standing on one foot no less! The Rabbi recalled the sixth chapter of the Book of Micah and said "to do justly, to love mercy, and to walk humbly with thy God." In a similar spirit, Levi summed up the essence of the humanities by saying, "It is to think critically, to communicate successfully, and to walk proudly with thy tradition."

Ostensibly, Levi defined the essence of the humanities in procedural terms, as a manner of comporting oneself—be critical, speak effectively, honor tradition. Construed as ways of doing things, the "arts" in the liberal arts thus become skills, and Levi sorts them according to the ends toward which they are deployed, for example, those subsumed under the categories of communication, continuity, and criticism, and points out their inherent humanizing functions. But, as his *The Humanities Today* makes clear, he was always careful to conjoin these skills with substantive subjects appropriate to each group—the skills of communication with languages and literature, the skills of continuity with history, and the skills of criticism with philosophy (in its ordinary sense of critical thinking).[10] By associating skills with their respective subjects, Levi synthesized the two great traditions of the humanities: the tradition of the Middle Ages, which stressed the procedural aspects of the humanities, and the tradition of the Renaissance, which understood the humanities essentially as contents or subject matters. These two conceptions—the procedural and the substantive—provide major options for teaching the humanities today, as does Levi's synthesis, which would ensure the teaching of both humanistic knowledge and humanistic ways of thinking. Levi in some contexts leaned more toward the procedural sense and in others toward the substantive sense. A procedural definition of the humanities recommends itself in light of the difficulties that have accrued on the substantive side due to the enlargement of the corpus of humanistic works now available for study. On the other hand, opting for the substantive definition could yield a means for stemming the rising wave of cultural illiteracy in the society and for counteracting the trend toward content neutrality in the teaching of basic skills.[11] I endorse Levi's

synthesis of content and skills under language/communication, history/continuity, and philosophy (or critical reflection)/criticism and hope to show how it applies to art education.

Art not only is a language that communicates in special ways, it also has a history of accomplishment and problems of interpretation and evaluation requiring critical analysis; hence, it qualifies as one of the humanities and can be taught as a humanity, for example, in art education. When taught in this way, art education can also contribute to the realization of the more general aims of the humanities—the search for personal identity, a cohesive social structure, and the reformation of values. These objectives ground the humanities in the very essence of human nature as well as in the conditions of social life. As Levi puts it, in its style and nuances of meaning and implication, language not only sets the limits of one's intellection and emotional perceptions, it also constitutes a form of life. The manner of its use reveals and betrays attributes of character. But above all, language (and works of art as a principal mode of communication) figures importantly in the quest for human expression and response and says much about the nature of being and the importance of sharing ideas.

A person's character, substance, and style are also shaped by the need to discover roots, to find a place in time and in a tradition; this is the essence of continuity and the reason for studying history. History records the accomplishments and misadventures of our remote and more recent ancestors, as it will also record our own. But history for Levi is not just an account of causes and effects or mountains of statistical data; it is a reflection of human relevance and importance.[12] Nowhere is this realized more vividly than in the history of art, one of the facts that indicate the importance of art history for art education.

Finally, human existence is defined in connection with a need not only for expression and orientation in the flow of time but also for reasonableness, the latter being the product of criticism or philosophical thinking. Only through careful critical reflection can people clarify their ideas, beliefs, and values in order to improve the conditions of their own life and the lives of others. The need for critical thinking about matters of art is particularly acute today when people are increasingly confused about art's nature and function. As a result, they either acquiesce in practically everything done in the name of art or are reduced to voicing their opinions dogmatically, that is, without providing adequate reasons for them. This state of affairs has made the task of art educators a difficult one—how to

build a sense of art in the young at a time when art itself has become so problematic.

Teaching any subject as a humanity then means bringing to bear on it the skills and substantive content of the liberal arts of communication, continuity, and criticism. Levi illuminates the skills and disciplines of the humanities through an image that recalls Kaufmann's discussion of reading a classic text: a series of concentric circles, as if caused by pebbles thrown into a pond, each having its own irradiating intention yet overlapping the others to some extent. Borrowing this dynamic image, we may say that the irradiating intention of artistic creation as a special mode of communication is born of the human need to express feelings and ideas in visual forms and results in the making of unique objects. The irradiating intention of the history of art as the exemplification of continuity is born of the human need to be reminded of roots and to recall events worth remembering and results in an understanding of works of art under the aspects of time, tradition, and style. The irradiating intention of critical talk about art is born of the human need to perceive clearly and to separate the meritorious from the meretricious and results in the refinement of perception and in the ability to make informed qualitative judgments.

Each of the three categories involved in the characterization of art as a humanity subsumes, or brings to mind, certain other key concepts, topics, and questions. First, from the fact that every work of art is created in a particular medium, has a structure, a style, and a meaning derive four concepts or features—medium, structure, style, and meaning. These characteristics of the work of art are interrelated and mutually reciprocal, but it is the first three that determine the fourth—the meaning the work communicates. Meaning is thus the dimension that relates the artwork to the arts of communication. Second, every artwork was produced in a given stylistic period and within a tradition; it has a date and was made in a certain place by a certain person or group of persons for a particular audience and in a particular social situation. Concepts like date, situation, and audience thus identify a dimension that relates the artwork to the arts of continuity. Third, every artwork expresses certain attitudes or values, perforce a philosophy of life, and therefore contains implicitly or explicitly a critical message. Attitudes, values, and message thus form a dimension that relates the artwork to the arts of criticism. In summary, Levi writes:

In the case of the arts of communication this has meant the presentation of languages as forms of life enlarging a limited

imagination and producing that mutual sympathy Kant took to be the defining property of social man. In the case of the arts of continuity, comprehending both history proper and the use of the classics of literature and philosophy, presented as elements in a continuous human tradition, this has meant the presentation of a common past in the service of social cohesiveness and enlarged social sensitivity. And finally, in the case of the arts of criticism, this has meant the enlargement of the faculty of criticism, philosophically conceived as intelligent inquiry into the nature and maximization of values. A humane imagination, the forging of a universal social bond based upon sympathy, and the inculcation of a technique for the realization of values then become the ultimate goals of the liberal arts.[13]

When we add the masterworks of the visual arts to the classics of literature, we may say the same thing about visual arts education. Of any artwork, Western or non-Western, merely entertaining or serious, we may thus ask the following questions:

1. What is its peculiar medium?
2. What is its structure?
3. What is its style?
4. When was it made?
5. Why was it made?
6. For whom was it made?
7. What attitudes does it express?
8. What values does it assert or deny?
9. What message (if any) does it convey?
10. What quality of aesthetic experience does it afford?
11. What was its function in the culture in which it was made?
12. What is its function in the culture of today?
13. What peculiar problems does it present to understanding, appreciation, and evaluation?

I now describe the phases of a K-12 excellence curriculum. Although it is quite feasible and appropriate to initiate the discussion of serious works of art in the early years of art education and, after that, in the upper elementary years to make a start toward developing a sense of art history and the art world as well as some awareness of aesthetic problems, the more explicit teaching of art as a humanity is customarily thought to occur at the secondary

and college levels. But since the foundations for a disposition to appreciate excellence in art must be laid quite early in a student's life, it is helpful to think in terms of a continuum of aesthetic learning that passes from a beginning to more advanced stages. Aesthetic learning differentiates itself into five phases ranging from exposure to and familiarization with aesthetic properties and refinement of perception in the early years to historical and critical studies in the later ones. The early years should continue to stress creative and performing activities that, when suitably taught, foster certain powers of mind (e.g., perception, imagination, memory) and at the same time are intrinsically enjoyable. Such activities should also include perceptual exercises and, as I've mentioned, some information about the history of art and cultural institutions. Learning of this kind paves the way for formal historical and critical studies during the secondary years when the emphasis shifts to the aesthetic object and its cultural context as well as to problems of understanding and appreciating art. The general aim throughout is to develop and refine percipience in matters of art and culture; that is to say, to cultivate in students a reflective percipience that will enable them to experience works of art for the sake of their constitutive and revelatory values. I identify five phases of aesthetic learning; they consist of (1) perceiving aesthetic qualities—K-3; (2) developing perceptual finesse—4-6; (3) acquiring a sense of art history—7-9; (4) cultivating exemplar appreciation—10-11; and (5) refining critical thinking—12.

Phase One: Perceiving Aesthetic Qualities (K-3). Very young children are hardly prepared to engage works of art in all their formal complexity and dramatic intensity, to say nothing about their thematic and symbolic import. But they are sensitive to the simple sensory and expressive qualities of things, and the years from kindergarten through third grade are the time to exploit and expand this proclivity. This can be done through exposure to the aesthetic qualities not only of works by mature artists but also of all sorts of other things, for example, scenes of nature, ordinary objects, and works of the children's own making. It might be said that during this phase the general goal is an appreciation of the qualitative immediacy of life.[14] Young students learn to take delight in the looks, sounds, tastes, and smells of things around them. But since these qualities are found in the highest concentration in visual, auditory, and verbal works of art, it is important that the students' attention also be directed toward works of art. Learners in the early grades should not only be encouraged to note a work's sensory and expressive

qualities but also be led to understand that artworks are special objects found in special places that society maintains at considerable effort and expense. This early, and still quite casual, introduction of artworks and their qualities lets young learners take their first steps on the road to an understanding of art and the art world. Simultaneously and intuitively, students also acquire a sense of object directedness, a fundamental feature of aesthetic experience discussed in chapter 4.

In short, aesthetic learning during phase one begins the job of building relevant habits and dispositions. Whatever notions about art children bring to school start to undergo modification. Young students are initiated into the mysteries of art and into cultural institutions that comprise the art world, and they gain some insight into the nature of the artistic creative process from their own attempts at art making. They come to realize that a work of art is a product of an artist's having composed the special qualities of materials into an aesthetic object that features medium, form and content.[15] They learn, in other words, that there is a way to communicate aesthetically. Thus do they make their first acquaintance with the arts of communication mentioned in the humanities interpretation of art education. Learning during phase one should not be inordinately formal, and children's inclinations and interests should be given considerable leeway. And although all phases of aesthetic learning are instrumental to the achievement of a certain level of percipience, all of them, and especially the first, will offer numerous moments of intrinsic satisfaction as ulterior objectives temporarily recede.

Much of what is currently being done in the early years of art education can suffice for achieving the objectives of phase one, and so I have few specific suggestions.[16] However, if teachers plan activities and lessons with the long-term goal of aesthetic percipience in mind, they might go about their teaching somewhat differently. The important consideration is that learning should at all times have a definite point and lead in a certain direction. This applies more emphatically to phase two than to phase one, for now aesthetic learning moves decidedly toward sharpening perceptual finesse.

Phase Two: Developing Perceptual Finesse (Grades 4-6). It is not possible to draw precise dividing lines between learning phases, but by the upper elementary years the young are capable of more sustained concentration. They can perceive finer distinctions in their own works and those of mature

artists. The latter should now gradually be made the focus of attention, for it is only through learning to perceive the greater complexity of acknowledged works of art that students can hone their perceptual skills.

In addition to the immediate qualities of artworks, their complex webs of relations and expressive import are now brought more fully and clearly into view. It is time for scrutinizing artworks more closely while simultaneously learning about the art world in which works of art find a home and caretakers. While still not excessively formal, learning is more structured in phase two than it had been in phase one. Besides engaging in making, seeing, and listening, during this period students should begin to acquire a meaningful vocabulary for talking about art.[17]

During phase two it is advisable to introduce some system and method into teaching. Learners can now be expected to pay close attention to a work's sensory, formal, expressive, technical, and symbolic aspects. A procedure called "scanning" has been recommended as a way to make initial contact with these aspects; it can be effective provided excessive claims are not made for it.[18] To guard against unrealistic expectations from scanning as it is usually represented, it might be helpful to examine another version of it. Consider the way Kenneth Clark, the distinguished art historian, described his own perceptual habits and pattern of response. In *Looking at Pictures* he speaks of the initial impact a work of art makes. This first encounter is followed by a period of close scrutiny and examination that aims to discover what is actually in a work to be perceived and enjoyed. The phase of scrutiny gives way to a time of recollection when relevant kinds of information—biographical and historical, for example—are summoned in order to make better sense of the work. After that, alternating periods of additional scrutiny and recollection serve to renew and revitalize earlier aesthetic responses.[19] Beyond describing a sequence for aesthetic engagement, I think Clark's account makes two additional points. The first is that since undistracted aesthetic experience is difficult to sustain for very long, the senses need a respite in order to regroup. The second is that although one's initial impression of a work has the merits of freshness and spontaneity, it is not always a reliable key to an artwork's real character or import. To return to the art-educational context, neither scanning nor any other approach should be used mechanically. Teachers should not specify precisely what learners are to look for and in what order. Students should be encouraged to discover as many of a work's features as possible on their own; otherwise they are not likely to remain perceptually engaged.

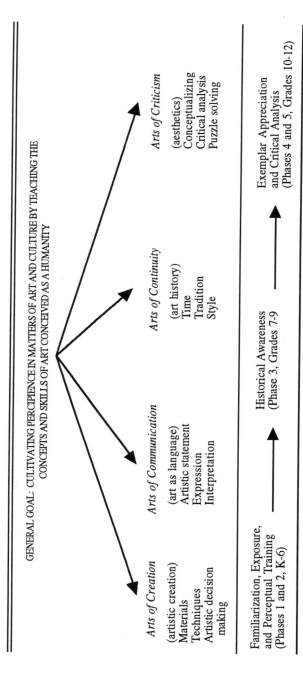

GENERAL GOAL: CULTIVATING PERCIPIENCE IN MATTERS OF ART AND CULTURE BY TEACHING THE CONCEPTS AND SKILLS OF ART CONCEIVED AS A HUMANITY

Arts of Creation

(artistic creation)
Materials
Techniques
Artistic decision making

Arts of Communication

(art as language)
Artistic statement
Expression
Interpretation

Arts of Continuity

(art history)
Time
Tradition
Style

Arts of Criticism

(aesthetics)
Conceptualizing
Critical analysis
Puzzle solving

Familiarization, Exposure, and Perceptual Training (Phases 1 and 2, K-6)

Historical Awareness (Phase 3, Grades 7-9)

Exemplar Appreciation and Critical Analysis (Phases 4 and 5, Grades 10-12)

Teaching and learning proceed along a continuum from exposure, familiarization, and perceptual training to historical awareness, exemplar appreciation, and critical analysis, stressing discovery and reception learning, didactic coaching, and dialogic teaching methods. Evaluation of aesthetic learning concentrates on the development of aesthetic conceptual maps and the conditions conducive for doing so. Reprinted with permission from B. Reimer and R. A. Smith, eds., *The Arts, Education, and Aesthetic Knowing* (Chicago: University of Chicago Press, 1992). Slightly edited.

An Excellence Curriculum (K-12)

At the end of phase two, far more so than at the end of phase one, students should be able not only to convey to others the character of their first impressions (impact) but also to engage in formal analysis (scrutiny) and to apply what knowledge they have acquired (recollection) in sustaining their interest in a work (renewal). When they practice the skills of aesthetic perception during what may be called the complete act of informed aesthetic response, learners experience, though not necessarily self-consciously, additional features of the aesthetic encounter, for example, feelings of felt freedom, detached affect, and active discovery. I am assuming that a great variety of artworks, created by women as well as men and with origins in different cultures and ethnic groups, will be found suitable for display and discussion during phases one and two. Since a well-developed sense of art implies an awareness of a broad range of artworks, a humanities curriculum is not indifferent to culturally diverse artworks.

Phase Three: Acquiring a Sense of Art History (Grades 7-9). Having learned how to perceive the qualitative immediacy, relational properties, and expressive and symbolic meanings of works of art, students are now ready to examine works under the aspects of time, tradition, and style. A well-designed survey course will allow students to discover that throughout history artists have both celebrated and criticized society's beliefs and values and that works of art therefore reflect the growth (or at times regression) of civilization. Apart from their specific import, works of art may also be regarded as records of humankind's perennial effort to impose form and style on unworked, unshaped material. These civilizing efforts have taken many sorts of artistic shapes that have changed over time, gradually and sometimes quite abruptly, retaining some features while discarding others. This is why the study of art history can lead students to appreciate the idea of an evolving tradition[20] while it also enlarges their general cultural literacy. Finally, historical study makes students aware not only of the relevance of contextual knowledge to the proper interpretation of a work of art but also of the relative irrelevance of such information to the assessment of the work's stature. As Arendt put it, truly great works of art have the capacity to retain their power despite severance from religion, magic, and myth and to transcend the circumstances of their origination; these include the gender, class, and race of their makers.

In contrast to the pedagogy of the first two phases of aesthetic learning, phase three will of necessity be more formal and require systematic

instruction. Although in a survey course students won't have time to linger long over any particular work, they will develop important insights into the processes of historical continuity and change and will come to realize that continuity is by far the greater part of the story. The ideas of continuity, change, and tradition could, of course, be illustrated through the history of practically any culture or civilization, but it is only common sense that American youth should be made acquainted with the principal cultural heritage of their own society. The teaching of art history need not rely exclusively on the formal lecture with paired-slides presentations. As Stephen Addiss and Mary Erickson point out in their *Art History and Education,* there are additional ways to make historical study active and interesting.[21] The chronological study of art is currently out of favor, yet I find it difficult to conceive of anyone's developing an adequate sense of art history in any other way. Thematic study of art—that is, works arranged according to themes like lamentation, love, courage, and so forth—enjoys popularity but, as David Lowenthal points out, has limitations that must be corrected by attention to historical narrative. "The pearls of history," he writes, "take their value not merely from being many and illustrious, but from being arranged in causal narrative sequence. The narrative lends the necklace meaning as well as beauty."[22]

Phase Four: Cultivating Exemplar Appreciation (Grades 10-11). The purpose of phase four is neither skill training nor historical study so much as the development of appreciation in the best sense of the term. This is the time for the in-depth study works of art without which any talk about excellence in art education is empty rhetoric. During phase four, students pause to admire some of the finest achievements of humankind—great works of art resplendent in their beauty, form, significance, and mystery. The aim is to appreciate artistic manifestations of *human* excellence regardless of its origins.

As I conceive of it, exemplar study provides further opportunities for highlighting the role of contextual factors in appreciating art. To be sure, we can appreciate a work of art on its own terms without much regard for the historical factors that helped to shape it, but we fail to give the arts their humanistic due unless, as Levi remarked in the epigraph to this chapter, we take time to understand the various functions they perform. A work of art and the contextual information pertaining to it sustain a figure-ground relationship that should not be reversed; contextual information is primarily

an aid to appreciation, and the work of art should not be permitted to disappear into its context.

From the aim of cultivating an appreciation of artistic excellence during the fourth phase of aesthetic learning it follows that examples of artistic excellence wherever they can be found are candidates for study. Although for reasons I've made clear one would expect such study to feature masterworks from the Western and European cultural heritage, efforts should also be made to teach students to appreciate some exemplars of artistic excellence from non-Western civilizations. Cross-cultural comparative studies of artworks might be entertained as well.[23]

Phase Five: Refining Critical Thinking (Grade 12). Beyond exemplar appreciation an excellence curriculum is intended to promote critical thinking about the sorts of problems students typically encounter in their attempts to understand art. *Puzzles about Art: An Aesthetics Casebook,* by Margaret B. Battin and others, is an excellent compilation of just such problems; they challenge students to develop their skills of critical thinking.[24] Instead of presenting theories of art by various philosophers of art and then drawing from them implications for understanding and appreciating art, the authors have collected (or concocted) what they call puzzles. These are brief statements of confusing situations that have arisen, or could conceivably arise, in conjunction with artworks. Students are then asked to find their way toward solving them with their available knowledge and experience. Since students need to have accumulated some background knowledge and experience in order to address puzzles fruitfully, the senior year would be a good time to examine aesthetic puzzles and a senior seminar a suitable forum for doing so.

Phase five also marks the time when young adults start to fashion their own beliefs about art, about its functions, meanings, and values. They can begin to stake out positions, however tentatively, on a number of arts-related issues, for example, the arts and the environment, the arts and the mass media, the social responsibilities of artists and cultural institutions, and so forth. In senior seminars, a beginning can be made toward asking the right questions and sorting out responses.

To sum up: my view of an ideal excellence curriculum for developing a sense of art would have the young pass through five phases of aesthetic learning, K-12. The early years would stress the development of perceptual capacities

while the latter years would concentrate on historical and critical studies. Among the features of such a curriculum (though not necessarily in the order in which they were presented) are a stress on progressive learning from the simple to the more complex; an organization of knowledge that specifies both the content and skills to be acquired; an emphasis on the quality and excellence of the works studied; a humanities interpretation of aesthetic learning that places importance on the arts of creation, communication, continuity, and criticism; a wary attitude toward politicizing aesthetic learning; a theory of the uses of knowledge; thirteen questions that can be asked of any work of art; and, in general, an emphasis on the development of intellectual power in the domain of art. It is expected that from such a curriculum young people will graduate equipped to transverse the world of art with taste and sensitivity and to realize in their experience of the excellences of art all the benefits that art is capable of conferring.

10

Anticipated Reactions

It would be an act of authorial hubris to try to prescribe how a book should and should not be interpreted; any such attempt is likely to have an effect opposite of the one intended. My purpose in the following few pages is to set the record straight on some surprising responses to *Excellence in Art Education* and on some others that I feel reasonably sure will be elicited by its sequel.

I address my remarks both to matters relating to the substance of my recommendations and to others relating to what may be called the spirit of the book. First, on the substantive proposals I made for an excellence curriculum in art education: I do not say in this volume, nor did I in its predecessor, that young people should occupy themselves exclusively with masterpieces of art. There are of course phases in the curriculum when such study will be emphasized, but at other times students' attention will focus on the aesthetic qualities of nature, of objects of daily use, and of works that are good of their kind. Nor is it suggested anywhere that the selection of works should be restricted by gender or racial considerations. Nothing in the program I envision would, for example, discourage including works by women; furthermore, a well-developed sense of art demands familiarizing the young with a wide range of works that includes works by artists of color and masterworks from non-Western cultures. A certain order or sequence, however, should be observed, for I believe that acquaintance with the Western heritage we share should form the foundation from which explora-

tions of other cultures proceed lest the entire course of study become amorphous and directionless. In short, while I hold that education in the arts for American youth should feature the cultural traditions of Western civilization, I do not mean that nothing else should be studied.

I have been, and may again be, accused of advocating an acontextual formalism as the method for teaching art appreciation. And to the extent that formalism is associated with modernism, I might also be taxed with clinging to an outmoded modernism as well (a charge that might be reinforced by some things I've said about postmodernism). But I clearly and emphatically attach importance to semantic content and such contextual considerations as are relevant to understanding an artwork. My love of art history settled my position on that question long ago and should have been apparent from my first anthology, *Aesthetics and Criticism in Art Education,* 1966.

My stress on the cumulative, progressive development of a sense of art and the cultivation of a taste for artistic excellence was not meant to relegate creative activities to the status of mere means to these ends. True, in a K-12 curriculum students acquire a sense of art gradually, and ideally what they learn in one phase carries over to the next. In this way they will acquire a rich apperceptive mass or store of knowledge with which to experience art. But all along, the intrinsically pleasurable qualities of creative activities as well as of the other phases (historical, critical, etc.) are to be savored. It is expected, then, that students will enjoy what they are doing, and that their enjoyment will be of the kind that contributes to expanding mental powers, most notably the powers of perception, imagination, and problem solving. In short, an excellence curriculum endorses a view of learning that has been referred to as the cognitive revolution in human understanding. I took for granted that this would be evident in *Excellence in Art Education;* the responses of some commentators made clear that I was wrong in that assumption.

Another complaint about this book might be that it fails to give attention to the talented, on the one hand, and to special education students, on the other. Where the latter group is concerned, the only humane thing to do is to encourage those who fall under this category to do as much as possible given their capabilities. As for giftedness in art, it is usually understood as an unusual talent in artistic creation or performance that the schools should take pains to recognize and foster; the K-12 curriculum I've sketched makes no special provisions for doing so. But when the conception of giftedness also encompasses a student's striking aptness for historical and

critical study, it does become relevant to my discussion. In general—excepting only individuals evincing truly extraordinary talents—students with interests and gifts (both creative and academic) that demand special cultivation should find opportunities for exercising them and having them attended to within the K-12 curriculum I envision. Indeed, it would be inconsistent for an excellence curriculum not to provide additional motivation and stimulation for such students.[1]

To the charge that the kind of K-12 curriculum I recommend is rendered unfeasible by prevailing economic conditions and the realities of schooling, I reply that less change would be necessary than might at first appear. What currently passes for art education in the early years would merely require being redirected toward the long-term goal of cultivating excellence. That is, activities would be changed only subtly, if at all, by the new rationale underlying them and by their anticipated payoff. And if all the arts electives and requirements now found in the secondary years could be combined into a department of arts education, as Sizer recommends in *Horace's Compromise,* it should not be too difficult, I think, to establish a sequence of required courses from grades 7 to 12. But this cannot happen so long as educators are wedded to the idea that the arts can survive in the curriculum only if they are integrated into other subjects where they would function instrumentally to achieve extra-aesthetic outcomes.[2] I have stated my reasons for insisting that the study of art deserves its own curriculum time. What is more, I believe that states, school board members, and parents might be more supportive of art in the schools if they became persuaded that art education programs could be clearly substantive—as would be true of academic humanities programs devoted to excellence. Once more, schools with such a program might become schools of choice. But even if the type of prototype curriculum I propose cannot be implemented fully, it can still serve as a model against which other ideas may be examined.

Now for the guiding spirit of my writing. Given the politically charged atmosphere in culture and education today, it is a near certainty that *Excellence II* will be, as its predecessor was, examined for its "political agenda." I have tried rather strenuously to avoid having one, for I believe that politics, the preferred parlor game of many academics, should not enter into substantive discussions of art education. I am of course familiar with the theory that holds that every human choice, action, or utterance is at base political, whether or not we intend it, know it, or are conscious of it. But the "whether we know it or not" clause renders this view suspect because it

makes verification as well as falsification in principle impossible. When I have nonetheless openly argued against certain positions I consider extreme, I have done so not for ideological or political reasons but for educational ones. For the extreme positions I discuss seem to me to lead to consequences that are profoundly anti-educational and anti-educative. I have, for example, no quarrel with the form of multiculturalism that seeks to identify and give recognition to the many cultural strands that have contributed and lent their distinctive coloring to our common culture, so long as the emphasis remains on a *common* culture. But I criticize the balkanizing kind of multiculturalism that imprisons individuals in ethnic enclaves, subjects them to the tyrannies of group identity, and discourages them from seeking commerce and communication with outsiders or with society at large. The aim of educators must be to broaden horizons, not to restrict them; to expand and deepen understanding of others, not to impede it. Likewise, I have no qualms endorsing certain strains of postmodernism that can be seen as merely the latest wrinkle in a continuing tradition or at worst a kind of eclectic play with several traditions. But I do feel constrained to point out the logical outcome of deconstruction*ism,* which is a philosophical and political manifestation of the postmodern temper. That outcome is the demise of art as we have known, appreciated, and benefitted from it—and therefore also, of course, the end of art education.

Whether similarly deleterious consequences can be expected to flow from the phenomenon known as gender feminism I cannot say, since the subject is fairly new. As for equity feminism, I see nothing in *Excellence II* that should offend it (except when "equity" is construed as requiring a strict numerical balance between works by female and male artists, male and female figures represented, and so forth. Such niggling is especially inappropriate as applied to art, for the artist's gender is unrelated to an artwork's aesthetic merit and is merely a fact that, along with other contextual information, may be worth knowing about the work). That women have made valuable contributions to the field of aesthetics is beyond doubt, and I often and gratefully refer to their writings and incorporate their thoughts into my own. About "feminist aesthetics" as a separate subfield I am not so sure; the verdict does not seem to be in. In a special issue of the *Journal of Aesthetics and Art Criticism* devoted to "Feminism and Traditional Aesthetics," Hilde Hein writes that "feminist theory is still in its infancy, and feminist aesthetic theory is only beginning to find itself."[3] Moreover, one aspect of such theory is suggested by Anita Silvers who in

the same issue thinks that feminist aesthetic theory will be less fruitful than it could be if it neglects to address the question of quality. Mere expressions of egalitarian sentiment, she remarks, are "disconcertingly divorced from art."[4] Peter Shaw, in a study of the shifts in feminist literary theory, also ponders the consequences of shirking the task of giving adequate aesthetic accounts of works of art. "Until and unless feminist criticism commits itself to aesthetic value, one can predict it will continue to turn in on itself, repudiating one stage after another of necessarily inadequate theory."[5] In view of all this, I'm reluctant to extrapolate implications for art education at this time.

What, then, would I subscribe to without reluctance? As I hope *Excellence II* has made clear, it is a humanities point of view toward art education, a position grounded in basic individual and societal needs. These Albert William Levi identified as the human need for expression and communication in a number of languages, including the language of art; the need for a knowledge of one's roots and an awareness of historical continuity; and the need for critical reflection on values, all in the service of human fulfillment and social harmony. Levi, then, recommends liberal education in the best sense of the term—education for the fullest possible realization of significant human powers. It is an ideal that subsumes art education as I understand it.

So much about my art-educational views in general. About an excellence curriculum in particular and the kind of objectives especially appropriate for it, I'll give the last word to Arnold Hauser, a distinguished Marxist scholar. In his *Social History of Art*, Hauser writes: "The problem is not to confine art to the present-day horizon of the broad masses, but to extend the horizon of the masses as much as possible. The way to a genuine appreciation of art is through education. Not the violent simplification of art, but the training of the capacity for aesthetic judgment is the means by which the constant monopolizing of art by a social minority can be prevented."[6] Hauser thus defused the charge of "elitism" that is sometimes levied against the art-educational emphasis on excellence.[7] Only the monopoly on art by a social minority can be termed elitist, while giving everyone access to art via education is a profoundly democratic, empowering thing to do. But, of course, this is not a peculiarly Marxist insight. It is conventional wisdom.

Appendix: Aesthetic Experience

Because an excellence curriculum stresses the importance of aesthetic experience, it will be instructive to provide a brief history of the concept and some examples of response, real and imagined, to a range of situations and works of art. These responses allow us to infer that aesthetic awareness and experience had occurred or could occur. These examples should, I think, erase any doubts that there is such a thing as aesthetic experience, that it consists in our taking delight in the intrinsic properties of things traditionally considered worthwhile, or that we can know when such experience is authentic.

In his *History of Six Ideas* Wtadistaw Tatarkiewicz locates the roots of the concept of aesthetic experience in the writings of classical antiquity and traces thinking about the concept through later antiquity, the Middle Ages, the Enlightenment, and the last hundred years, culminating in Roman Ingarden's and Tatarkiewicz's own version of the concept.[1] True, says Tatarkiewicz, the term "aesthetics" was not coined until the eighteenth century by Alexander Baumgarten and "beauty" and "taste" were often used to discuss the type of interest implied by the contemporary term aesthetic experience. But a concept, he says, is not equivalent to a term, and well before the eighteenth and nineteenth centuries there was interest in understanding the nature of human response to beauty and art. Tatarkiewicz thinks that the concept of aesthetic experience is at least as old as Pythagoras who wrote that "life is like an athletic contest; some turn up as wrestlers, others as vendors, but the best appear as spectators" (310). And by "spectators" Tatarkiewicz assumes Pythagoras meant those and only those who adopt an aesthetic attitude. At least the image of a spectator taking an aesthetic attitude toward something is the one he holds in view as he reviews the literature on aesthetic experience.

Central to Tatarkiewicz's account is a recurring dualism distinguished in Latin by *sensitivus* and *intellectus,* or sensory and intellectual cognition. The former was sometimes called *aestheticus,* though only in theoretical philosophy and not in discourses on beauty and art and the experiences associated with these. In the eighteenth century Baumgarten brought the two terms together in the notion of sensitive cognition (*cognitio sensitiva),* which he identified with the cognition of beauty (*cognitio aesthetica,* or *aesthetica* for short). The continuing interest in aesthetic experience, whatever term designated it, ultimately led Kant, Herbart, and

Hegel to the acceptance of aesthetics as one of the principal divisions of philosophy, along with logic and ethics. The terms "aesthetic" and "aesthetics," then, though they originated in Latin, are relatively late additions to philosophical terminology. What is more, it is only in modern aesthetic theory that two of the major concepts of aesthetics, the aesthetic and the artistic (a third being beauty) become closely associated. As we have seen, the belief of some theorists that works of art are preeminently suited to induce aesthetic experience was sufficient to posit this capacity of art as its defining feature.

The classical concept of aesthetic experience implied interest in both the features of what is seen and heard and the special mental faculty responsible for the perception of beauty. Descriptions of the former are found in Aristotle's writings and of the latter in Plato's. Plotinus in late antiquity followed Plato's thought and contributed the idea that only a sense of beauty, in conjunction with certain moral and spiritual qualities of mind, enables one to perceive beauty, while in the Middle Ages Aquinas, in an Aristotelian vein, made a distinction between aesthetic pleasure and the instinct for human survival, or what we now recognize as the contrast between the aesthetic and the practical attitude. The few statements on aesthetic experience by Plato, Aristotle, and Plotinus, says Tatarkiewicz, are of extreme historical importance. "They contain the earliest description (in its relevance perhaps unsurpassed) of the aesthetic experience and the earliest reflections on the mental capacities which render this experience possible" (315).

The Platonic tradition in the Middle Ages was perpetuated by Boethius who also presupposed a special faculty of the mind without which we could not account for the fact that many people enjoy listening to the same sounds. The name given to this faculty varied from "inner sense of the soul" (by Erigena) to "spiritual vision" (by St. Bonaventure). In time this inner sense came to be known as the sense of beauty. Like Aquinas, Erigena also anticipated modern ideas when he distinguished the contemplative from the practical point of view. The former does not covet a beautiful object but is attracted by its beauty, the perception of which is akin to perceiving the glory of God and His works.

In the Renaissance period, theorists adopted the ideas of beautiful objects as well as of a special mental faculty appropriate to perceiving beauty, and they described this attitude as either active (Ficino) or passive (Alberti). That is, aesthetic experience implied either an active sense of

beauty or a passive reception of it, and both conceptions of aesthetic experience found adherents within the circles of the Florentine Quattrocentro. Once it was accepted that there are special mental powers to perceive beauty, however, it became natural to inquire whether such powers were rational or irrational. As evidenced by the vogue of Aristotle's *Poetics* and Vitruvius's theory of the visual arts, the former view held sway. Later, however, in the Baroque period, Gian Vincenzo Gravina expressed a contrary opinion, saying that the perception of beauty was a function of a mind possessed by irrational emotions that resulted in dreaming with one's eyes open, a state, that is, of delirium (*delerio*). This view seemed to recall Plato's theory of the divine madness of the artist except that Gravina extended it to the aesthetic experience of the spectator as well.

The questions about aesthetic experience asked by writers in antiquity, the Middle Ages, and the Renaissance turned mainly on the nature of the requisite faculties and attitudes responsible for the perception of beauty. Yet in reviewing the history of the concept, Tatarkiewicz discerned an additional question: Did aesthetic experience fulfill any kind of need? Plato's response was that aesthetic experience both made sense of and was the end of human existence, whereas much later, in the eighteenth century, J. B. Dubos said that aesthetic experience satisfied a fundamental need to occupy the mind in order to avoid boredom. Boredom could be overcome either through difficult or dangerous activities or through art and aesthetic experience. Dubos's view, however, had few adherents in his day.

As we move into the Age of the Enlightenment, aesthetic questions were less about the nature of beauty and the beautiful than about taste (*gôut, gusto*), which implied an interest in why people think certain things are beautiful and worth enjoying. This type of psychological interest was expressed first in England and then in Germany. The major eighteenth-century figures in England were Locke and Shaftesbury whose analysis of mind on the one hand and the nature of emotions and values on the other produced a sober intellectualism and a poetic anti-intellectualism, respectively, with Locke's intellectualism tending to prevail.

Interest in the concept of taste was aroused by the continuing curiosity about the faculty responsible for aesthetic experience, and theories of taste began to complement doctrines emphasizing either perception, reasoning, or intuition. Taste, it was believed, was exercised less for the intense perception of beauty than for the discrimination of beauty from ugliness. Kant termed the faculty of taste *sensus communis aestheticus* and

believed its purpose was to determine what everybody likes. In France, Diderot stressed the varieties of taste and its unequal distribution, while in England Shaftesbury was positing a sense of beauty given to everyone, which he coupled with an ability to recognize goodness that resulted in a moral sense. Francis Hutcheson then distinguished the two faculties and in so doing described beauty as a passive faculty that was not the object of rational knowledge. As Tatarkiewicz puts it, "knowledge of beauty is not attained by means of comparison, reasoning, application of principles; beauty is perceptible through the specific sense" (320). Though there were efforts to identify a variety of senses of beauty, the concept of a single sense of beauty remained dominant and is typical of the writings of Hutcheson, Burke, and Hume, and later, Santayana. Hume, however, along with Hartley, no longer assumed a specific sense of beauty and held instead that things are capable of evoking a sensation of aesthetic satisfaction by virtue of association, a belief also held by Hartley and Burke (in a modified version). For example, on the question of the subjectivity or objectivity of aesthetic experience Shaftesbury held that beauty was an objective quality of objects, whereas Hutcheson regarded beauty as a sensible quality of subjective responses. Tatarkiewicz points out that while Hume was extreme in his belief that beauty exists only in the mind of the beholder, he often expressed ideas that were far from being subjective. Hume also wrote that it was the order and structure of beauty that were responsible for occasioning the delight and satisfaction gained from it. Also worth recalling in this context is Hume's remark that argument and reflection are often requisite for a proper relishing of beauty.

Enlightenment thinking in Germany also expressed an interest in aesthetic experience but used methods that yielded different results. Alexander Baumgarten—once again, the originator of the term aesthetics—believed aesthetic experience to be cognitive, albeit sensual and hence an inferior kind of cognition, in large because aesthetic experience itself was so obscure. Baumgarten both followed and rejected tradition in admitting the cognitive status of aesthetic experience as well as its irrational character. The state of affairs soon became such that it demanded a significant synthesis of diverse views, and it was Kant's special accomplishment to integrate English and German thought on the subject.

Following English thinking, Kant believed that the basis of aesthetic experience is noncognitive and subjective. Yet aesthetic experience rests its claims on more than the pleasure it affords, for aesthetic judgments

also make a claim to universality. The peculiar character of aesthetic experience lies precisely in the fact that its judgment does not have justification but is nonetheless irrefutable. Aesthetic experience, however, is not only noncognitive, nonconceptual, subjective, and universal in its judgments, but it is also disinterested in that the image, or form, of an object is more important than its material existence. And yet for all the subjectiveness and noncognitiveness of aesthetic experience, the pleasure it affords is of the whole mind and is not restricted to sensuous pleasure. What is more, though aesthetic experience is subjective, it does contain an imperative, but one for which there is no rule that can determine those things that will please. From this it would seem to follow that each object must be judged separately and that aesthetic experience is individual and subjective. Yet, writes Tatarkiewicz, "as human minds are built similarly, there are grounds for expecting that an object which pleases one man will please others as well; therefore aesthetic judgments are characterized by universality, although it is a very special universality since it resists definition by any rules" (323).

And, in truth, although Kant's ideas about aesthetic experience followed logically from his speculation about aesthetic judgment and were acknowledged to be a brilliant attempt at synthesis, according to Tatarkiewicz they proved to be too complex, and simpler explanations were soon sought. An experience with the features of disinterestedness, nonconceptuality, form, fullmindedness, subjective necessity, and ruleless universality was literally too much for many writers to accept.

A simpler conception of aesthetic experience was provided by Schopenhauer who, going beyond Enlightenment thinking, stated that aesthetic experience is essentially contemplation; it consists of the sensation realized when practical attitudes are forsaken and attention directs itself solely at a thing beheld. Describing this stance, Tatarkiewicz writes:

> A man experiences this sensation when he assumes the beholder's attitude, when—as Schopenhauer wrote—he forsakes the usual, practical attitude toward things, when he ceases thinking of their origin and purpose and concentrates solely on what he has before him. He ceases to think abstractly and bends his powers of mind to the beholding of objects, submerges himself in them, fills his consciousness with what he beholds with what he has before him. He becomes oblivious of his own personality, curbs his will; the subject becomes a reflection of the object, there is no longer in his consciousness a division into onlooker and what is looked upon; his entire consciousness is filled with a pictorial representation of the

world. This state of mind, this passive submission to objects, Schopenhauer termed beholding, contemplation, aesthetic pleasure (*aesthetisches Wohlgefallen*) and the "aesthetic attitude" (*aesthetische Betrachtungsweise*) (324).

Typically, Tatarkiewicz mentions numerous antecedents of such notions; they recall, for example, not only Kant but also Pythagoras, Aristotle, and Aquinas. But Tatarkiewicz credits Schopenhauer with in effect formulating a new concept; all the more pity then, he also says, that Schopenhauer went on to drown this concept in an incomprehensible metaphysics that took contemplation to be the solace of an ever-restless will. Still, this has not prevented theorists from taking what they found useful in Schopenhauer's position.

In the last hundred years the attention of theorists has shifted more explicitly from the concept of beauty to that of aesthetic experience. This psychological interest, which after 1860 led to the formulation of aesthetics as an experimental science, continues today, even though aesthetics is now commonly regarded as a branch of philosophy. The shift away from the concept of beauty was caused by the conviction that, while it was impossible to discover the common features of beautiful things, it was conceivable that the common features of aesthetic experience could be identified. Yet this belief too proved overly optimistic, and it spawned numerous theories that emphasized different features of the aesthetic experience. Chief among these were what Tatarkiewicz calls simple hedonistic and cognitive theories; others stressed illusion and isolation, and still others disinterestedness and euphoria. He also discusses some corollaries of active and passive conceptions of contemplation. Summarizing them rather sweepingly, Tatarkiewicz states that these theories ranged from the belief that aesthetic experience was irreducible and thus incapable of being analyzed (Wundt and Fechner) to rejections of such a view in favor of others stressing either the pleasure afforded by aesthetic experience (Santayana), the enlightenment it provides (Croce and Fiedler), its fictitiousness and the disengagement from reality it occasions (Lange), the spuriousness of the feelings and judgments it engenders (Hartmann and Meinong), and its being an exemplification of play, or having a gamelike quality (Schiller). Active theories of aesthetic experience tended to feature such notions as empathy (Lipps) while others stressed their converse, that is, passive submission (Bergson and Ducasse).

Corollaries of cognitive theories attempt to clarify the requirements for aesthetic experience and the aesthetic attitude, especially the bracketing that isolates objects (Hamann), psychical distancing (Bullough), disinterested attention (Kant), and holistic perception (Arnheim). In reaction to cognitive accounts of aesthetic experience, theories of euphoria (Valéry and Brémond) denied the possibility of any cognitive description of aesthetic experience, preferring instead to stress its thrilling, enchanting, or mystical qualities on the assumption that they effected communion with the mysteries of reality and induced a repose resembling prayer. But such an account, Tatarkiewicz points out, does justice neither to the composite character of aesthetic experience—identified, for example, in Nietzsche's notions of the Dionysian and Apollonian modes of experience—nor to Tatarkiewicz's own view that there are different kinds of aesthetic experience.

Regarding the legacy of efforts to analyze the nature of aesthetic experience, with whatever term writers described it, Tatarkiewicz remarks that if accounts vary so widely it is because different thinkers had different interests. Some sought to define aesthetic experience or to provide a theory of it. Others looked either to its conditions, the mental faculties presupposed by it, the features of objects that induced it, or to the features of the experience itself. In sum, concludes Tatarkiewicz, the concept of aesthetic experience is a complex one.

Tatarkiewicz concludes his brief survey with a reference to Roman Ingarden's account of the concept. Ingarden thinks aesthetic experience owes its compound character to its passage through a series of stages during which it exemplifies both intellectual and emotional components and active and passive stances. According to Tatarkiewicz, Ingarden believed that

the beginning of an aesthetic experience is marked by what he calls an "initial emotion" having the character of an excitement. The second stage of the experience occurs when, under the influence of that excitement, we turn our entire consciousness toward the object that aroused it; the normal course of consciousness is arrested, its field is narrowed, interest centers on the perceived quality. Then the third stage begins a "concentrated beholding" of that quality. At this third stage the aesthetic experience may cease, but it may also continue. If it does continue, the subject faces the object that he has now formed and communes with it, responding emotionally to what he has himself produced. Thus in aesthetic experience there occur successively: pure excitement on the part of the subject, the forming of the object by the subject, and the perceptive experiencing of the

object. The earlier stages have an emotional and dynamic character
which in the final stage recedes before contemplation (337-38).

Tatarkiewicz's own account of aesthetic experience is likewise a compound
one and is consistent with his belief that the concept of aesthetic experience
can be rendered only by giving alternative conceptions of it. Whether the
concept of aesthetic experience is vitiated when characterized this way is a
relevant question, but, once again, it is difficult to deny the importance of a
concept to which so many writers have devoted attention. One is compelled
to conclude that it refers to a significant human interest.

These scant references to the history of the concept of aesthetic experience
permit a few observations about the discussion of aesthetic experience in
chapter 4 and elsewhere. Like their predecessors in aesthetics, Beardsley,
Osborne, Goodman, Kaelin, and Eaton have special interests and ask
different questions, and thus their theories and conclusions vary in certain
respects. Inasmuch as Beardsley wanted to ground a theory of aesthetic
value in aesthetic experience, he deemphasized the cognitive and moral
dimensions of works of art in estimating their artistic goodness. In one of
his last essays on the topic, however, he admitted to having had only
qualified success in doing this.[2] And though Beardsley sees aesthetic
experience as being a complex and composite phenomenon, he believed that
more than for any other of its features it is valued for the special feeling of
gratification it yields. Beardsley's theory recalls not only Kant's account of
aesthetic judgment but, in its emphasis on gratification, also Schopenhauer's
aesthetics with its stress on the pleasurable sensation of concentration.
 Osborne's theory of aesthetic experience is likewise complex yet
singular in its effect; it holds that aesthetic experience is valuable above all
for its strengthening of the powers of percipience. His account draws
inspiration from both Kant and eighteenth-century British thinkers, but he
corrects Kant who believed that aesthetic judgment is noncognitive and is
largely about form alone. Goodman concentrates not on the felt qualities of
aesthetic experience so much as on the conception of features of artworks
as characters in a symbol system. About all Goodman says about aesthetic
experience is that the mind, in responding to works of art, is active not
passive (recall the different opinions on this in historical accounts of
aesthetic experience) and that feelings and the emotions are part and parcel
of aesthetic knowing. Although Goodman's claims for the capacity of

works of art to provide enlightenment have many predecessors, he did succeed in articulating new ideas. The same is true of Kaelin's account of aesthetic experience; it too has antecedents as well as accents that are his own, for example, his emphasis on aesthetic communication and the ways in which aesthetic experience exemplifies human freedom and contributes to the efficacious functioning of cultural institutions.

Eaton's understanding of experiencing art within a tradition also reflects the ideas of many predecessors. I see nothing in her theory that couldn't accommodate the benefits ascribed to aesthetic experience by either Beardsley, Osborne, Goodman, or Kaelin. Yet her concern to show how aesthetic values intermingle with intellectual and moral values gives her conception a different slant. Once more, although all of these writers have special interests, they also hold certain things in common.

The varieties of aesthetic experience that theorists have articulated as well as a brief account of their antecedent ideas recall the theme of this essay and force the conclusion that art variously has the capacity to gratify the aesthetic sense, stimulate perception, and enlighten the mind. These are the powers that Cicero attributed to rhetoric, and presumably to art, and which he called the ability to move, delight, and inform. With Cicero, says Harry S. Broudy, we continue to believe that works of art "do say something, are expressive, and in some sense communicate even as they please and move."[3]

I now provide some examples of recorded responses to scenes of nature, ordinary objects and situations, vistas, and works of art from which I think we may infer the presence of many of the features, values, and consequences of aesthetic experience discussed in the theoretical literature.

Let us start with Osborne who in his *The Art of Appreciation* begins his account of aesthetic experience by drawing attention to some simple moments of daily awareness.

We pass our lives, strenuously or languorously, in a never-ending give and take with a partly malleable, partly resistant environment, material and human, adapting it to our ends when we can and accommodating ourselves to it when we must. Occasionally the busy flow of life's intricate involvements is interrupted as there occur sudden pauses in our practical and theoretical preoccupations, moments of calm amidst the turmoil . . . as our attention is caught by . . . the rhythmic rise and fall of susurration on a summer's day, the smoky calligraphies of wheeling birds painted on a trans-

parent grey sky in winter, the grotesque contorted menace of an olive tree's branches, the lissom slenderness of a birch, or the sad sloppiness of a rain-crushed dandelion. Commonplace objects suddenly shed their murk and enter the focus of attention. Perhaps for the first time in our memory we see a familiar sight.[4]

Let us call such moments of awareness the perception of the qualitative immediacy of life. Yet there are persons who find it difficult to respond to even the simple qualities of things. At least this seems to have been the case with a rather well-known fictional character, Sherlock Holmes, whom we come across in "The Adventure of the Copper Beeches" traveling by train with his companion, Dr. Watson.

> By eleven o'clock the next day we were well upon our way to the old English capital. Holmes had been buried in the morning papers all the way down, but after we had passed the Hampshire border he threw them down and began to admire the scenery. [Or so Watson thought.] It was an ideal spring day, a light blue sky, flecked with little fleecy white clouds drifting across from west to east. The sun was shining very brightly, and yet there was an exhilarating nip in the air, which set an edge to a man's energy. All over the countryside, away to the rolling hills around Aldershot, the little red and gray roofs of the farm-steadings peeped out from amid the light green of the new foliage.
>
> "Are they not fresh and beautiful?" [exclaimed Watson] . . . with all the enthusiasm of a man fresh from the fogs of Baker Street.
>
> But Holmes shook his head gravely.
>
> "Do you know Watson, . . . that it is one of the curses of mind with a turn like mine that I must look at everything with a reference to my own special subject. You look at these scattered houses, and you are impressed by their beauty. I look at them, and the only thought which comes to me is a feeling of their isolation and of the impunity with which crime may be committed there."
>
> "Good heavens!" [cried Watson] . . . "Who would associate crime with these dear old homesteads?"
>
> [To which Holmes said] "They always fill me with a certain horror. It is my belief, Watson, founded upon my experience, that the lowest and vilest alleys in London do not present a more dreadful record of sin than does the smiling and beautiful countryside."

"You horrify me!" [said Watson].
"But the reason [replied Holmes] is very obvious."[5]

Holmes went on to explain why the beautiful and smiling countryside is so vile (a view, we may take it, not shared by many of his nonfictional countrymen). The point, of course, is not the beauty or vileness of the English countryside but the potentially inhibiting nature of professional preoccupation. Thoughts about crime were too much with Holmes for the aesthetic instinct to surface and break through.

Indeed, the reactions of Holmes and Watson are reminiscent of another famous pair of companions who met and decided to take a walk outside the city walls of Athens. The meeting takes place in Plato's dialogue *Phaedrus* and is recalled by Albert William Levi.

Socrates and Phaedrus meet by chance, and when Socrates asks: "Where do you come from, Phaedrus my friend, and where are you going?" Phaedrus replies: "I take my walks on the open roads for it is more invigorating than walking in the colonnades in the city." Socrates is at last persuaded to accompany Phaedrus for a walk outside the walls, and as they turn off the road to rest beside the Ilissus, a quiet country stream, Socrates in spite of himself exclaims over the beauty of the place. "Upon my word, a delightful resting place, with this tall, spreading tree, and a lovely shade from the high branches. Now that it's in full flower, it will make the place ever so fragrant. And what a lovely stream under the plane tree, and how cool to the feet! . . . And then too isn't the freshness of the air most welcome and pleasant, and the shrill summery music of the cicada choir! And as crowning delight the grass, thick enough on a gentle slope to rest your head on most comfortably. In fact, my dear Phaedrus, you have been the stranger's perfect guide." "You, my excellent friend," replies Phaedrus, "Strike me as the oddest of men. Anyone would take you, as you say, for a stranger being shown the country by a guide instead of a native—never leaving town to cross the frontier, nor even, I believe, so much as setting foot outside the walls." And Socrates answers: "You must forgive me, dear friend, I'm a lover of learning, and trees and open country won't teach me anything, whereas men in the town do. . . ."[6]

Had civic and moral concerns not been so pressing, perhaps Socrates would have had a greater disposition to delight in the qualities of simple things, for example a falling leaf, which is Pepita Haezrahi's model for aesthetic experience. In *The Contemplative Activity* she writes:

Our leaf falls. It detaches itself with a little plopping sound from its
place high up in the tree. It is red and golden. It plunges straight
down through the tree and then hesitates and hovers for a while just
below the lowest branches. The sun catches it and it glitters with
mist and dew. It now descends in a leisurely arc and lingers for
another moment before it finally settles on the ground.

And she goes on:

You witness the whole occurrence. Something about it makes you
catch your breath. The town, the village, the garden around you sink
into oblivion. There is a pause in time. The chain of your thoughts
is severed. The red and golden tints of the leaf, the graceful form
of the arc described by its descent fill the whole of your conscious-
ness, fill your soul to the brim. It is as though you existed in order
to gaze at this leaf falling, and if you had other preoccupations and
other purposes you have forgotten them. You do not know how long
this lasts, it may be only an instant, but there is a quality of
timelessness, a quality of eternity about it. You have had an
aesthetic experience.[7]

We may assume that the need to rake up fallen leaves quickly
dissipates the aesthetic interest, but the immediate impression of nature's
beauties, which Socrates remarked and of which Haezrahi speaks, deserves
some comment. In *A New Theory of Beauty*, which perhaps represents a
renewal of interest in the concept in contemporary aesthetics, Guy Sircello
remarks the characteristically exclamatory character of our responses to
beauty of different kinds.

We don't, generally speaking, simply see, hear, feel, taste, or
otherwise apprehend beauty. Beauty is typically an attention-
getter; we suddenly notice it; it breaks into our consciousness.
Moreover, it does so gratuitously; it does so despite the fact that we
may not have been looking for it, despite the fact that we had no
inkling it was going to be there. The beauty of the freeway
interchange that we have never seen before suddenly dawns on us
as we drive through it. The exotic face of a stranger in the crowd
"leaps out" at us as we push our way along in our usual everyday
daze. But even beauties we have seen many times before can catch
our notice. We anticipate the majestic view as we round the bend,
and, as always, it grabs our attention as it comes in sight.
 In these situations beauty always appears the "aggressor." The
metaphors we use to describe the experiences all point to this fact.
Beauty "catches" our attention; it "breaks on us;" it "leaps out" at

us; it "strikes" us. We seem powerless before its pull. It seems as if it is not we who give our attention to beauty, but beauty that, as it were, forces our attention on it. Thus we often sensibly recoil when we notice beauty; our head draws back, or feels as if it does.

And he goes on:

This "impact" that beauty has on us is not merely emotional. It may be true that "my heart leaps up when I behold the rainbow in the sky," but so do my eyes "light up." The element that I want particularly to stress in our reaction to beauty is its effect on our senses, our perceptual faculties, our minds. Specifically, this effect is one of "expansion." Our eyes are "filled" with the beauty of the landscape, our ears with the sweetness of the melody, our mind with the elegance of the argument. It is as though the receptive faculty were growing larger to take in the abundance offered it. Visual beauty, especially, is like a light dawning on us, flowing out from its source and filling the world and us with itself. Medieval philosophers were sufficiently impressed by this phenomenon to insist that beauty is, in part, *claritas,* which has been aptly translated as "radiance."

Finally, beauty has a tremendous holding power for us. When we perceive a beautiful thing, we don't want to let it go, we never want to stop perceiving it. It is as if our eyes wanted to drown in the sight, our ears in the sound. When the beautiful thing has disappeared, or we have gone our way, we sense a loss, we feel let down.[8]

The sense of beauty described by Sircello is revealed in numerous passages from Darwin's journals. Unlike Holmes, Darwin did not let his professional interests inhibit his capacity for aesthetic experience, as his account of the following response to a vista in the Andes Mountains indicates:

When we reached the crest and looked backwards, a glorious view was presented. The atmosphere resplendently clear; the sky an intense blue; the profound valleys; the wild broken forms; the heaps of ruins, piled up during the lapse of ages; the bright-colored rocks, contrasted with the quiet mountains of snow; all these together produced a scene no one could have imagined. Neither plant nor bird, excepting a few condors wheeling around the higher pinnacles, distracted my attention from the inanimate mass. I felt glad that I was alone: it was like watching a thunderstorm, or hearing in full orchestra a chorus of the *Messiah.*[9]

With similar intensity the Russian painter Wassily Kandinsky writes of his response to Moscow an hour before sunset.

> Pink, lavender, yellow, white, blue, pistachio green, flame-red houses, churches—each an independent song—the raving green grass, the deep murmuring trees, or the snow, singing with a thousand voices, or the allegretto of the bare branches, the red, stiff, silent ring of the Kremlin walls and above, towering overall like a cry of triumph, like a Hallelujah forgetful of itself, the long, white, delicately earnest line of the Uvan Veliky Bell Tower. And upon its neck, stretched high and taut in eternal longing to the heavens, the golden head of the cupola, which is the Moscow sun amid the golden and colored stars of the other cupolas.[10]

In contrast, Henry James, the novelist and inveterate traveler, provides a more muted response to another great city. When he thought of Venice he said that it was not so much its grand vistas that came to mind as

> a narrow canal in the heart of the city—a patch of green water and a surface of pink wall. The gondola moves slowly; it gives a great smooth swerve, passes under a bridge, and the gondolier's cry, carried over the quiet water, makes a kind of splash in the stillness. A girl crosses the little bridge, which has an arch like a camel's back, with an old shawl on her head, which makes her characteristic and charming; you see her against the sky as you float beneath. The pink of the old wall seems to fill the whole place; it sinks even into the opaque water. Behind the wall is a garden, out of which the long arm of a white June rose—the roses of Venice are splendid—has flung itself by way of spontaneous ornament. [And for a dash of dramatic contrast.] On the other side of this small waterway is a great shabby facade of Gothic windows and balconies—balconies on which dirty clothes are hung and under which a cavernous-looking doorway opens from a low flight of slimy watersteps. It is very hot and still, the canal has a queer smell, and the whole place is enchanting.[11]

Yet when Mark Twain reflects on that great American canal, the Mississippi River, it is a sunset that he recalls:

> The face of the water, in time, became a wonderful book—a book that was a dead language to the uneducated passenger, but which told its mind to me without reserve, delivering its most cherished secrets as clearly as if it uttered them with a voice I still keep in mind a certain wonderful sunset which I witnessed when

steamboating was new to me. A broad expanse of the river was turned to blood; in the middle distance the red hue brightened into gold, through which a solitary log came floating, black and con-spicuous; in one place a long, slanting mark lay sparkling upon the water; in another the surface was broken by boiling, tumbling rings, that were as many-tinted as an opal; where the ruddy flush was faintest, was a smooth spot that was covered with graceful circles and radiating lines, ever so delicately traced; the shore on our left was densely wooded, and the sombre shadow that fell from this forest was broken in one place by a long, ruffled trail that shone like silver; and high above the forest wall a clean-stemmed dead tree waved a single leafy bough that glowed like a flame in the unob-structed splendor that was flowing from the sun. There were graceful curves, reflected images, woody heights, soft distances; and over the whole scene, far and near, the dissolving lights drifted steadily, enriching it, every passing moment, with new marvels of coloring.

I stood like one bewitched. I drank it in, in a speechless rapture. [12]

True, Twain also said that once the language of the majestic river had been mastered for purposes of navigation the enjoyment of its grace, beauty, and poetry was no longer possible. Ostensibly this seems to reinforce the belief that the practical and aesthetic attitudes are in conflict and cancel each other out. Yet I think it is arguable that this necessarily occurs.

But then we may ask, just what does happen when the mind shifts from one point of view to another—from a professional, practical, civic, or moral point of view to an aesthetic one? In an essay that maps the structure of knowledge in the arts and includes a discussion of knowing in the aesthetic experience, Harry S. Broudy conjured up the following possibility. It is an experience that anyone who has ever seen a Hollywood musical with Fred Astaire and Ginger Rogers, or with Gene Kelly and Leslie Caron for that matter, can easily imagine having had.

Suppose we observe our neighbor walking briskly down the street on a weekday morning. The walk has a certain rhythm and pace, but our perception of it is likely to be no more than a registration of clues for inferences about what our neighbor is up to. . . . Suppose now that our neighbor suddenly breaks into a little hop, skip, and jump routine. Our interest perks up immediately, forcing strange hypoth-eses into our minds as to what might be the cause of this unusual behavior. The walking has become expressive of something; joy, excitement, or nervousness. In any event, we now watch the scene

more intently. As we do, suppose our neighbor wheels about to face us and begins a fairly simple tap dance. At this juncture we either call the police, or we become absorbed in the dance itself. The practical and intellectual attitudes will then have begun to turn into the aesthetic attitude. Our interest is in perceiving the field and the motions within it.

If, however, the neighbor continues the tapping indefinitely our interest flags. The field has been explored; there is no further surprise to be anticipated, no further excitement. But suppose he varies the routine; suppose the rhythms become more complicated; suppose out of nowhere music sounds with a rhythm synchronized to the dancing; suppose a female dancer appears and joins our neighbor in his act. Suppose now instead of the drab ordinary street clothing, the dancers acquire brilliant costumes and that the simple music swells to a multi-instrumented orchestra. By this time our practical concerns with our neighbor will probably have been completely submerged in our aesthetic interest. Instead of one sense many of our senses are functioning at a high rate of intensity; instead of monotony there is variation of a pattern, there is contrast of pace, male and female, light and heavy, tension and release, a building up of climax and resolution. Before our eyes, so to speak, an ordinary piece of pedestrianism has been turned into a work of art, that is, into a field designed for perceiving and for not much of anything else.

Broudy further remarks that the degree of interest occasioned by works of art will be a function not only of their formal complexity but also of the nerves they touch in percipients. The experience of blue skies, falling leaves, and tap dancing may be refreshing and moving, but not profoundly so. But if, says Broudy, "the dance is a caricature (a sketch) of war, of death, of love, of tragedy, of triumph, our perceiving becomes serious in the sense that we are beholding an expression that is also trying to be a statement about something so important, so close to the big issues in human life, perhaps so dangerous, so revolting that we have not yet formulated language to state it clearly." Perhaps, says Broudy, such works "portray impulses and instincts that man would just as soon forget he had."[13] Perhaps we may say that some of these instincts and impulses are revealed in Picasso's *Guernica* described here by E. F. Kaelin:

When we respond to a shape as a representation of a bull or horse, our experience deepens: more of the world is now includable within our brackets. If we look more closely, we can identify other objects: a broken warrior, frozen in rigor mortis, his severed arm still

clutching a broken sword; a mother in agony over the death of her child; a woman falling through the shattered timbers of a burning building; a flickering light; a wounded dove, its peace gone astray. . . . Let the mind play over these images and an idea grips the understanding: The wages of war, as it is currently conducted, are death and destruction. . . . So interpreted, our experience of *Guernica* deepens and comes to closure in a single act of expressive response in which we perceive the fittingness of this surface—all broken planes and jagged edges in the stark contrast of black and white [the way the picture looks]—to represent this depth [the work's import], the equally stark contrast of the living and the dead.[14]

Broudy and Kaelin remind us of our capacity to delight in artworks that express the darker side of human existence, a fact that deserves remarking. For example, when one speaks of delight as a characteristic or essential feature of our aesthetic experience of works of art, one might be quickly rebutted by someone saying that so many works of art are so horrifying, dreadful, or unsettling that it is unrealistic to insist on pleasure as an essential aspect of aesthetic experience. Yet such a response would be too quick and unreflective, and the reason is that the meaning of pleasure and delight in an aesthetic context is not well understood. For example, in his "Aesthetic Experience Regained," which has been called a model of philosophical analysis, Beardsley responds to criticisms that the aesthetic cannot be defined in terms of gratification. Commenting on a purported counterexample—that the muzzles of the guns pointed at us in Eisenstein's film *Potemkin* "are positively menacing"—Beardsley points out that "it is not the battleship Potemkin that confronts us when we go to a motion picture theater to see the Eisenstein film, but merely a picture of it. And this picture does not in any way menace us, but instead offers us the *quality* of menace— a quality that we deeply enjoy in its dramatic context."[15] Similarly, in a philosophical essay titled "Aesthetic Education," Diané Collinson emphasizes that we must understand how "aesthetic delight" has to be applied to our experiences of artworks if it is to encompass, say, the fearfulness of a Francis Bacon painting, the horrific tension of *Waiting for Godot,* or the anguish of Marlowe's *Faustus*. "It is not," says Collinson, "that it describes the character of every appropriate experience in the presence of works of art, but that it is characteristic of ultimate aesthetic approval. It is a delight that clarity has been achieved, that something matchless, intelligible and illuminating has been present to us."[16] And what enables us to enjoy or take delight in the less attractive aspects of life is that we are, as Eaton points out,

in control of the experience of menace, terror, and so forth, expressed in works of art. Such control is needed for achieving detached affect—which, although a feature of aesthetic experience, does not mean that percipients remain uninvolved.

But to continue; in contrast to the landscape of destruction and suffering in the *Guernica,* Cézanne produces in his mature works something that is about as close as one can come to pure aesthetic vision. Here is Meyer Schapiro on Cézanne's *Mont Saint-Victoire* (1885-87, London). His commentary is notable for his description of the work's formidable qualities, fusion of opposites, and sense of drama.

> It is marvelous how all seems to flicker in changing colors from point to point, while out of this vast restless motion emerges a solid world of endless expanse, rising and settling. The great depth is built up in broad layers intricately fitted and interlocked, without an apparent constructive scheme. Towards us these layers become more and more diagonal; the diverging lines in the foreground seem a vague reflection of the mountain's form. These diagonals are not perspective lines leading to the peak . . . [rather they] conduct us far to the side where the mountain slope begins; they are prolonged in a limb hanging from the tree.
>
> It is this contrast of movements, of the marginal and centered, of symmetry and unbalance, that gives the immense aspect of drama to the scene. Yet the painting is a deep harmony, built with a wonderful finesse. It is astounding how far Cézanne has controlled this complex whole.[17]

As I've said in different places, much of the writing about art today that passes for art criticism pays less attention to the kinds of formal and expressive qualities favored by artists like Cézanne; preferring instead to discuss a work in social and political terms. Yet lovers of art will always delight in the kinds of qualities that Cézanne's works feature; they are what has earned him the status of a modern master. While I have made clear that formalism as a theory of art has limitations, formal qualities are nonetheless the redeeming values of many artworks whose subjects and stories we no longer take seriously.

With the descriptions by Kaelin and Schapiro we return to the consideration of the aesthetic experience of major works of art, which was the topic of chapters 4 and 5. If in those chapters the discussion of aesthetic experience seemed inordinately slanted toward works of art, the examples of aesthetic response provided in this appendix are meant to introduce some

balance. The examples also underline a point made by Beardsley, namely, that Dewey's notion of aesthetic experience, with its emphasis on a temporal unfolding and the dramatic organization of components, does not apply to all encounters properly called aesthetic. To accommodate this fact, Beardsley in his later writings spoke of experiences that have an aesthetic character despite the shortness of their duration, although he still thought Dewey's ideal was relevant to the experience of major works whose complexity can be grasped only over an extended period of time.

In concluding, it is worth remarking some of the dualities, polarities, and paradoxes of aesthetic experience. As described by various writers and depending on the object of experience, aesthetic experience has phases not only of exhilaration but also of serenity, repose, and contemplation; it leads not only to feelings of sensuous gratification but also to the discovery of the nature and reality of things; it gives not only pleasure but also pain (in the sense discussed by Eaton); it has not only a tonic effect but also a melancholic aftereffect; and its value is not only immediate but also instrumental. In short, aesthetic experience provides the benefits ascribed to it by the theorists discussed in chapter 4: It yields a high degree of gratification, energizes mental powers, produces understanding, contributes to the functioning of the institutions of the art world, and, in general, inspires and vitalizes human existence. Whatever the difficulties of trying to isolate a strand of experience that can be called aesthetic, those who have tried to do so have contributed important insights into the nature of our encounters with works of art as well as with other objects of contemplation. Obviously, such accounts have much to say about our ability to make sense of works of art, the development of which ability is, overall, the goal of art education. And in view of the long history of what in effect has always been aesthetic experience, irrespective of whether it was always recognized as such, it seems unlikely that interest in this kind of experience will fade away.

Notes

Chapter 1. Excellence, the Continuing Ideal

The epigraph is from Moses Hadas, *The Greek Ideal and Its Survival* (New York: Harper, 1966), 13.

1. Jerome Bruner, *The Process of Education,* with new preface (Cambridge: Harvard University Press, 1977). First published 1960.

2. In *The Unschooled Mind: How Children Think and How Schools Should Teach* (New York: Basic Books, 1991), Howard Gardner writes that "in nearly every student there is a five-year-old 'unschooled' mind struggling to get out and express itself '" (5). The extent of the cultural illiteracy of young people is documented in E. D. Hirsch, Jr., *Cultural Literacy* (New York: Random House, 1988), Diane Ravitch and Chester Finn, Jr., *What Do Our 17-Year-Olds Know?* (New York: Harper and Row, 1987), and Daniel S. Singal, "The Other Crisis in American Education," *The Atlantic Monthly* 268, no. 5 (November 1991): 59-74. Highlighting the dearth of general knowledge by college students, Singal writes: "Indeed, one can't assume that college students know anything anymore" (62).

3. Max Lerner, *America as a Civilization,* 2d ed. (New York: Henry Holt, 1987), 1008. First published 1957.

4. In *The Pelican History of Canada* (Baltimore: Penguin Books, 1969), Kenneth McNaught writes that "Callaghan's novels of urban life have been compared, not inappropriately, to the work of Fitzgerald and Hemingway" (239).

5. Marcia Muelder Eaton, *Aesthetics and the Good Life* (Rutherford, N.J.: Farleigh Dickinson University Press, 1989), preface.

6. The classic discussion of Greek culture is Werner Jaeger's *Paideia: The Ideals of Greek Culture,* 3 vols., translated by Gilbert Highet (New York: Oxford University Press, 1939-45). *The Paideia Proposal: An Educational Manifesto* (New York: Macmillan, 1982) by Mortimer J. Adler prints on its dedication page the following: "PAIDEIA (py-dee-a) from the Greek pais, paidos: the upbringing of a child. (Related to pedagogy and pediatrics.) In an extended sense, the equivalent of the Latin humanitas (from which 'the humanities'), signifying the general learning that should be the possession of all human beings." Hirsch's notion of cultural literacy consists of the minimal knowledge of names, dates, events, and values that all individuals need to participate effectively in a national literate culture. In this respect, it encompasses only part of what Adler calls general knowledge. For an interpretation of cultural literacy that goes beyond Hirsch's notion of an extensive curriculum, see my *General Knowledge and Arts Education* (Urbana: University of Illinois Press, 1994).

Chapter 2. The Eighties' Call for Reform

The epigraph is from John Goodlad, *A Place Called School* (New York: McGraw-

Hill, 1984), 220.

1. The major educational studies and works discussed in this chapter are: The National Commission on Education, *A Nation at Risk* (Washington, D.C.: Government Printing Office, 1983); Goodlad, *A Place Called School* (New York: McGraw-Hill, (1984), Mortimer J. Adler, *The Paideia Proposal: An Educational Manifesto* (New York: Macmillan, 1982), *Paideia Problems and Possibilities* (New York: Macmillan, 1983), and *The Paideia Program: An Educational Syllabus* (New York: Macmillan, 1984), which contains essays by different writers on the skills and subjects that constitute a paideia program; Ernest L. Boyer, *High School: A Report on Secondary Education in America* (New York: Harper and Row, 1983); Theodore Sizer, *Horace's Compromise: The Dilemma of the American High School* (Boston: Houghton Mifflin, 1984); *Academic Preparation for College* (New York: The College Board, 1983) and *Academic Preparation in the Arts* (New York: The College Board, 1985). Information about Paideia programs can be found in *Paideia Next Century,* a newsletter of the National Paideia Center, School of Education, the University of North Carolina at Chapel Hill.

2. Jerome Hausman, ed., *Arts and the Schools* (New York: McGraw-Hill, 1980).

3. See, e.g., Ernest L. Boyer, *College: The Undergraduate Experience in America* (New York: Harper and Row, 1987). The study found "divisions on the campus, conflicting priorities and competing interests that diminish the intellectual and social quality of the undergraduate experience and restrict the capacity of the college effectively to serve its students" (2). Cf. the introduction by Herbert I. London to Jacques Barzun, *The American University: How It Runs, Where Is It Going?* 2d ed. (Chicago: University of Chicago Press, 1993), ix - xxii. First published 1968.

4. John Van Dorn, "The Fine Arts" in Adler, *The Paideia Program: An Educational Syllabus,* 141-53.

5. See, e.g., V. A. Howard's discussion of learning in Part II of his *Learning by All Means: Lessons from the Arts* (New York: Peter Lang, 1992), and Mari Sorri, "The Body Has Reasons: Tacit Knowing in Thinking and Making," *Journal of Aesthetic Education* 28, no. 2 (Summer 1994): 15-26.

6. For critical discussions of efficiency models of schooling, see R. A. Smith, ed., *Regaining Educational Leadership: Critical Essays on PBTE/CBTE, Behavioral Objectives, and Accountability* (New York: John Wiley, 1975).

7. In the following I discuss Harry S. Broudy, *Truth and Credibility: The Citizen's Dilemma* (New York: Longman, 1981); Maxine Greene, "Aesthetic Literacy in General Education," in *Philosophy and Education,* ed. Jonas Soltis, Eightieth Yearbook of the National Society for the Study of Education, Part I (Chicago: University of Chicago Press, 1981); Mary Ann Raywid, Charles A. Tesconi, Jr., and Donald Warren, *Pride and Promise: Schools of Excellence for All the People* (Westbury, N.Y.: American Educational Studies Association, 1984).

8. Saul Bellow, *The Dean's December* (New York: Pocket Books, 1983), 334.

9. See my "The Changing Image of Art Education: Theoretical Antecedents of Discipline-based Art Education," in *Discipline-Based Art Education: Origins,*

Development, and Meaning, ed. R. A. Smith (Urbana: University of Illinois Press, 1989), 3-34.

10. Frank Sibley "Aesthetic and Nonaesthetic," *The Philosophical Review* 74, no. 2 (April, 1965), 136-37.

11. A sense of the kinds of writings philosophers of art have contributed to the field of arts education may be gained by scanning the volumes of the *Journal of Aesthetic Education* (1966-). Several of the more pertinent writings have been assembled in R. A. Smith and Alan Simpson, eds., *Aesthetics and Arts Education* (Urbana: University of Illinois Press, 1991).

12. A brief, which is to say by no means complete, bibliography of books that contributed to the substantive reform movement in art education from the fifties to the mid-eighties, would have to include Rudolf Arnheim, *Art and Visual Perception* (Berkeley and Los Angeles: University of California Press, 1954, second version, 1974); Manuel Barkan, *A Foundation for Art Education* (New York: Ronald Press, 1955); Thomas Munro, *Art Education: Its Philosophy and Psychology* (New York: Liberal Arts Press, 1956); Vincent Lanier, *Teaching Secondary Art* (Scranton: International Textbook, 1964); Ralph A. Smith, ed., *Aesthetics and Criticism in Art Education* (Chicago: Rand McNally, 1966); Elliot W. Eisner and David W. Ecker, eds., *Readings in Art Education* (Waltham, Mass.: Blaisdell, 1966); Reid Hastie, *Encounter with Art* (New York: McGraw-Hill, 1969); Edmund B. Feldman, *Becoming Human through Art* (Englewood Clifts, N.J.: Prentice-Hall, 1970); George Pappas, ed., *Concepts in Art and Education* (New York: Macmillan, 1970); Ralph A. Smith, ed., *Aesthetics and Problems of Education* (Urbana: University of Illinois Press, 1971); David W. Ecker and Eugene F. Kaelin, "The Limits of Aesthetic Inquiry: A Guide to Educational Research," in *Philosophical Redirection of Educational Research,* ed. Laurence G. Thomas, Seventy-first Yearbook of the National Society for the Study of Education, Part I (Chicago: University of Chicago Press, 1972) 258-86; Harry S. Broudy, *Enlightened Cherishing: An Essay on Aesthetic Education* (Urbana: University of Illinois Press, 1993; first published 1972); Elliot W. Eisner, *Educating Artistic Vision* (New York: Macmillan, 1972); Howard Gardner, *The Arts and Human Development* (New York: John Wiley, 1973); *Report of the NAEA Commission on Art Education* (Reston, Va.: National Art Education Association, 1977); Laura H. Chapman, *Approaches to Art in Education* (New York: Harcourt Brace Jovanovich, 1978); Charles D. Gaitskell, Al Hurwitz, and Michael Day, *Children and Their Art,* 4th ed. (New York: Harcourt Brace Jovanovich, 1982).

13. Lelani Lattin Duke, "Striving for Excellence in Art Education," *Design for Arts in Education* 85, no. 3 (January/February, 1984): 46. Among the earlier Getty publications, all published by the Center in Los Angeles are: *Beyond Creating: The Place of Art in American Schools* (1985); Harry S. Broudy, *The Role of Imagery in Learning* (1987); *Issues in Discipline-Based Art Education: Strengthening the Stance, Extending the Horizons* (1987); Elliott W. Eisner, *The Role of Discipline-Based Art Education in America's Schools* (1988); and *The Pre-Service Challenge: Discipline-Based Art Education and Recent Reports on Higher Education* (1988). A comprehensive and systematic statement of DBAE is "Discipline-based Art Education: Becoming Students of Art" by Gilbert A. Clark, Michael D. Day, and

W. Dwaine Greer, first published in the *Journal of Aesthetic Education* 21, no. 2 (Summer 1987), a special issue devoted to DBAE, and subsequently in a book *Discipline-Based Art Education: Origins, Meaning, Development,* ed. R. A. Smith (Urbana: University of Illinois Press, 1989), 129-93, currently in a second printing. Arthur Efland in his *History of Art Education* (New York: Teachers College Press, 1990), 253, states that it was W. Dwaine Greer who first used the term "discipline-based art education." Cf. Greer's "A Discipline-based View of Art Education: Approaching Art as a Subject of Study," *Studies in Art Education* 25, no. 4 (Summer 1984): 212-18. More recent Getty publications are mentioned in later chapters.

14. *The New National Endowment for the Artists-in Education Program: A Briefing Paper for the Arts Education Community.* Available from Music Educators National Conference, 1902 Association Drive, Reston, Virginia.

15. See Lonna Jones, "Excellence in Arts Education: The Impulse to Search and to Know," *Design for Arts in Education* 85, no. 3 (January/February 1984). Also a special issue of *Daedalus* 112, no. 3 (Summer 1983) devoted to arts education.

16. *Art History, Art Criticism, and Art Production,* 3 vols. (Santa Monica: Rand Corporation, 1984). Vol. 1 compares the process of change across districts (Milbrey Wallin McLaughlin and Margaret A. Thomas); Vol. 2 consists of case studies of seven selected sites (Michael Day, Elliot Eisner, Robert Stake, Brent Wilson, Marjorie Wilson); Vol. 3 is an executive summary (McLaughlin, Thomas, and Joyce Petersen).

17. See *National Standards for Arts Education* (Reston, Virginia: Music Educators National Conference, 1994).

Chapter 3. Recent Developments: 1986-1994

The epigraph is from *Toward Civilization: A Report on Arts Education* (Washington, D.C.: National Endowment for the Arts, 1988), 120-21.

1. Arthur Efland, *A History of Art Education: Intellectual and Social Currents in Teaching the Visual Arts* (New York: Teachers College Press, 1990); Foster Wygant, *School Art in American Culture: 1820-1970* (Cincinnati: Interwood Press, 1993); and Diana Korzenik's contribution to Maurice Brown and Diana Korzenik, *Art Making and Education* (Urbana: University of Illinois Press, 1993). An earlier work also worth noting is Korzenik's *Drawn to Art: A Nineteenth Century American Dream* (Hanover, N.H.: University Press of New England, 1985).

2. Michael J. Parsons, *How We Understand Art: A Cognitive Developmental Account of Aesthetic Experience* (Cambridge: Cambridge University Press, 1987). Cf. Abigail Housen, *The Eye of the Beholder: Measuring Aesthetic Development.* Unpublished doctoral dissertation. Harvard Graduate School of Education, 1983; and "Museums in an Age of Pluralism," in *Art Education Here,* ed. Pamela Banks (Boston: Massachusetts College of Art, 1987).

3. Bennett Reimer and R. A. Smith, eds., *The Arts, Education, and Aesthetic Knowing,* Ninety-First Yearbook of the National Society for the Study of Educa-

tion, Part II (Chicago: University of Chicago Press, 1992).

4. Howard Gardner and D. N. Perkins, eds., *Art, Mind, and Education* (Urbana: University of Illinois Press, 1989); Howard Gardner, *Art Education and Human Development*, (Los Angeles: Getty Center for Education in the Arts, 1990); and David Perkins, *The Intelligent Eye: Learning to Think by Looking at Art* (Los Angeles: Getty Center for Education in the Arts, 1993).

5. Volumes in this series are: Albert William Levi and R. A. Smith, *Art Education: A Critical Necessity* (1991), Stephen Addiss and Mary Erickson, *Art History and Education* (1993), Michael J. Parsons and H. Gene Blocker, *Aesthetics and Education* (1993), Maurice Brown and Diana Korzenik, *Art Making and Education* (1993), and Theodore Wolff and George Geahigan, *Art Criticism and Education* (forthcoming). The intention of this series is to contribute to the substantive literature of discipline-based art education by having academic specialists and artists coauthor volumes with educational specialists.

6. R. A. Smith, ed. *Discipline-Based Art Education: Origins, Meaning, Development* (Urbana: University of Illinois Press, 1989).

7. Stephen Mark Dobbs, *The DBAE Handbook: An Overview of Discipline-Based Art Education* (1992) and Kay Alexander and Michael Day, *Discipline-Based Art Education: A Curriculum Sampler* (1991), both published by the Getty Center for the Arts, Los Angeles. Cf. Gilbert A. Clark, *Examining Discipline-Based Art Education as a Curriculum Construct* (Bloomington, Ind.: ERIC: ART, 1991), 27 pp.

8. Michael Kirst and Carolyn Kelley, *Network News and Views* 12, no. 6 (June 1993): 58-62.

9. Thomas Toch, *In the Name of Excellence: The Struggle for Reform in the Nation's Schools, Why It's Failing, and What Should Be Done* (New York: Oxford University Press, 1991).

10. The severe constraints on learning and human development in schools is a major theme of Howard Gardner's *The Unschooled Mind* (New York: Basic Books, 1991). That is to say, not only conservatives are critical of the schools' performance. Liberals are as well.

11. Charles Leonhard, *The Status of Arts Education in American Public Schools: Summary and Conclusions* (Urbana: Council for Research in Music Education, School of Music, University of Illinois at Urbana-Champaign, 1991).

12. National Endowment for the Arts, *Toward Civilization: A Report on Arts Education* (Washington, D.C.: Government Printing Office, 1988), 13.

13. See *Art Education in Action: An All Participants Day Video Teleconference* (Los Angeles: Getty Center for Education in the Arts, 1994). Describes the Getty's major activities.

14. I follow, in large, Howard Gardner, "Toward More Effective Arts Education," in *Aesthetics and Arts Education*, ed. R. A. Smith and Alan Simpson (Urbana: University of Illinois Press, 1991), 281.

15. Nelson Goodman, *Languages of Art*, 2d ed. (Indianapolis: Hackett, 1976) and Howard Gardner, *Frames of Mind* (New York: Basic Books, 1983).

16. Dennie Palmer Wolf and Mary Burger, "More Than Minor Disturbances: The Place of the Arts in American Education," in *Public Money and the Muse*, ed.

Stephen Benedict (New York: W. W. Norton, 1991), 118-52.

17. See, e.g., Jessica Davis and Howard Gardner, "The Cognitive Revolution: Consequences for the Understanding and Education of the Child as Artist," in *The Arts, Education, and Aesthetic Knowing,* ed. Reimer and Smith, Part II, 92-123.

18. Efland, *The History of Art Education,* 260-63.

19. In this connection, see Laura Chapman's discussion of the federal government's artists-in-schools program in *Instant Art, Instant Culture: The Unspoken Policy for American Schools* (New York: Teachers College Press, 1982), esp. pages 119-21; excerpt reprinted in R. A. Smith and Ronald Berman, eds., *Public Policy and the Aesthetic Interest: Critical Essays on Defining Cultural and Educational Relations* (Urbana: University of Illinois Press, 1992), 119-36.

Chapter 4. Aesthetic Experience

The epigraph is from Marcia M. Eaton, *Aesthetics and the Good Life* (Rutherford, N.J.: Farleigh Dickinson University Press, 1989), preface.

1. Francis Sparshott, *The Theory of the Arts* (Princeton: Princeton University Press, 1982), 3.

2. In favoring dispositions as goals of teaching and learning, I follow William Frankena in his *Three Historical Philosophies of Education: Aristotle, Kant, Dewey* (Glenview, Ill.: Scott, Foresman, 1965), esp. chap. 1, and his "The Concept of Education Today," in *Educational Judgments,* ed. James F. Doyle (Boston: Routledge and Kegan Paul, 1973). In the latter, Frankena writes that "what I am suggesting is that education be conceived of as the fostering and acquiring, by appropriate methods, of desirable dispositions, and that the dispositions that are desirable . . . consist of a mastery of forms of thought and action with their respective standards, together with responsibility and autonomy" (31). Cf. Donald Arnstine, *Philosophy of Education* (New York: Harper & Row, 1967), 31-40.

3. For the discussions of talk about art, see David W. Ecker and E. F. Kaelin, "Levels of Aesthetic Discourse" and E. Louis Lankford, "Principles of Critical Dialogue" in *Aesthetics and Arts Education,* ed. R. A. Smith and Alan Simpson (Urbana: University of Illinois Press, 1991): 301-306, 294-300. Cf. Mihaly Csikszentmihalyi and Rick E. Robinson, *The Art of Seeing: An Interpretation of the Aesthetic Encounter* (Los Angeles: Getty Center for Education in the Arts, 1990).

4. Monroe C. Beardsley, *Aesthetics: Problems in the Philosophy of Criticism,* 2d ed. (Indianapolis: Hackett, 1981). First published 1958.

5. I have traced Beardsley's efforts to find the most appropriate terms to describe the hedonic character of aesthetic experience in "The Aesthetics of Monroe C. Beardsley: Recent Work," *Studies in Art Education* 25, no. 3 (Spring 1984): 141-50.

6. "Aesthetic Experience" in Beardsley, *The Aesthetic Point of View: Selected Essays,* ed. Michael J. Wreen and Donald M. Callen (Ithaca: Cornell University Press, 1982), 285-97; reprinted in Smith and Simpson, eds., *Aesthetics and Arts Education,* 72-84.

7. Harold Osborne, *The Art of Appreciation* (New York: Oxford University Press, 1970), esp. chap. 2. Without question the best philosophical analysis of

appreciation in the literature, with a strong pedagogical slant.

8. Kenneth Clark, "Art and Society," in *Moments of Vision* (London: John Murray, 1981), 79.

9. Nelson Goodman, *Languages of Art,* 2d ed. (Indianapolis: Hackett, 1976), 241-42. A good introduction to Goodman's philosophy is his *Of Mind and Other Matters* (Cambridge: Harvard University Press, 1984), esp. chap. 5.

10. Eugene F. Kaelin, *An Aesthetics for Art Educators* (New York: Teachers College Press, 1989).

11. Marcia M. Eaton, *Basic Issues in Aesthetics* (Belmont, Cal.: Wadsworth, 1988).

12. Eaton, *Aesthetics and the Good Life,* 95.

13. I emphasize the term *treating* and not just *discussing* works of art because in her recent writing Eaton acknowledges that in some cultures, for example, Native American, works of art are considered too sacred to be talked about. See her "Philosophical Aesthetics: A Way of Knowing and Its Limits," *Journal of Aesthetic Education* 28, no. 3 (Fall 1994): 26-27. This is a special issue devoted to the theme "Aesthetics for Young People," Ronald Moore, guest editor.

14. Personal correspondence.

15. Monroe C. Beardsley, "Aesthetic Experience Regained," in Beardsley, *The Aesthetic Point of View: Selected Essays,* ed. Michael J. Wreen and Donald Callen (Ithaca, N.Y.: Cornell University Press, 1982), 90.

16. I take this to be a response to Arthur Efland's belief that aesthetic experience should not be a major objective of art education because there is no way of knowing when a person has had such an experience and that it can easily be faked. See his "Ralph Smith's Concept of Aesthetic Experience and Its Curriculum Implications," *Studies in Art Education* 33, no. 4 (Summer 1992): 201-209.

17. Richard Hofstadter, *Anti-intellectualism in American Life* (New York: Alfred A. Knoph, 1963), 29.

18. Morris Weitz, "The Role of Theory in Aesthetics," *Journal of Aesthetics and Art Criticism* 15, no. 1 (1956): 180; reprinted in R. A. Smith, ed., *Aesthetics and Criticism in Art Education: Problems in Defining, Explaining, and Evaluating Art* (Chicago: Rand McNally, 1966), 84-94 and Joseph Margolis, ed., *Philosophy Looks at the Arts,* 3d ed. (Philadelphia: Temple University Press, 1987), 143-53.

Chapter 5. The Marks of Excellence

The epigraphs are from Kenneth Clark, *What Is a Masterpiece?* (New York: Thames and Hudson, 1979), 5; E. H. Gombrich, "The Tradition of General Knowledge" in his *Ideals and Idols* (New York: E. P. Dutton, 1979), 15-16; and Arnold Hauser, *Philosophy of Art History* (New York: Alfred A. Knopf, 1959), 5.

1. Monroe C. Beardsley, "Aesthetic Experience Regained," in Beardsley, *The Aesthetic Point of View: Selected Essays,* ed. Michael J. Wreen and Donald M. Callen (Ithaca, N.Y.: Cornell University Press, 1982), 77.

2. For a convenient summary of this tradition, see Herbert Read, *The Redemption of the Robot* (New York: Simon and Schuster, 1966). Cf. V. A. Howard, *Learning by All Means: Lessons from the Arts* (New York: Peter Lang,

1992). For Schiller's place in the history of aesthetics, see Monroe C. Beardsley, *Aesthetics from Classic Greece to the Present* (New York: Macmillan, 1966), to date the standard history of aesthetics.

3. Francis Sparshott, *The Theory of the Arts* (Princeton: Princeton University Press, 1982). Sparshott groups theories of art under four rubrics: classical, expressive, mystic, and purist lines.

4. See Arnold Hauser, *Philosophy of Art History* (New York: Alfred A. Knopf, 1959), 369; and John Passmore, *Serious Art* (La Salle, Ill.: Open Court, 1991). The constant discovery of counterexamples led Passmore to conclude that his effort to find necessary and sufficient conditions for something's being serious art was not successful. Still, there is much to be learned from his attempt. Cf. "Symposium: On the Serious in Art," *Journal of Aesthetic Education* 27, no. 4 (Spring 1993): 31-53, with contributions by Edward Sankowski, Stanley Godlovitch, and Catherine Lord, and a response by Passmore.

5. Jakob Rosenberg, *On Quality in Art: Criteria of Excellence, Past and Present* (Princeton: Princeton University Press, 1967).

6. Sherman E. Lee, "Painting," in *Quality: Its Image in the Arts,* ed. Louis Kronenberger (New York: Atheneum, 1969), 120; reprinted as "The Quality of Painting" in Lee's *Past, Present, East and West* (New York: George Braziller, 1983), 187-204. For the impact details in paintings can have, see Kenneth Clark, *100 Details from Pictures in the National Gallery* (Cambridge, Mass.: Harvard University Press, 1990).

7. Kenneth Clark, *What Is a Masterpiece?* 10-11.

8. Meyer Schapiro, *Cézanne* (New York: Harry N. Abrams, 1952), 74.

9. Harold Rosenberg, "Avant-Garde," in *Quality: Its Image in the Arts,* ed. Louis Kronenberger, 419-49.

10. Hilton Kramer, *The Age of the Avant-Garde* (New York: Farrar, Strauss and Giroux, 1973).

11. For example, Martin S. Dworkin in "Seeing for Ourselves: Notes on the Movie Art and Industry, Critics, and Audiences," *Journal of Aesthetic Education* 3, no. 3 (July, 1969): 45-46.

12. Stanley Kauffmann, "Film," in *Quality: Its Image in the Arts,* ed. Louis Kronenberger, 374-78.

13. Martin S. Dworkin, "The Desperate Hours and the Violent Screen," in *Aesthetics and Criticism in Art Education,* ed. R. A. Smith (Chicago: Rand McNally, 1966): 445-52.

14. See, e.g., Kauffmann's discussion of the creative use of color in Antonioni's *The Red Desert,* a use that advanced the art of film. Also see the discussion of Kauffmann in my *The Sense of Art* (New York: Routledge, 1989), 83-93.

15. Francis Sparshott, "Basic Film Aesthetics," *Journal of Aesthetic Education* 5, no. 2 (April, 1971): 34. Reprinted in Gerald Mast and Marshall Cohen, eds., *Film Theory and Criticism,* 2d ed. (New York: Oxford University Press, 1979), 321-34.

16. H. Gene Blocker, *The Aesthetics of Primitive Art* (New York: University Press of America, 1994).

17. Harold Osborne, "Assessment and Stature," in *Aesthetics and Arts Education*, ed. R. A. Smith and Alan Simpson (Urbana: University of Illinois Press, 1991), 95-107.

18. Nelson Goodman, *Of Mind and Other Matters* (Cambridge: Harvard University Press, 1984), 179-80.

19. Kenneth Clark, *Landscape into Art* (Boston: Beacon Press, 1961). First published 1949.

20. See, e.g., Barry Sadler and Allen Carlson, eds., *Environmental Aesthetics: Essays in Interpretation* (Victoria, British Columbia: University of Victoria, 1982); Yrjö Sepämas, *The Beauty of the Environment* (Helsinki: Suomalainen Tiedeakatemia, 1986); Arnold Berleant, *The Aesthetics of the Environment* (Philadelphia: Temple University Press, 1992); and Marcia M. Eaton, *Aesthetics and the Good Life* (Rutherford, N.J.: Farleigh Dickinson University Press, 1989).

21. Hilton Kramer, "The Varnedoe Debacle: MOMA's New 'Low'," *The New Criterion* 9 no. 4 (December 1990): 7.

22. William Arrowsmith, "Art and Education" in *The Arts and the Public*, ed. James E. Miller and Paul D. Herring (Chicago: University of Chicago Press, 1967), 256.

23. Iris Murdoch, *The Fire and the Sun: Why Plato Banished the Artists* (New York: Oxford University Press, 1977), 86.

24. Kenneth Clark, "Art and Society," in *Moments of Vision* (London: John Murray, 1981), 79.

25. Francis Sparshott, *The Theory of the Arts* (Princeton: Princeton University Press, 1982), 133.

26. Morris Weitz, "The Role of Theory in Aesthetics," Smith, ed., *Aesthetics and Criticism in Art Education*, 94. Also in Joseph Margolis, ed., *Philosophy Looks at the Arts*, 3d ed. (Philadelphia: Temple University Press, 1987), 153.

Chapter 6. Elitism and Populism

The epigraphs are from Robert Penn Warren, *Democracy and Poetry* (Cambridge: Harvard University Press, 1975), 85-86; Sherman E. Lee, *Past, Present, East and West* (New York: George Braziller, 1983), 71; and Bernard Malamud, *The Stories of Bernard Malamud* (New York: Farrar, Strauss, Giroux, 1983), x-xi.

1. Hannah Arendt, *The Human Condition* (Chicago: University of Chicago Press, 1958), 167. Emphasis added.

2. I believe this is the position of Vincent Lanier. See his "Aesthetic Literacy as the Product of Art Education," in *The Product of a Process*. Selection of papers presented at the 24th INSEA World Congress (Amsterdam: 'De Trommel,' 1981): 115-21. Foreword by Ab Meilink. Editorial by Henri Van Merwijk.

3. Stuart Hampshire, "Private Pleasures and the Public Purse," a review of Janet Minahan's *The Nationalization of Culture* (New York: New York University Press, 1977), *Times Literary Supplement*, 13 May 1977, 579.

4. In *Other Criteria* (New York: Oxford University Press, 1972), Leo

Steinberg writes: "No critic, no outraged bourgeois, matches an artist's passion in repudiation" (4).

5. Rebecca West, *The Strange Necessity* (London: Johnathan Cape, 1928), 57, and Kenneth Clark, *Moments of Vision* (London: John Murray, 1981), 7. Both West's and Clark's views are discussed in Albert William Levi and R. A. Smith, *Art Education: A Critical Necessity* (Urbana: University of Illinois Press, 1991), 23-25.

6. See, e.g., Erwin Panofsky, "Style and Medium in the Motion Pictures," in *Film Theory and Criticism,* 2d ed., Gerald Mast and Marshall Cohen (New York: Oxford University Press, 1979); William Arrowsmith, "Film as Educator," in *Aesthetics and Problems of Education,* ed. R. A. Smith (Chicago: Rand McNally, 1966); Meyer Schapiro, *Romanesque Art: Selected Papers* (New York: George Braziller, 1977) and *Modern Art: 19th and 20th Centuries* (New York: George Braziller, 1978); Leo Steinberg, *Jasper Johns* (New York: George Wittenborn, 1963), and *Michelangelo's Last Paintings* (New York: Oxford University Press, 1975); Charles Jencks, *Post-Modernism: The New Classicism in Art and Architecture* (New York: Rizzoli, 1987); Meyer Schapiro, *Cézanne* (New York: Harry N. Abrams, 1952); Susan Galassi, "The Arnheim Connection: *Guernica* and *Las Meninas," Journal of Aesthetic Education* 27, no. 4 (Winter 1993): 45-56 (a special issue on Arnheim's work); Frank Stella, *Working Space* (Cambridge: Harvard University Press, 1986), to mention but a few examples of the point at issue.

7. An instructive discussion on this point is Monroe C. Beardsley's "Tastes Can Be Disputed," in *Classic Philosophical Questions,* 3d ed., ed. James A. Gould (Columbus: Charles E. Merrill, 1979).

8. Faulkner's remarks are referred to by Philip K. Jason in "The University as Patron of Literature: The Balch Program of Virginia," *Journal of General Education* 34, no. 3 (1983): 178.

9. Clark, "Art and Society," in his *Moments of Vision,* 66. For a description of the festivities that attended the completion of Duccio's *Maestà,* see John Canaday, *Lives of the Painters,* vol. 1 (New York: W. W. Norton, 1969), 15-16. The interest and controversy stirred by the discovery of the so-called Warriors of Riace was reported in the *New York Times,* 12 July, 1981, 3.

10. Nelson Edmonson, "An Agnostic Response to Christian Art," *Journal of Aesthetic Education* 15, no. 4 (October, 1981): 34.

11. E. H. Gombrich, "The Tradition of General Knowledge," in his *Ideals and Idols: Essays on Values in History and In Art* (New York: E. P. Dutton, 1979), 15-16. I have further discussed this essay in my *General Knowledge and Arts Education* (Urbana: University of Illinois Press, 1994), chap.1.

12. Richard Rorty, "The Dangers of Over-philosophication," *Educational Theory* 40, no. 1, 1990: 41-44.

13. Richard Hoggart, "Excellence and Access," in his *An English Temper* (New York: Oxford University Press, 1982), 160. Keeping in mind his liberal, leftist sympathies, Hoggart further writes that "it needs to be said again and again that we don't acquire 'a sense of community' by willing or wishing it; that because an activity is provincial and small-scale these qualities don't in themselves give it one percent more of virtue; and the fact that something is from the metropolis and

belongs to the 'high arts' doesn't disqualify it or make it an automatic target for abuse . . . It's a cops and robbers most participants posit. Many of them [communitarians] are not talking about art in any recognizable sense. They are talking about politics, confrontation, the bringing about of social change. What they call art is often propaganda which implicitly belittles the people they are working among" (153-54). In short, a concern with excellence is not exclusively a preoccupation of the political Right. Some critical reviewers of *Excellence in Art Education* conveniently failed to observe this point.

14. See, e.g., Doug Blandy and Kristin G. Condon, eds., *Pluralistic Approaches to Art Criticism* (Bowling Green, Ohio: Bowling Green University Press, 1991).

15. Charles Frankel, "The New Egalitarianism and the Old," *Commentary* 56, no. 3 (September 1973): 61.

16. Arthur Schlesinger, Jr., "The Challenge to Liberalism," in *An Outline of Man's Knowledge of the Modern World,* ed. Lyman Bryson (New York: McGraw-Hill, 1960), 473.

17. Matthew Arnold, *Culture and Anarchy,* ed. J. Dover Wilson (New York: Cambridge University Press, 1969), 70. First published in 1869.

18. Lawrence A. Cremin, *The Genius of American Education* (New York: Random House, 1966).

19. Roy Shaw, *Elitism versus Populism in the Arts* (Eastbourne: John Oxford, n.d.). Also his "The Arts Council and Aesthetic Education," *Journal of Aesthetic Education* 15, no. 3 (July 1981): 85-92.

20. Remarks in David W. Ecker, Jerome J. Hausman, and Irving Sandler, eds., *Conference on Art Criticism and Art Education* (New York: Office of Field Research and School Services, New York University, n.d.), 23.

21. Robert Penn Warren, *Democracy and Poetry* (Cambridge: Harvard University Press, 1975).

22. In the Introduction to his *Aesthetics and Art Theory: An Historical Introduction* (New York: E. P. Dutton, 1968), Harold Osborne writes that many people "believe that the aesthetic motive has been operative throughout history to control the making and appraisal of those artifacts which we now regard as works of art even though it has been latent and unconscious. Though there was no explicit theory of aesthetic experience in classical antiquity or in the Middle Ages or at the Renaissance, works of art were fashioned [that] meet for appreciation; and from the earliest human periods artifacts were made with formal qualities enabling us now to appreciate them aesthetically although these formal qualities—often far from easy to achieve—were redundant to their practical utility or to the religious, magical, or other functions which they were designed to fulfill" (23). Support for this view can be found in Jacques Maquet, *The Aesthetic Experience: An Anthropologist Looks at the Arts* (New Haven: Yale University Press, 1986); H. Gene Blocker, *The Aesthetics of Primitive Art* (New York: University Press of America, 1994); E. Dissanayake, *What Is Art For?* (Seattle: University of Washington Press, 1988); and in John Walker's introduction to Frank Getlein's *Art Treasures of the World* (New York: Clarkson N. Potter, 1968). Walker, erstwhile director of the National Gallery of Art, writes that what unites a Yorubian bust of a king, a chalice

of the Abbot Suger, a Byzantine ivory, and Sung Dynasty jade horse, what enables them to accommodate each other's company is an "almost universally felt fitness between some transcendent value . . . and the utmost man can provide in the way of splendor, beauty, harmonious proportions and superb craftsmanship" (5).

23. Ortega y Gasset, *The Revolt of the Masses* (New York: W. W. Norton, 1932), 18. In *Man and His Circumstances: Ortega as Educator* (New York: Teachers College Press, 1971), Robert McClintock emphasizes that Ortega's notion of the mass man is not necessarily one from the working classes but a person of any class who manifests a certain disposition. "The essential difference between a man of noble character and one of mass complacency was not in the type of actions that each undertook, but in the spirit with each pursued outwardly similar acts: the noble man chose to make his deeds serve a demanding ideal, whereas the mass man was content if his acts satisfied his immediate appetite" (336). Today we would, of course, say the noble man and the noble woman.

24. For a discussion of the best self, see G. H. Bantock, *Studies in the History of Educational Theory, vol. 2, The Minds and the Masses, 1760-1980* (Boston: George Allen and Unwin, 1984), chap. 9.

Chapter 7. Multiculturalism and Cultural Particularism

The epigraph is from Walter Kaufmann, *The Future of the Humanities* (New York: Thomas Y. Crowell, 1977), 22.

1. For my earlier views on cultural diversity, see "Celebrating the Arts in their Cultural Diversity: Some Wrong and Right Ways to Do It," in *Arts in Cultural Diversity,* ed. Jack Condous, Janterie Howlett, and John Skull (New York: Rinehart and Winston, 1980), 82-88; "Forms of Multicultural Education in the Arts," *Journal of Multi-Cultural and Cross-Cultural Research in Art Education* (Fall 1983): 23-32; and "The Uses of Cultural Diversity, *Journal of Aesthetic Education* 12, no. 2 (April 1978): 5-10. "Forms of Multicultural Education in the Arts" has been widely quoted and referred to and its distinctions served as organizing ideas for Rachel Mason's *Art Education and Multiculturalism* (New York: Croom Helm, 1988), 1-2.

2. Kaufmann, *The Future of the Humanities.*

3. Francis Haskell, "Museums and Their Enemies," *Journal of Aesthetic Education* 19, no. 2 (Summer 1985): 2. A special issue on art museums and education.

4. Lionel Trilling, "Mind in the Modern World," in *Lionel Trilling, The Last Decade: Essays and Reviews,* 1965-1975, ed. Diana Trilling (New York: Harcourt Brace Jovanovich, 1977), 122-23. Delivered as the first National Endowment for the Humanities Thomas Jefferson Lecture in the Humanities, 1973.

5. Irving Howe, "On Lionel Trilling: 'Continuous Magical Confrontation'," *The New Republic,* 13 March 1976, 30.

6. See, e.g., David Lowenthal, *The Past Is a Foreign Country* (New York: Cambridge University Press, 1985) and Clifford Adelman, *Tourists in Our Own Land: Cultural Literacies and the College Curriculum* (Washington, D.C.: Government Printing Office, 1992).

7. Trilling, "Why We Read Jane Austen," in *Trilling, The Last Decade,* 204-25.

8. Clifford Geertz, "From the Native's Point of View: On the Nature of Anthropological Understanding," *Bulletin of the American Academy of the Arts and Sciences* 28 (October 1974): 30.

9. Geertz, "Person, Time, and Conduct in Bali," in his *The Interpretation of Cultures* (New York: Basic Books, 1973), 403.

10. Geertz, "From the Native's Point of View," 35.

11. Trilling, "Why We Read Jane Austen," 225.

12. Mary Ann Raywid, "Pluralism as a Basis for Educational Policy: Some Second Thoughts," in *Educational Policy*, ed. Janice F. Weaver (Danville, Ill.: Interstate, 1975), 81-99.

13. Diane Ravitch, "Multiculturalism: E Pluribus Plures," *The American Scholar* 59 (Summer 1990): 337-54.

14. Ravitch, "Response," *The American Scholar* 60 (Spring 1991): 272-76.

15. Ravitch, *Network News and Views* 9 (March 1990): 1-9, from a presentation made before the Manhattan Institute, November 29, 1989, with follow-up remarks, 10-11.

16. John Wilson, "Art, Culture, and Identity," *Journal of Aesthetic Education* 18, no. 2 (Summer 1984): 89-97.

17. Since this chapter was written, two discussions have appeared which cast further perspective on the issues. In *The Disuniting of America* (New York: Norton, 1992), Arthur J. Schlesinger, Jr., reinforces the importance Ravitch attaches to sound scholarship and provides counterexamples to some extremist views. In "E Pluribus Nihil: Multiculturalism and Black Children," *Commentary* 92, no. 3 (September 1992), Midge Decter writes that "Whatever was the case with their ancestors, they [black children] are the legitimate heirs of a common culture in which the disparate racial and ethnic groups living here came together as Americans, sharing the same national traditions and speaking the same language, and that this common culture must be the name of their desire" (29).

Chapter 8. Modernism and Postmodernism

The epigraphs are from Hilton Kramer, *The Revenge of the Philistines: Art and Culture, 1972-1984* (New York: The Free Press, 1985), xii-xiii; and Charles Jencks, *Post-Modernism: The New Classicism in Art and Architecture* (New York: Rizzoli, 1987), 7.

1. Jacques Barzun, *The Use and Abuse of Art* (Princeton, N.J.: Princeton University Press, 1975), 7-8.

2. Ihab Hassan, *The Postmodern Turn* (Columbus: Ohio State University Press, 1987).

3. Richard Ellmann and Charles Fieldelson, eds., *The Modern Tradition: Backgrounds of Modern Literature* (New York: Oxford University Press, 1965); e.g., Nietzsche and Heidegger.

4. Jacques Maquet, "Perennial Modernity: Forms as Aesthetic and Symbolic," *Journal of Aesthetic Education* 24, no. 4 (Winter 1990): 47-58.

5. Roger Fowler, *Dictionary of Modern Critical Terms*, rev. ed. (New York: Routledge and Kegan Paul, 1987), 151-52.

6. Hilton Kramer, *The Age of the Avant-Garde: An Art Chronicle of 1956-1972* (New York: Farrar, Straus and Giroux, 1973), Introduction.

7. Michael J. Parsons and H. Gene Blocker, *Aesthetics and Education* (Urbana: University of Illinois Press, 1993), 49-62. Cf. Terry Barrett, *Criticizing Art: Understanding the Contemporary* (Mountain View, Cal.: Mayfield 1994), chap. 5.

8. H. Gene Blocker, *Philosophy of Art* (New York: Charles Scribner's, 1979). So far as I know, Blocker's views in this book were not regarded as postmodern, or modern for that matter, just good philosophy.

9. I have discussed critics of postmodernism in my *The Sense of Art* (New York: Routledge, 1989), 169-83.

10. Joseph Margolis, "Deconstruction: A Cautionary Tale," *Journal of Aesthetic Education* 20, no. 4 (Winter 1986): 91-94.

11. See, e.g., Louis Arnaud Reid, *Ways of Knowledge and Experience* (London: George Allen and Unwin, 1961); Philip H. Phenix, *Realms of Meaning* (New York: McGraw-Hill, 1964); Paul H. Hirst, *Knowledge and the Curriculum* (Boston: Routledge and Kegan Paul, 1974); Elliot W. Eisner, *Cognition and Curriculum* (New York: Longman, 1982); Howard Gardner, *Frames of Mind* (New York: Basic Books, 1983).

12. R. A. Smith, ed., *Aesthetics and Criticism in Art Education: Problems in Defining, Explaining, and Evaluating Art* (Chicago: Rand McNally, 1966).

13. Frederick Crews, *Skeptical Engagements* (New York: Oxford University Press, 1986), 164.

14. David Bromwich, "Recent Work in Literary Criticism," *Social Research* 53, no. 3 (Autumn 1986): 414-15. Bromwich describes how the forceful imposition of an ideological perspective can attribute qualities to a character that are inconsistent with a text's own internal evidence. The context for his remarks is Gayatri Chakravorti Spivak's "Three Women's Texts and a Critique of Imperialism," *Critical Inquiry* 12, no. 1 (Autumn 1985): 243-61.

15. M. J. Wilsmore, "Against Deconstructing Rationality in Education," *Journal of Aesthetic Education* 25, no. 4 (Winter 1991): 99-113.

16. See, e.g., Annette Barnes, "Is there a Doctrine to this Landscape?" *Journal of Aesthetic Education* 23, no. 3 (Fall 1989), 77-84; Peter Shaw, "Devastating Developments are Hastening the Demise of Deconstruction in Academe," *Chronicle of Higher Education* 37, no. 13 (November 28, 1990): 131-2; and Martin Schiralli, "Reconstructing Literary Values," *Journal of Aesthetic Education* 25, no. 4 (Winter 1991): 115-19.

17. Marcia M. Eaton, *Basic Issues in Aesthetics* (Belmont, Cal.: Wadsworth, 1988), 86-88.

18. John R. Searle, "Is There a Crisis in American Higher Education?" (1992). © John R. Searle. Department of Philosophy, University of California at Berkeley. Unpublished paper.

19. Jacques Barzun, *The Use and Abuse of Art* (Princeton: Princeton University Press, 1975), 58-72.

20. Albert William Levi, "Psychedelic Science," *Journal of Aesthetic Education* 6, nos. 1-2 (January-April 1972): 80.

21. Joseph Epstein, "Culture and Capitalism," *Commentary* 96, no. 5 (November 1993): 32-36.

22. That artists and schools that prepare them are sensitive to the economic atmosphere of the current situation is suggested by Thomas Crow in an essay in *Endgame: Reference and Simulation in Recent Painting and Sculpture* (Cambridge: The MIT Press, 1986), a catalogue for an exhibition held at the Institute of Contemporary Art in Boston, September 25-November 30, 1986. After remarking the increase in intensity of artistic activity and corporate patronage in which there is heated competition for the acquisition of new art, Crow writes that "It is routine to hear of young, relatively untried artists having waiting lists and of collectors buying uncompleted work on studio visits." Not only that. "Certain schools, such as Cal Arts, have begun to function as efficient academies for the new scene, equipping students with both expectations and realizable plans for success while still in their twenties" (18).

23. Charles Jencks, *Post-Modernism: The New Classicism in Art and Architecture.*

24. T. S. Eliot, "Tradition and the Individual Talent," in his *Selected Essays, New Edition* (New York: Harcourt, Brace and World, 1950).

25. The complaint of critics along a political spectrum was that the show in question was little more than obvious propaganda and had little to do with art. For a sense of the situation, see Peter Plagens and Carolyn Friday, "From Hopper to Hip-Hop" in *Newsweek*, 8 November 1993, 76-77. Also, Richard Ryan, "The Whitney Fiasco and the Critics," *Commentary* 96, no. 1 (July 1993): 51-54. Ryan writes that "just about everybody reviewing the show agreed that the art was dull and didactic, an embarrassment even by the Biennial's inverted standards. But beyond that, all was confusion." He says that far from being revolutionary, the show consisted of "talentless experiments" which "should be remembered, rightly, as a debacle for the cultural Left" (53-54).

Chapter 9. An Excellence Curriculum, K-12

The epigraph is from "Teaching the Humanities through the Arts" by Albert William Levi. Unpublished material prepared for a humanities project. Available from R. A. Smith.

1. I draw particularly on my *The Sense of Art: A Study in Aesthetic Education* (New York: Routledge, 1989); Albert William Levi and R. A. Smith, *Art Education: A Critical Necessity* (Urbana: University of Illinois Press, 1991); and "Toward Percipience: A Humanities Curriculum for Arts Education," in *The Arts, Education, and Aesthetic Knowing,* Ninety-first Yearbook of the National Society for the Study of Education, Part II, ed. Bennett Reimer and R. A. Smith (Chicago: University of Chicago Press, 1992), 51-69.

2. Arthur Danto, *The Transfiguration of the Commonplace* (Cambridge: Harvard University Press, 1981). Commenting on the role of theory in constituting an art world, Danto writes: "To see something as art at all demands nothing less than this, an atmosphere of artistic theory, a knowledge of the history of art" (135).

3. Such methods are discussed in Mortimer Adler, *The Paideia Proposal*

(New York: Macmillan, 1982), esp. chap. 4. Cf. the discussion of seminars, coaching, and didactic instruction in Adler, *The Paideia Program* (New York: Macmillan, 1984), part 1. For a discussion of "thinking with," see Harry S. Broudy, "On 'Knowing With,' " in *Philosophy of Education,* 1970 ed. H. B. Dunkel (Edwardsville, Ill.: Philosophy of Education Society, 1970), and Broudy's "Didactics, Heuristics, and Philetics," *Educational Theory* 22, no. 3 (Summer 1972): 251-61.

4. On the subject of responding to reviewers and commentators, I think writers have no obligation to respond to those who (1) write more about their own ideas than those contained in the book under consideration; (2) distort the argument of a text through highly selective quoting and paraphrasing; (3) disparage parenthetically a text's purported character without troubling to spell out the text's actual position; (4) think that an argument is appropriately responded to by an absurd, theatrical verbal performance (which, of course, discredits not the target of the performance but the perpetrator of the farce); (5) criticize a writer's ideas while in fact subscribing to the very same ideas (in short, practice hypocrisy); and (6) are simply incompetent to review or comment. Happily, not all the discussants of *Excellence in Art Education* fell into these categories, although several of them did. Among the more thoughtful and responsible respondents were Mary Ann Stankiewicz, George Geahigan, Arthur Efland, Margaret DiBlasio, Bennett Reimer, Janice Riddell, and Nick Webb—which is not to say that they raised no questions, some of which I've responded to in this volume. For a discussion of what a book review should be, see Jacques Barzun and Henry F. Graff, *The Modern Researcher* (New York: Harcourt, Brace and Company, 1957), 245-46. Several editions.

5. Harry S. Broudy, B. Othanel Smith, and Joe R. Burnett, *Democracy and Excellence in American Secondary Education* (Chicago: Rand McNally, 1964), esp. chaps. 2 and 3. Cf. Broudy's "Cultural Literacy and General Education," in *Cultural Literacy and Arts Education,* ed. R. A. Smith (Urbana: University of Illinois Press, 1991): 7-16.

6. See, e.g., Manuel Barkan, "Is There a Discipline of Art Education?" *Studies in Art Education* 4, no. 2 (Spring 1963): 4-9.

7. For a helpful discussion of slogans, metaphors, and definitions in education, see Israel Scheffler, *The Language of Education* (Springfield, Ill.: Charles C. Thomas, 1960). Scheffler points out that the logic of the concept of art (and its subconcepts) and the logic of the concept of education (and its subconcepts) are quite similar.

8. For some historical perspective on pedagogical method, see Harry S. Broudy and John Palmer, *Exemplars of Teaching Method* (Chicago: Rand McNally, 1965). Cf. Gary D. Fenstermacher and Jonas F. Soltis, *Approaches to Teaching* (New York: Teachers College Press, 1986); and Philip W. Jackson, *The Practice of Teaching* (New York: Teachers College Press, 1986).

9. Albert William Levi, "Teaching Literature as a Humanity," *Journal of General Education* 28, no. 4 (Winter 1977): 283-87.

10. Levi, *The Humanities Today* (Bloomington: Indiana University Press, 1970).

11. In this respect Levi anticipated by seventeen years E. D. Hirsch's concern

in *Cultural Literacy* (New York: Random House, 1987); Broudy et al. in *Excellence in American Secondary Education* (1964) did so even earlier than Levi.

12. For a humanistic interpretation of history, see Jacques Barzun, *Clio and the Doctors: Psycho-History, Quanto-History, and History* (Chicago: University of Chicago Press, 1974).

13. Levi, *The Humanities Today*, 85-86.

14. I borrow the expression "qualitative immediacy" from Levi's discussion of C. S. Peirce's phenomenology that features the universal categories of Fistness (qualitative immediacy), Secondness (interactive force or movement), and Thirdness (meaning). See Levi's *Literature, Philosophy, and the Imagination* (Bloomington: Indiana University Press, 1962), 140-44, and following.

15. This image is conventional enough, but it is interestingly developed by Virgil C. Aldrich in *Philosophy of Art* (Englewood Cliffs, N.J.: Prentice-Hall, 1963), chap. 2; and H. Gene Blocker, *Philosophy of Art* (New York: Scribner's, 1979), Introduction.

16. For specific suggestions along these lines, see Laura H. Chapman, *Discover Art: 1-6* (Worcester, Mass.: Davis, 1987); Al Hurwitz and Michael Day, *Children and Their Art: Methods for the Elementary Schools,* 5th ed. (New York: Harcourt Brace Jovanovich, 1991); Kay Alexander and Michael Day, *Discipline-Based Art Education: A Curriculum Sampler* (Los Angeles: Getty Center for Education in the Arts, 1991); *Improving Visual Arts Education: Final Report of the Los Angeles Getty Institute for Educators in the Visual Arts* (Los Angeles: Getty Center for Education in the Arts, 1993), introduction by W. Dwaine Greer.

17. Such a vocabulary could include not only more or less technical terms that are relevant to discussing works of art but also terms, events, and names knowledge of which comprises what E. D. Hirsch calls cultural literacy. These items might be acquired the way vocabulary lists are learned in studying a foreign language. They are words, etc., needed to participate effectively in public talk about art. Such words appear in Hirsch's *Dictionary of Cultural Literacy*, with Joseph F. Kett and James Trefil (Boston: Houghton Mifflin, 1988), and in graded dictionaries, e.g., *What Your 1st Grader Needs to Know, Your 2nd Grader,* and so forth, through six grades, edited by Hirsch and published by Core Publications and Doubleday Books.

18. See the discussion of aesthetic scanning by Harry S. Broudy and Ronald Silverman in Broudy's *The Role of Imagery in Learning* (Los Angeles: Getty Center for Education in the Arts, 1987), 52-53.

19. Kenneth Clark, *Looking at Pictures* (New York: Holt, Rinehart and Winston, 1960). I have discussed Clark's pattern of response in connection with his description of Vermeer's *The Artist in His Studio* in my *The Sense of Art* (New York: Routledge, 1989), 72-75.

20. For a discussion of a historical tradition, see H. W. Janson *History of Art,* 3d ed., revised and expanded by Anthony F. Janson (Englewood Cliffs, N.J.: Prentice-Hall, 1986), 13-15. Periodically revised. Also see Daniel Biebuyck, ed., *Tradition and Creativity in Tribal Art* (Berkeley: University of California Press, 1969). Marcia M. Eaton also has some interesting things to say about the idea of a tradition in her *Basic Issues in Aesthetics* (Belmont, Cal.: Wadsworth, 1988), 142-45.

21. Stephen Addiss and Mary Erickson, *Art History and Education* (Urbana: University of Illinois Press, 1993).

22. David Lowenthal, *The Past is a Foreign Country* (New York: Cambridge University Press, 1985), 224.

23. For some suggestive ideas for comparisons, see Benjamin Rowland, *Art in East and West* (Cambridge: Harvard University Press, 1954); Theodore Bowie et al., *East-West in Art: Patterns of Cultural and Aesthetic Relationships* (Bloomington: Indiana University Press, 1966); and H. Gene Blocker, *The Aesthetics of Primitive Art* (Lanham, Md.: University Press of America, 1994).

24. Margaret P. Battin, John Fisher, Ronald Moore, Anita Silvers, *Puzzles about Art: An Aesthetics Casebook* (New York: St. Martin's Press, 1989). Cf. "Aesthetics for Young People," a special issue of the *Journal of Aesthetic Education* 28, no. 3 (Fall 1994), Ronald Moore, guest editor.

Chapter 10. Anticipated Reactions

1. For a comprehensive survey and discussion of the gifted and talented in art education, see Gilbert A. Clark and Enid Zimmerman, *Issues and Practices Related to Identification of Gifted and Talented Students in the Visual Arts* (Fairfield, Conn.: The National Research Center on the Gifted and Talented, University of Connecticut, 1992).

2. I am not saying that teachers of non-art subjects should not use works of art or artistic activities to achieve their objectives. I am merely saying that such use of art should not be a substitute for the serious study of art as a subject with distinctive forms of expression, accomplishments, and problems of understanding and evaluation. I have discussed this point in "Trends and Issues in Policy-Making for Arts Education," in *Handbook of Research on Music Teaching and Learning,* ed. Richard Colwell (New York: Schirmer, 1992), 749-59.

3. Hilda Hein, "The Role of Feminist Aesthetics in Feminist Theory," *Journal of Aesthetics and Art Criticism* 48, no. 4 (Fall 1990): 288.

4. Anita Silvers, "Has Her(oine's) Time Now Come?" Ibid. Silvers writes: "Still seeking freedom in a criticism of their own, but finding that the canon needs a history of its own, feminists need to guard against imagining that egalitarian fervor transfigures commonplace speechwriting into artwriting inspired enough for aesthetic revolution" (377).

5. Peter Shaw, "Feminist Literary Theory," in his *The War against the Intellect* (Iowa City: University of Iowa Press, 1989), 85.

6. Arnold Hauser, *The Social History of Art,* vol. 4 (New York: Vintage Books, 1958), 259.

7. I might observe that in *Studies in Art Education* 33, no. 2 (Winter 1992), Karen Hamblen aptly writes that "problems develop when art educators are designated *elitist* or entire bodies of research are labeled *populist*—and then dismissed" (68).

1. Wtadistaw Tatarkiewicz, "The Aesthetic Experience: History of the Concept," in his *History of Six Ideas,* trans. Christopher Kasparek (Boston: Martinus Nijhoff, 1980), 310-38. The other five ideas are art, beauty, form, creativity, and imitation.

2. Monroe C. Beardsley, *Aesthetics: Problems in the Philosophy of Criticism,* 2d ed. (Indianapolis: Hackett, 1981), xi.

3. Harry S. Broudy, "On Cognition and Emotion in the Arts," in *The Arts, Cognition, and Basic Skills,* ed. Stanley Madeja (St. Louis: CEMREL, 1978), 21.

4. Harold Osborne, *The Art of Appreciation* (New York: Oxford University Press, 1970), 20-21.

5. Arthur Conan Doyle, *The Complete Sherlock Holmes,* vol. 1 (New York: Doubleday, n.d.), 322-23.

6. Albert William Levi, "Nature and Art," *Journal of Aesthetic Education* 18, no. 3 (Fall 1984): 5-6.

7. Quoted by Osborne in *The Art of Appreciation,* 25.

8. Guy Sircello, *A New Theory of Beauty* (Princeton: Princeton University Press, 1975), 19-20.

9. Charles Darwin, *The Voyage of the Beagle,* ed. Millicent E. Selsam (New York: Harper and Row, 1959), 216.

10. Quoted by Harold Osborne in *Abstraction and Artifice in Twentieth-Century Art* (New York: Oxford University Press, 1979), 103. In describing a view of Moscow an hour after sunset and at night, George Will writes that "To watch dusk descend on Moscow is to watch a city vanish. It is as though it sinks into the sandy soil that limits high-rise construction in this horizontal capital. To see Moscow at night is to be struck by what you do not see, and to long for neon—the electronic exuberance that is freedom's signature in the form of capitalism's crackling energy." *News Gazette* (Champaign-Urbana, Illinois), 13 March 86, A-4. With the breakup of the Soviet Union, Moscow nights are beginning to crackle.

11. Morton D. Zabel, ed., *The Art of Travel: Sciences and Journeys in America, England, France and Italy from the Travel Writings of Henry James* (New York: Doubleday, 1958), 396-97.

12. Mark Twain, *Life on the Mississippi* (New York: Penguin, 1984), 94-96. Quoted in Margaret P. Battin, John Fisher, Ronald Moore, and Anita Silvers, *Puzzles about Art* (New York: St. Martin's Press, 1989), 50-51. For another view of a sunset consider the following entry in the diary of Edvard Munch (1889): "One evening I was walking along a path, the city was on one side and the fjord below. I felt tired and ill. I stopped and looked out over the fjord—the sun was setting, and the clouds turning blood red. I sensed a scream passing through nature; it seemed to me that I heard the scream. I painted this picture, painted the clouds as actual blood. The color shrieked. This became *The Scream.*" Reprinted in *Ballart Quarterly Review* 9, no. 2 (Winter 1993): 12.

13. Harry S. Broudy, "The Structure of Knowledge in the Arts," in *Education and the Structure of Knowledge,* ed. Stanley Elam (Chicago: Rand McNally, 1966), 91-92; reprinted in R. A. Smith, ed., *Aesthetics and Criticism in Art Education*

(Chicago: Rand McNally, 1966), 34-35.

14. E. F. Kaelin, "Aesthetic Education: A Role for Aesthetics Proper," in *Aesthetics and Problems of Education,* ed. R. A. Smith (Urbana: University of Illinois Press, 1971), 154; reprinted in E. F. Kaelin, *An Aesthetics for Educators* (New York: Teachers College Press, 1989), 65-83.

15. "Aesthetic Experience Regained," in Beardsley, *The Aesthetic Point of View: Selected Essays,* ed. Michael V. Wreen and Donald M. Callen (Ithaca: Cornell University Press, 1982), 89.

16. Diané Collinson, "Aesthetic Education," in *New Essays on the Philosophy of Education,* ed. G. Langford and D. J. O'Connor (London: Routledge and Kegan Paul, 1973), 200.

17. Meyer Schapiro, *Cézanne* (New York: Harry N. Abrams, 1952), 74.